PIERLUIGI DE VECCHI

MICHELANGELO

Translated by Alexandra Campbell

BCA

LONDON · NEW YORK · SYDNEY · TORONTO

First published in Great Britain in 1992 by
Barrie & Jenkins Ltd
20 Vauxhall Bridge Road, London SW1V 2SA

This edition published 1992 by BCA
by arrangement with Barrie & Jenkins Ltd

Translated by Alexandra Campbell

Typeset by SX Composing Ltd
Printed in Switzerland

CN 3084

The publishers thank Princeton University Press for
permission to quote from *Complete Poems and
Selected Letters of Michelangelo,* translated by
Creighton Gilbert and edited by Robert N. Linscott,
Princeton, New Jersey, 1963; other verse quotations
are from *The Sonnets of Michelangelo,* translated by
J. A. Symonds.

Frontispiece: An *ignudo,* detail from the vault of the
Sistine Chapel.

Michelangelo

Towards the middle of the nineteenth century, in a small painting now in the Montpellier Museum, Delacroix portrayed Michelangelo in his workshop. It is a large room resembling more a nineteenth-century sculptor's studio than the workplace of a Renaissance artist in Florence and in it can be glimpsed the great white shapes of the Medici *Madonna* and of *Moses*. In the foreground, Michelangelo, who has thrown his chisel to the ground, seems in the grip of acute despondency and dissatisfaction. According to a contemporary witness, T. Silvestre, Delacroix was trying here to realise a form of ideal self-portrait. The real subject of the painting is clearly the inner suffering and doubt assailing the artist at the moment of creation.

Melancholia, a favourite theme of the Romantic period, was already in vogue at the Renaissance. In the eyes of his own contemporaries, Michelangelo seemed to exemplify the typical 'saturnine' artist, weighed down, particularly in his maturity, by an incurable dissatisfaction with his work; as Vasari wrote, his *Last Judgement* was 'so large that he was never satisfied with what he had done'.

By presenting Michelangelo as the prototype of an unsatisfied and tormented genius with whom the Romantic painter could readily identify, Delacroix's small picture played a significant role in establishing the ultimate reputation of Michelangelo's *oeuvre*. Certain pages in Delacroix's *Journal* and particularly two published essays, one in the *Revue de Paris* in 1830, the other in the *Revue des Deux Mondes* in 1837, provide further evidence of his deep interest in and admiration for Buonarroti's sculptures – even if he later came to feel a number of reservations, and at

the end of his life clearly preferred the work of Titian.

Making perceptive observations on technique and form in Michelangelo's work, Delacroix's writings depict a solitary and impassioned artist, a portrayal very close to that given by Stendhal in his *Histoire de la Peinture en Italie* (1817). While noting that *The Last Judgement* was still often viewed askance in artistic circles, Stendhal asserted prophetically that in a few decades 'a taste for Michelangelo' would be reborn. A third person stands with Stendhal and Delacroix as an originator of the 'modern' rediscovery of the character and work of Michelangelo: Géricault. Before his journey to Italy (1816-17) Géricault's only acquaintance with Michelangelo's work was through engravings made from originals. He told a friend that his first sight of the frescos in the Sistine Chapel – to which he had hastened on his arrival in Rome – provoked such emotion and shock that he suffered a fit of giddiness from which he only gradually recovered. Following his initial bedazzlement, he embarked on a systematic study of the frescos and copied parts of *The Last Judgement*, the influence of which is readily apparent in his tumultuous and epic representation of *The Raft of the Medusa* (1819) as well as in the studies that preceded it. Fully to appreciate the importance and novelty of the attitudes of Stendhal, Géricault and Delacroix towards Buonarroti's work, one has to remember that their interest and admiration were far from common in French artistic circles in the early nineteenth century. Michelangelo's influence was still regarded as dangerous and pernicious, a cause of the 'corruption of taste' and an obstacle to the development of a

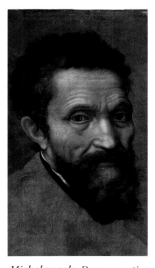

Michelangelo Buonarroti
by J. del Conte

refined and harmonious sensibility.

The attitude of these three great Romantics, which derived from their recognition of a profound spiritual affinity, finds precedent, albeit indirectly and to less marked effect, in England in the last decades of the eighteenth century with Reynolds, Füssli and Blake. These men, each with a different emphasis, portrayed Michelangelo as an 'epic' artist driven by the irresistible force of his genius to flout all academic laws and conventions.

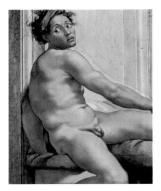

Ignudi, detail above
Erythraean Sibyl

Thus in England and France the general estimation of Buonarroti's work began to undergo a radical change, after some two centuries in which his reputation had suffered a partial eclipse because of both aesthetic and moral prejudice. The condemnation was not outright; indeed it was initially accompanied by an acclaim perhaps more spectacular than any accorded to an artist in his lifetime. From 1540, after Michelangelo finally left Florence for Rome, the 'legend' began to take shape. The last survivor of an age already viewed with nostalgia as the culminating point of a civilisation on the verge of inevitable decline, the artist was at the end of his life surrounded by the unqualified admiration of the younger generations as well as that of the most influential and cultivated patrons, who saw his works as the incarnation of an absolute ideal, of a perfection that transcended traditional art and nature itself. 'This man towers over and excels not only those before him who have virtually outdone nature, but even the celebrated artists of the antique who have so admirably surpassed her and, single-handed, he triumphs over all and sundry. It is hard to imagine anything so strange and incredible that, by virtue of his inspired intelligence, in his work, drawing, art, judgement and grace, he does not far exceed it.' Even if the praises that Vasari heaped on Michelangelo in the first edition of *Lives* (1550) seem bombastic and

Male nude, from back

hyperbolic, they reflect not the fervour of a lone admirer but widespread opinions and ideas.

Though subsequently a treacherous and bitter detractor of Buonarroti, earlier, in 1537, Aretino had written to him: 'In you lives the secret of another nature.' Vasari's *Lives* followed a strict and lofty historical plan leading progressively upwards towards the 'perfection of art' in the work of Michelangelo, the only living artist to be cited. Before its publication, however, two works (the *Dialogues* of Donato Gianotti and Francisco da Hollanda and the *Lessons* on two sonnets by the artist published by Benedetto Varchi) had paved the way to the celebration – taken to the point of a cult – not only of Michelangelo's work but also of his personality, increasingly described as 'divine'. In the 1550s the writings of Antonio Francesco Doni and the biography by Ascanio Condivi (1553) laid emphasis on the heroic and almost superhuman aspects of the artist's character. As will be seen later, however, it was *The Last Judgement* that first provoked Michelangelo's detractors. To accusations of 'obscenity', flouting of 'conventions' and betrayal of 'historical truth' even to the point of heresy, voiced already in Aretino's notorious letter (November 1545), were added serious formal reservations, stemming particularly from Lodovico Dolce (1557).

Michelangelo's work met with spectacular success among contemporary artists, as is evidenced by a great number of engraved reproductions. But he rapidly came to be criticised for his 'lack of proportion' and of 'harmony', his excessive and monotonous anatomical virtuosity, in contrast to 'the celebrated grace of Raphael with its pleasing beauty of invention' (Aretino).

This paved the way for criticisms by the disciples of classicism in the seventeenth and eighteenth centuries, from Baglione to Bellori and Milizia in Italy, from Fréart de Chambray to Felibien and

Quatremère de Quincy in France. The unfavourable comparison with Raphael and the art of classical antiquity and the condemnation of 'anatomical' excess became commonplace, but incomprehension and hostility were often taken to the point of accusing Michelangelo of being at the origin of a 'perversion' of taste and of systematic violation of the 'conventions' and of all rules; 'infamous free-thinking' was Fréart de Chambray's definition of Michelangelo's art (1662). In the course of the two centuries of his disgrace, there were naturally some attitudes and schools of thought running against the general current, particularly among artists. Michelangelo's works – studied directly and also indirectly in engravings – continued to offer a brilliant source of inspiration to a number of great masters, from Caravaggio to Carracci and above all Rubens, also to Velázquez, Rembrandt and even Poussin. According to Bernini, Michelangelo was 'a great sculptor and a great painter, but a truly divine architect'.

Theoretical texts almost never disputed the 'greatness' of the Florentine artist's drawing and ideas: Fénelon and the Abbé du Bos described him as 'the Corneille of painting'. More explicit still are the comments of the well-known expert and collector P.J.Mariette who had in his possession some of the artist's beautiful drawings. Stressing, like Vasari, the significant influence of his work on Raphael's development, Mariette rejects all accusations of 'licence' and asserts that: 'The genius of Dante is to be found in Michelangelo's *Last Judgement*.'

While in Italy at the end of the eighteenth century the prejudices of the classical age were still to be found intact in the writings of Milizia and of Lanzi, the critical opinions of the German Neoclassical school were more divergent, notably in the case of Winckelmann who, having termed Buonarroti the greatest sculptor after the Greeks and before Canova (1755), refused to credit him with a genuine 'feeling for beauty', probably influenced in this by Mengs, and blamed him yet again for leading the way to a 'degeneration of taste'. It is only in the *Italienische Reise* of the young Goethe that the greatness of Michelangelo's 'genius' is explicitly recognised; however, Goethe, too, came to prefer Raphael in later years.

The deep spiritual affinity underlying the interest Stendhal, Géricault and Delacroix felt in Michelan-gelo's work, their readiness to identify with the image of a solitary and tormented genius that they themselves had helped to create, was not only extensively echoed in the Romantic movement in the years to follow, but also served to encourage a multiplicity of historical study and criticism of the artist's work and character during the second half of the nineteenth century.

At this period the values of the classical age were no longer current as they had been in the preceding centuries. However, moral prejudices still found expression in lone voices such as that of Ruskin (1872) who judged the manner in which Michelangelo represented the human body as immodest, insolent and artificial in contrast to the faithful, modest and natural style of the ancient Greeks and the Venetian artists of the Renaissance. For a long time yet it was the personality of Michelangelo that attracted the most attention and served – even more than his work – as a focal point for learned studies that endeavoured to place him in the context of the period. Jacob Burckhardt, in the pages he devoted to Michelangelo in *Cicero*, insisted on the *terribilità* of his genius. It is significant here that from 1860, for some fifty years, publications about Michelangelo took the form mainly of biographies, for example those by H. Grimm (1860-3), A. Gotti (1865), J. A. Symonds (1883), C. Justi (1900), Romain Rolland (1905) and H. Thodo (1908-13). H. Wölfflin's essay on the subject of Michelangelo's early work which on principle excluded all biographical material, marked a turning point in the exaggerated development of Michelangelo's romantic legend – and its accompanying cult.

From this point, studies of different aspects of Michelangelo's activities and his complex relationship to the culture of his time proliferated the world over. The multiplicity and impassioned character of the arguments and commentaries are evidence of a growing interest in the work and person of the artist, regarded as one of the greatest of all time by an increasingly wide public.

The recent cleaning and restoration of the frescos in the vault of the Sistine Chapel – that of *The Last Judgement* has barely begun – have revealed the

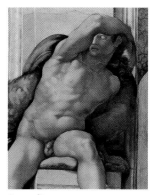

Ignudi,
detail above *Isaiah*

7

splendour of the original colours and deeply enriched and revived our knowledge of Michelangelo's art and pictorial technique.

Michelangelo was one of a relatively small group of Renaissance artists belonging to the 'gentry'. According to the biography, written probably under his supervision, by his pupil Ascanio Condivi, the Buonarroti family were descended from the Counts of Canossa. In fact, they were an old Florentine family whose members had held public office in the second half of the fourteenth century and the first decades of the fifteenth before falling victim to financial adversity.

When Michelangelo was born his father, Lodovico, was *podesta*, or mayor, of Chiusi and Caprese. A few months later, his term of office accomplished, the family returned to Florence where they lived on a modest scale while doing their best to maintain their social position.

Michelangelo's mother died when he was six years old and he was enrolled in a school run by the humanist Francesco da Urbino, a grammar teacher. He was quick to display a marked artistic talent which was encouraged by his friend the painter Francesco Granacci. Despite the opposition of his family, who viewed the artist's calling as socially beneath them, in 1488 the young Michelangelo became an apprentice in Domenico Ghirlandaio's workshop with a three-year contract 'to learn to paint'. He was at the same time working there for a salary which rose progressively from six florins to ten in his third year. The contract was mentioned by Vasari in the second edition of *Lives*, while Condivi chose to ignore it, thus respecting the image Michelangelo wished to give to himself as an artist outside the scope of any workshop, driven solely by an irresistible calling, that of 'nature which never

Charles VIII arriving in Florence (detail), by Francesco Granacci

ceased to stimulate him'. Instead Condivi gave weight to the hospitality of Lorenzo *il Magnifico* who welcomed the young artist to his palace 'as a son', giving him access to its collections of antiques and also to literary and humanistic circles – including Poliziano, Francesco Landino and Marsilio Ficino – for whom artistic activity was not 'mechanical' but intellectual and one of the highest in its inspiration and 'creative passion'.

In the few months that he spent in Ghirlandaio's workshop and while the frescos in the Tornabuoni family chapel in Santa Maria Novella were being executed, Michelangelo copied from Masaccio's work in the Carmine and Giotto's in the Peruzzi Chapel at Santa Croce. There is nothing surprising in his choice of models as Ghirlandaio was seeking to return to the sources of Tuscan art in the Renaissance period, but the young artist's drawings already demonstrated his aptitude in the sure-handedness with which he identified fundamental stylistic principles, seeming to model his figures and invest them with a monumental quality.

His abandonment of Ghirlandaio's workshop, his entry into the Medicean circle, his frequenting of a cultural milieu that deeply influenced his personality and his ideas of art and beauty, his study of antique sculpture in the garden at San Marco under the supervision of Bertoldo di Giovanni, who had been a pupil and assistant of Donatello's, are the major events of Michelangelo's youth. Henceforward classical art was not for him a mere repertory of models to be copied, he recognised the indissoluble unity of its forms and the myths and passions they expressed. This new awareness, encouraged by his familiarity with Florentine humanistic circles, enabled him to learn from and interpret his models with exceptional virtuosity. From his earliest sculptures, *Madonna of the Steps* and *Battle of the Centaurs*, the requirement that there be absolute correspondence between subject and chosen form led him to use classical and Christian themes simultaneously, observing a double stylistic register.

In *Madonna of the Steps* the spare, severe quality of the image evokes the funerary steles of antiquity but the figure of the Virgin, who is holding the sleeping child in her arms and gazing into the distance with a prophetic air, derives from the Donatellian technique of *stiacciato*.

On the other hand in his treatment of the mythological *Battle of the Centaurs*, a subject suggested to him by Poliziano, Michelangelo drew his inspiration not from the iconographic or stylistic models of the Florentine tradition of the Quattrocento, but from the battle scenes that decorated Roman sarcophagi and from the panels of Giovanni Pisano's pulpits. Comparison of this work with Bertoldo's bronze relief *Battle of Horsemen* inspired by a sarcophagus in the Camposanto at Pisa clearly shows that the young artist, far from imitating the antique style like his old master, eliminated all spatial reference and emphasised the dynamic character of the mêlée of naked bodies.

The *Battle of the Centaurs* was executed shortly before the death of Lorenzo *il Magnifico* (1492), a prelude to the grave political and religious crisis that was to shake Florence in the last years of the century. The arrival in Italy of the French king Charles VIII marked the breakdown of the fragile political relationships between the peninsular states and precipitated a popular uprising in Florence. Piero de' Medici, the rather unwarlike son of Lorenzo, was driven from the city and a republic established there with the Dominican Savonarola at its head. His preaching was inflammatory: he denounced the corruption of the Roman Curia and sought to bring about the reform of Florentine society as a model of universal reform.

The ensuing few years proved more than eventful, under the driving force of the *piagnoni*, the most intransigent and fanatical of Savonarola's disciples. The reform of morals and religion gave way to violent condemnation of Neoplatonic doctrines and of all secular art. In 1497 the carnival was transformed into a penitential ceremony: wood was heaped in city squares for the purpose of burning books, precious ornaments and articles of clothing, mythological pictures. This was the *bruciamento delle vanità*. Roughly a year later it was Savonarola himself who was on the funeral pyre, having been excommunicated by the Pope and deserted by the Florentine cardinals, the latter driven to revolt by his enemies and exasperated by his followers. These tragic events had a profound effect on the conscience of many contemporary artists – from Botticelli to Bartolommeo della Porta – and deeply shook the young Buonarroti who, having left Florence at the end of November 1494, went first to Venice, then to Bologna, where he lived for a year or so. Dating from this period are the figure of an *Angel*, which was to complete the sarcophagus of Saint Dominic, and two statues of *Saint Petronius* and *Saint Proculus*. The first drew its inspiration from a sculpture by Jacopo della Quercia whose reliefs on the façade of Saint Petronius Michelangelo had studied with passionate interest. The second, in its expression of extreme spiritual and physical tension, heralds the gigantic *David*.

Deposition from the Cross detail (Niccolò dell' Arca)

On his return to Florence, the artist reverted to classicism with a life-sized statue of *Cupid* asleep. At the instigation of Lorenzo de' Medici the statue, now lost, was reworked to make it resemble an excavated object and sent to Rome where a dishonest middle-man sold it to Cardinal Riario, a great collector of antiques, for a much higher sum than had been paid to Michelangelo. Made suspicious by rumours, the Cardinal sent a messenger to Florence and, once he discovered the truth, returned the *Cupid*. However, enthused by the artist's talent, he invited him to Rome where Michelangelo arrived in June 1496. In a climate of excited rediscovery of the antique, the artist studied and admired the objects in the Cardinal's and other collections. As if trying to rival these works, he sculpted for Cardinal Riario a statue of *Bacchus* which demonstrates his deep understanding of the antique in the sensuality of the carving – worthy of its Hellenistic models – of the body of an adolescent god, seeming to sway tipsily.

As *Madonna of the Steps* is contemporaneous with *Battle of the Centaurs*, the 'pagan' work *Bacchus* corresponds to the Christian *Pietà* sculpted for Cardinal Jean de Bilheres de la Graulas, then abbot of Saint Denis.

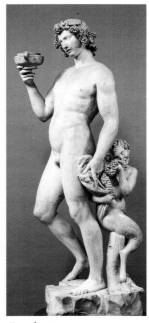

Bacchus

The subject of Our Lady of Sorrows holding the body of Christ taken down from the cross, while already current among Italian painters in the second half of the Quattrocento was actually of northern origin. It was principally to be found in Germany, in wood-carvings of groups of figures, or *Vesperbilder*, associated with the Good Friday liturgy. In place of the roughness and discordance of form that generally characterises these groups, in which the outstretched and lifeless body of the Son contrasts with the upright figure of the Mother, Michelangelo substitutes a composition at the same time more monumental, more ordered, more natural, uniting the figures particularly by a generous and rhythmic use of drapery. The emotional, high-pitched 'Nordic lamentations' yield to a more solemn and collected tone, which simultaneously expresses the suffering and sorrow of the Mother and an inner feeling of tenderness and gravity, with no concessions to sentimentality or descriptiveness.

In the overall composition, the notable 'truth and naturalness' of the image are conveyed by the 'perfection' of the details and the astonishing technical virtuosity with which the artist handles the surfaces to achieve an effect of transparency and waxen softness.

David

Michelangelo's first sojourn to Rome lasted for over four years. It was not until the spring of 1501 that he returned to Florence where the political situation had changed radically. After the execution of Savonarola, an oligarchic government was established in the city modelled on that of the Venetian republic under the direction of a gonfalonier appointed for life, Piero Soderini, one of whose main collaborators was Machiavelli. In contrast to the cultural politics of Lorenzo de' Medici who encouraged the greatest Florentine artists to emigrate to other centres in the peninsula, the new government sought to retain them by commissioning important work in order to increase the prestige of the city and the new republic.

Leonardo da Vinci had returned to Florence in advance of Michelangelo and exhibited a cartoon of the *Madonna and Child with Saint Anne* at the Santissima Annunziata. According to Vasari, this work 'not only called forth the admiration of all creative spirits, but when completed, men and women, young and old, for two days, came to see it and to contemplate the marvels of Leonardo which were wondered at by all the people'.

In the space of a few years the works of Leonardo and Michelangelo marked a crucial turning point in Florentine art and influenced decisively the evolution of style in Rome at the time of Julius II and Leo X. At the end of 1504, Raphael came to Florence in his turn, drawn by accounts of what was being done in the artistic world there. In June 1501, Michelangelo was commissioned by Cardinal Piccolomini to make fifteen statues for an altar in Sienna Cathedral. But two months later, doubtless thanks to the personal intervention of the gonfalonier Piero Soderini, the Office of Works of the Cathedral in Florence entrusted to him an even more prestigious task: the sculpture of a statue of *David* in a gigantic block of marble, started by Agostino di Duccio some forty years earlier. The project fired Michelangelo's imagination and in roughly two and a half years he produced a work of art that was to prove one of the most representative of Renaissance culture and ideals.

In accordance with iconographic tradition, *David* was represented by Donatello and Verrochio as a dreamy adolescent who triumphs over the brutish violence of the giant Goliath. Michelangelo's *David* is, by contrast, a young man full of strength and geared for the fight, his taut countenance expressing extreme physical and psychological concentration. In its nudity and vigour, the figure of the biblical hero evokes that of Hercules, in Florence a symbol of civic virtues. It perfectly expresses the ideal of Renaissance man in whom strength is allied to an absolute mastery of the passions and the humanist and republican conception of *civis-miles* as envisaged by Machiavelli, who advocated the institution of a citizens' army so that the defence of the State should not be entrusted to mercenary troops.

The ideal and political dimension of *David* was clearly apparent to the artist's contemporaries who decided to position the statue not at Santa Maria del Fiore but in front of the Palazzo Vecchio in the Piazza della Signoria, as a symbol of republican freedom.

In the course of the year 1503, the government of the republic of Florence commissioned Leonardo da

Vinci and Michelangelo to paint two frescos in the main hall of the Palazzo Vecchio. These were to illustrate two Florentine victories over the Milanese and the Pisans: the *Battle of Anghiari* and the *Battle of Cascina*. Because of various difficulties, the two great murals were never completed but the drawings for them and copies of some of the details of the cartoons amply illustrate the indefatigable zeal of the two artists set in competition with each other as well as the diversity of their talents and aims.

In the middle of Leonardo's composition, the tangle of horses and horsemen around the standard is conceived as an irresistible whirlwind, like the releasing of elements in a storm. In the violence of the movements and the attitudes of the combatants it expresses the chaos provoked by what the artist himself described as the 'bestial madness' of war. Michelangelo, drawing his inspiration from an episode recounted in Villani's *Chronicle*, portrayed the Florentine soldiers who, warned of the approach of the enemy while bathing in the Arno, hastened to get dressed and take up arms for the combat. This incident afforded him a pretext for representing naked figures in unwonted and violent attitudes, thus demonstrating his perfect understanding of anatomy and his ability to invest movement and attitude with intense expressive significance. The cartoon, studied extensively by Florentine artists as a model *par excellence* of the representation of the human figure in motion, was broken up and destroyed. Only the drawings and sketches survive to give us an idea of Michelangelo's large-scale project.

With the success of *David*, the artist's reputation was established and private commissions poured in with official ones. A few years later the Signoria of Florence asked Michelangelo to make a bronze *David* – now lost – for Maréchal Pierre de Rohan. The Office of Works of the Cathedral commissioned him to sculpt twelve marble statues of the

Apostles – only that of Saint Matthew was started – and the Flemish cloth merchant Mouscron ordered a marble Virgin and Child for the church of Notre-Dame in Bruges (*Bruges Madonna*). To these were added two tondi in marble for patrons from the Taddei and Pitti families and another painted for Angelo Doni. In the two sculpted tondi one can observe the artist's interest in the effects of atmospheric envelopment, of 'spatial imprecision', which was one of the most original aspects of Leonardo's work. The irregular appearance of the background, achieved by a light hatching with the chisel, gives the impression that the most distant figures, shaped by sinuous contours, are emerging from the shadows into the light of the foreground. As if in contrast, in the *Doni tondo*, while still bearing perfect comparison with the work of the oldest master in the complex harmony of his composition, Michelangelo accentuated the strict monumentality of the Holy Family group and achieved dynamic expression and sculptural relief by means of a vigorous, almost cutting definition of the profiles and the intense luminosity of the chromatic range.

Battle of Cascina
(copy of Michelangelo's cartoon by
Aristotile da Sangallo)

In March 1505, Michelangelo's frenetic activity in Florence was suddenly interrupted. Leaving a quantity of commissioned work unfinished – in particular the *Battle of Cascina* – the artist accepted Julius II's invitation and returned to Rome, lured by a project to erect a grand mausoleum intended for the pontiff in the apse of the Vatican basilica. The accession of Julius II to the papal throne (1503) marked, from the very first years of his reign, the beginning of a new era for Rome, the papal state and the arts. Pursuing the initiatives of his uncle Sixtus IV, whose ideas on the political significance and value of works of art he shared, Julius II enacted the programme of the *restauratio* of papal Rome with great determination, as a prelude to political renewal in the traditions of imperial Rome.

The intuition that guided the Pope's choice of men

11

best able to help carry out his bold and extensive plans was also manifest in the artistic field: he engaged Bramante, Michelangelo and Raphael on his grandiose projects. To the first, he entrusted the construction of the new basilica of Saint Peter's and the reconstruction of the Vatican palace, including the vast project of the Belvedere court; to the second, the building of his tomb and then the decoration of the vaulting of the Sistine Chapel; to the third, the frescos for the Stanze, his new official apartments.

Michelangelo accepted enthusiastically the commission for the tomb and spent eight months in the mountains of Carrara selecting suitable marbles. According to Vasari, the monument was to exceed 'in beauty, majesty, richness of decoration and the number of statues . . . all the ancient and imperial sculptures'. It is only through Vasari's and Condivi's descriptions that we can today get some idea of Buonarroti's project: a vast sacellum to a rectangular plan – some 10.8 m by 7.2 m – rising on three levels of decreasing size and housing a funerary chamber. Decorated alcoves with statues of *Virtues* and *Victories* alternated on the lowest level with pilasters fronted by figures of *Slaves*. Four statues representing *Moses* and *Saint Paul*, the *Active Life* and the *Contemplative Life* occupied the second level, while, on the top, two figures of angels which according to Vasari personified heaven and hell, were to support a mausoleum on which the dead Pope would be represented.

Moses

As conceived by Michelangelo, this final monument to the Pope and the Church based on the models of antiquity, bore the imprint of the Neoplatonic ideas very much in favour at the period.

The ascending progression of the monument is in line with the symbolic progression of the images: after *Slaves* came *Victories* on the lower level, then the personifications of the *Active Life* and the *Contemplative Life* and the figures of *Moses* and *Saint Paul* who had known the dazzling vision of God 'face to face'. The final stage was the 'passage' from death on earth to eternal life represented on the summit.

The mausoleum is thus an expression of ascesis, the liberation of the individual soul from matter and flesh by the exercise of virtue and inner illumination.

As Michelangelo did not share Bramante's ideas about the reconstruction of the Vatican basilica which was monopolising all the Pope's attention and resources, his project for the tomb was set aside.

Disappointed and embittered, Michelangelo precipitately left Rome for Florence on the eve of the laying of the first stone of Saint Peter's (18 April 1505), pursued by the Pope's messengers urging him, in vain, to return. This was the beginning of what the artist came to call 'the tragedy of the tomb'. Before Michelangelo's flight from Rome, Julius II had suggested to him, instead of the tomb, a commission no less prestigious: the decoration of the papal chapel. The Pope was anxious both to complete the work of his predecessor Sixtus IV and to repair the damage caused to the original decoration – a starry sky painted by Piero Matteo di Amelia – by settlement in the walls of the building and successive attempts to reinforce the structure. In spring 1504 a deep crack had appeared in the vaults.

Taking refuge in Florence, the artist proudly refused this new project. But the Pope would not accept defeat. He applied menacing pressure to the Signoria of Florence and, seven months later, in Bologna which his troops had just reconquered, a meeting and forced reconciliation took place between Julius II and Michelangelo. The latter afterwards observed, 'I was forced, the rope around my neck, to seek his pardon.'

Michelangelo spent fifteen months in Bologna modelling and casting in bronze a gigantic statue of the Pope destined for the façade of San Petronio, destroyed in 1511 following the return of the Bentivogli. Then, back in Florence again, Michelangelo waited to be released from all obligations to the Pope – in vain: finally he decided to go back to Rome, and started work on the vaulting of the Sistine Chapel. In the original plans, the figures of the Apostles were to be placed on little pedestals while the rest of the ceiling was simply to be decorated with geometric motifs in 'antique' style. However, once preliminary plans were completed, the project was extensively modified and made richer and more complex. The figures of the Apostles were replaced by those of seven *Prophets* and five *Sibyls*. A cornice supported by little pillars flanking the thrones of these soothsayers runs above the tops of the arcades,

about a third of the way up the curve of the vault, marking out a central area divided longitudinally by architectonic ribs in the form of an arc, which frame nine episodes of *Genesis*, from *God separating Light from Darkness* to *The Drunkenness of Noah*. In the sections of the vault situated above the thrones of the *Prophets* and *Sibyls*, the smallest space is occupied by naked figures (*ignudi*) bearing garlands of oak leaves – an allusion to the family of Sixtus IV and Julius II, the Della Rovere – and by bronze medallions illustrating biblical scenes.

In the sixteen lunettes and spandrels that link them to the vault are paintings of the forty generations of the *Ancestors of Christ* as enumerated in the Gospel of Saint Matthew. The four-sided pendentives illustrate four miraculous events that befell the chosen people: *David and Goliath, Judith and Holofernes, The Brazen Serpent* and *Esther and Haman*. The structural arrangement of the scenes painted by Michelangelo on the vaulted ceiling demonstrates an iconographic complexity. Notwithstanding this the series of frescos has a strong unity, achieved by the integration of the component parts through a connective network, incomparably rich both in form and in content.

His chosen scheme of decoration for the ceiling, which involved the association of *trompe-l'oeil* effects and motifs of classical inspiration, allowed Michelangelo to portray the *Prophets* and *ignudi* in astonishing relief. The relationship of the figures to the painted architectural structures also reveals an extensive use of elements devised for the tomb of Julius II.

Many different and sometimes contradictory interpretations of the iconography have been advanced by critics but there is general agreement that the *Story of Genesis* in the centre of the vault is not only a representation of 'historic events' but also a prophetic prefiguration of the Redemption offered by Christ based on typological concordances between the Old and New Testaments. This interpretation seems to be confirmed by the 'hinge' positation of the soothsayers – the *Prophets* and the *Sibyls* – in the overall iconographic scheme.

The significance Michelangelo's images had for his contemporaries is more fully understood when one knows that the sermons preached in the Sistine Chapel on the great liturgical feasts took the form of ancient panegyrics celebrating God's work as creator – culminating in the creation of Man in his own image – and the incarnation of Christ was understood not so much as a form of expiation for the sins of humanity as the perfect accomplishment of the creation, raising the dignity of Man to a point close to the divine.

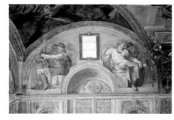

Eleazar and Mathan

It is viewed from this perspective that Michelangelo's epic celebration of the human body acquires its full significance, particularly in the *Creation of Adam* and the figures of the *ignudi*.

In July 1508, after the scaffolding was erected, Michelangelo began to paint the frescos on the vaulting. Other artists came from Florence to help him, among them Francesco Granacci, Juliano Bugiardini and Aristotile da Sangallo, the imprint of whose style is to be found in the first three frescos on entering: *Deluge, Drunkenness* and *Sacrifice of Noah*. The cartoons prepared by Michelangelo were transferred painstakingly on to the plaster by pouncing and recent restorations have disclosed many alterations and subsequent reworkings. After this Michelangelo dismissed his assistants who doubtless did not live up to his expectations and he carried out the work virtually singlehanded and without a break until the end of August 1510, covering nearly half the surface of the ceiling with frescos. When painting the lunettes, on which he could work more easily as they formed part of the side walls, he progressed with notable speed – 'three days per lunette' – without cartoons, proceeding immediately from preparatory sketches to outlining great figures on the wall. When the first half of the ceiling was completed, work was interrupted for about a year. Julius II was far from Rome, engaged in campaigns against the King of France and he lacked the funds to continue.

It was not until 15 August 1511 that the frescos done to date were 'unveiled' in the presence of the Pope who personally participated in Vespers and Mass solemnly celebrated in honour of the Assumption of the Virgin – to whom the Chapel was dedicated – 'Vel ut picturas novas ibidem noviter detectas videret, vel quia ex devotione ductus fuit' as was noted – not without malice – by the master of ceremonies Paris de Grassis.

Once the scaffolding was replaced, the decoration of the rest of the ceiling continued and was completed in October of the following year.

In the course of the work which lasted over four years, there was a perceptible evolution in Michelangelo's figurative expression. The sense of abundance in the first frescos gave way to a sparer and more sober style, the figures were drawn to a larger scale and their physical and psychological force was accentuated. The artist's technique became quicker and surer, achieving a greater unity and fusion of tone. The recent cleaning of the frescos has revealed an unsuspected richness and intensity of colour. If the figures of the *Prophets*, the *Sibyls* and the *ignudi* confirm the artist's taste for the sculptural relief of images, in other areas of the vault, specifically the lunettes and spandrels, Michelangelo employed a purely pictorial technique: he covered large surfaces with pure and diluted colours, ranging from the darkest to the lightest, using tinted shadows, shimmering tones and blurred effects for the background figures.

Libyan Sibyl, detail

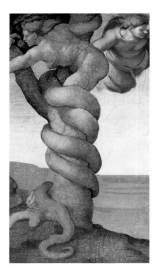

Fall and Expulsion, detail

In his frescos in the Sistine Chapel, Buonarroti revolutionised the figurative language of the Renaissance and his influence had immediate effect on the work of many of the greatest artists. But he himself remained indifferent to the reaction provoked by his painting. In a brief letter to his father, he alluded to the completion of his task and the Pope's satisfaction with it, regretting that he could not return to work on the 'tomb': 'the fault lies with the age which is in opposition to our art'.

His triumph seemed to be tempered by regret at having had to abandon the commission which had fired his imagination above all else and he was overwhelmed – this is apparent in his letters to his near-est and dearest during the four years he spent on the scaffolding of the Sistine – by feelings of immense fatigue and solitude. 'I am in a state of great anxiety and extreme physical exhaustion, I have no friends whatsoever and do not wish for any. I haven't even time to eat what I need. Let me be spared further worry because I cannot take another scrap.'

The death of Julius II increased Michelangelo's isolation in Roman circles. Despite their stormy relationship, the artist and the pontiff had a deep affinity of temperament and ideas.

The new Pope Leo X – Giovanni de' Medici, son of Lorenzo – had a personality very different from that of his combative and 'terrible' predecessor. Cultivated, a good diplomat, lover of the arts and above all of music, he increased the pomp and show of the liturgical ceremonies. From the start of his reign, he liked to present himself publicly as a defender of the peace and 'doctor' to the afflictions of Christianity. While he had known Michelangelo from childhood, he preferred Raphael whose art was closer to his tastes.

Notwithstanding the success of the Sistine Chapel, Michelangelo felt himself increasingly isolated from the new concerns of the papal court. He cut himself off and returned to work on the Julius tomb, designing a project even more grandiose than the original, on the basis of a contract signed in May 1513 with the Pope's heirs. In 1516 he sculpted *Moses* and two statues of slaves – *Dying Slave* and *Rebellious Slave* – which showed the same conception of divine illumination and physical beauty as the *Prophets* and the *ignudi* in the Sistine. The work inappropriately called *Dying Slave* is, in fact, an expression of the slow and painful struggle of conscience to escape the clutches of tormented sleep. The *Rebellious Slave* and *Moses* bring out the contrast and tension between an abounding physical and psychological energy and the constraints of material and physical bonds. Leo X's decision to give Michelangelo the commission for the façade of the church of San Lorenzo in Florence brought a further interruption to his work on the mausoleum. 'So Michelangelo returns to the tragedy of the tomb,' writes Condivi. This time, however, the tragedy was to last nearly thirty

years and did not end till 1545 when the tomb was completed and placed in San Pietro in Vincoli, a pale shadow of the projects that had fired the young artist's imagination. In fact, the years spent in Florence from 1516 to 1534 could be measured out in great unrealised or uncompleted projects.

Having finished the first studies for the façade of San Lorenzo, Michelangelo declared not without pride: 'My intention is to make this work . . . as much in its architecture as in its sculpture the mirror of all Italy.'

The work was discontinued in March 1520 for economic reasons and because the Pope had changed his mind. The New Sacristy of San Lorenzo with its Medici tombs and Biblioteca Laurenziana was unfinished when the artist, following his father's death, decided to leave his native city for good. This was the most tormented period of Michelangelo's life. After the Sack of Rome in 1527, in the dramatic years of the republic of Florence, the artist, who had ceased to work for the Medicis, was engaged by the republican government as a military architect. In January 1529 he was elected member of the *Nove della Milizia* and, the following April, Governor-General of the fortifications. A premonition of the imminent and inevitable fall of the city and the fact that he had been suspected of treachery, led him to leave Florence for Venice and there he planned to take refuge in France. Banished by the Florentine government as a rebel, suffering grievous doubts, he decided at the end of November to return to Florence which resisted the attacks of the papal and imperial troops for a further nine months.

Most of his drawings of fortifications date from this period. They express ideas that were in many ways innovatory at the time and are almost zoomorphic in appearance, with a marked tension in the concave and convex forms. Michelangelo invented structures bearing a closer resemblance to 'war machines' than to simple fortifications. On 12 August 1530 Florence surrendered. Michelangelo was driven to take refuge with the prior of San Lorenzo to escape the Medici supporters, trusting that the intervention of Clement VII – himself a Medici – would not deliver him to their mercies.

On the right side of the transept of San Lorenzo, in symmetry with the Old Sacristy designed by Brunelleschi a century before, the New Sacristy was to serve as a funerary chapel for the Medicis, accommodating the tombs of the *Capitani* – the dukes of Nemours and Urbino – as well as those of the *Magnifici*, Lorenzo and Giuliano, respectively the fathers of Leo X and Cardinal Giulio de' Medici who became Pope in 1523 under the name of Clement VII. Built to a plan analagous to that of Brunelleschi, the New Sacristy likewise employed *pietra serena* for the frame. However, Michelangelo modified the elevation by extending to every wall the gigantic order Brunelleschi had adopted for the end wall, and introducing a mezzanine between the lower level and the lunettes. The edifice was crowned by a coffered cupola of classical inspiration which gave it a greater density and unity, and a sense of reaching towards the heights.

Having first envisaged a free-standing monument surrounded by empty space – thus reverting, though on a reduced scale, to his original concept of the Julius tomb – Buonarroti decided finally on wall-tombs. These were not merely backed on to the wall, but were structurally integrated.

Day and *Night*, *Dawn* and *Dusk*, in a manner that plays both on symmetry and antithesis of form and symbol, recline on the covers of the sarcophagi of the *Capitani*. They give the impression they are about to break them open, and free the souls of the dead to contemplate the *Madonna and Child*, a symbol of eternal life towards which the statues of Giuliano and Lorenzo are also turned. Allegories of the destructive force of time, these four physically powerful figures seem prey to an anguished inertia, an overwhelming weariness. Michelangelo himself, in reply to an epigram by Giovanni Battista Strozzi, described, with reference to *Night*, a sense of sleep and forgetting as the ultimate refuge from the bitterness of painful political experience:

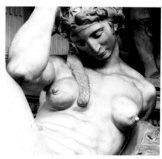

Night, Tomb of Giuliano de' Medici

Sweet is my sleep, but more to be mere stone,
so long as ruin and dishonour reign:
to bear nought, to feel nought, is my great gain:
then wake me not, speak in an undertone.

(trans. by J. A. Symonds)

Four doors – two real and two false – symmetrically placed in the four corners, paradoxically increase one's sense of the chapel interior as an enclosed space, cut off from life. The light that falls from above, with particular effect because the lower cornices of the windows are higher outside than inside, reaches the tombs. It illuminates the 'drama of the resurrection' represented by Neoplatonic themes, such as the Contemplative Life, a silent exchange between the deceased and the Virgin, achieved by the intercession of the Medici patron saints Cosmas and Damian.

When he went to Rome in 1534, Michelangelo left his work incomplete. The funerary monument of the *Magnifici* on the wall opposite the altar, the River Gods that were to be sculpted on the base of the tombs of the *Capitani*, the bronze reliefs and probably too the frescos and the lunettes, had not been completed. Also unfinished was the Biblioteca Laurenziana which was intended to house the manuscripts collected by the Medicis. Work on this project had alternated with that on the New Sacristy from 1524. The sense of peace and harmony created in the reading-room, the length of which is rhythmically measured out by fine pilasters of *pietra serena*, underlined by the divisions of the ceiling and floor, is set in opposition to the vertical reach and use of sudden contrast in the vestibule with its alcoves and pairs of columns embedded in the walls. It was not until 1558 that the artist sent to Rome a clay model of the spectacular staircase which was originally to have been constructed in wood but, in fact, was made in *pietra serena* by Amannati to accord with the wishes of Cosmas I. Although unfinished, the New Sacristy and the Biblioteca Laurenziana exercised considerable influence on the development of artistic culture in the second half of the sixteenth century and thereafter. Vasari specifically observed that Michelangelo had produced work very different in its 'measurement, rule and order from that of other men who conformed with common usage, Vitruvius and the works of Antiquity, because he did not want to add to what had been done before: this freedom gave those who had seen his manner of working a great desire to imitate him. . . . Thus artists owe him an immense and lasting debt for having broken the bonds and chains under which they continue to work in accordance with common usage.'

The 'freedom' introduced by Michelangelo into the classical syntax of the Renaissance language, by breaking the 'bonds and chains' of a tradition that had become the norm in order to achieve a new expressive tension affecting the very definition of space and architectonic volume, was the root cause of his condemnation by traditional classicists, but equally played a decisive role in the rediscovery of his art at the end of the seventeenth and beginning of the eighteenth centuries.

Michelangelo's activities throughout his long Florentine period (1516-34) were not restricted to his work on the façade of San Lorenzo, the New Sacristy and the Biblioteca Laurenziana. For a Roman patron, Metello Vari, the artist sculpted (1519-21) a 'figure in marble' of the *Risen Christ*, which was placed in the tabernacle of the church of Santa Maria Minerva. It was conceived as a variation on classical themes, as is shown by the gradual rotation of the body and the importance assigned to anatomical details. In comparison with Michelangelo's other works, it is characterised by a certain lack of vigour due particularly to the finishing carried out by assistants, so imperfectly that the artist himself offered to replace the model. Michelangelo's *Apollo*, also called *David*, a mysterious dream-like figure, never completed, was on the other hand sculpted after the fall of Florence for Baccio Valori. It is now in the Bargello, Florence.

Michelangelo's painting at this period, except for the now lost *Leda* for Alfonso d'Este, was marked by his collaboration with Sebastiano del Piombo, sole rival of the all-powerful Raphael. Referring to the *Pietà de Viterbo* (1516), Vasari wrote that 'while it was diligently executed by Sebastiano who added a highly esteemed dark landscape, the idea and the cartoons are Michelangelo's'. Their collaboration took effect in drawings and doubtless also cartoons for paintings in the Borgherini Chapel in San Pietro in Montorio but above all in the *Raising of Lazarus* painted by Sebastiano for Cardinal Giulio de' Medici

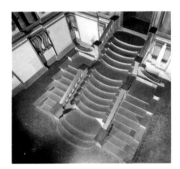

Staircase of Biblioteca Laurenziana

and inviting comparison with Raphael's *Transfiguration*.

After Raphael's death in 1520, the relationship between the two men waned, Michelangelo's principal objective having disappeared. With the establishment of the new republic of Florence, work on the *Tomb of Julius II* was restarted. Michelangelo sculpted a *Victory* incarnated by a young man who – in a 'serpentine' twist of his whole body – triumphed over an enemy whose features recall those of barbarians in Roman reliefs. The four statues of *Slaves*, who appear crushed by a weight more spiritual than material, are almost finished in parts, scarcely begun in others. To the extent that they are at different stages of completion, these statues allow one to form an idea of Michelangelo's technique: he attacked the block on one or two faces, so that the figure gradually merged, liberated from the excess of material that kept it imprisoned. The sculptor's task then was to discover and liberate 'by elimination' the form that is immanent in the block of stone but enclosed and trapped by it.

The best of artists hath no thought to show
which the rough stone in its superfluous shell
doth not include; to break the marble spell
is all the hand that serves the brain can do.
<div align="right">(trans. by J. A. Symonds)</div>

Michelangelo found in the process of creation a spiritual metaphor for the liberation of the soul from the prison of the body – the 'terrestrial prison' – and he increasingly projected his disquiet and his torment into his work.

victorious over death, is rendered with an admirable sense of movement and an extraordinary sensibility to physical beauty, seen in the exceptional purity of feature and the delicacy of the chiaroscuro. The same refinement of technical execution is evident in the presentation drawings which, according to Vasari, Michelangelo gave his friends for use as models in learning to draw.

These sheets have sometimes been accused of coldness and lack of spontaneity by modern critics but were termed 'fogli maggisterali' by Vasari and found great favour with his contemporaries, as is proved by the numerous reproductions and engravings that have been made from them.

Among these 'fogli', besides the enigmatic works such as the *Archers* and the *Dream*, it is worth mentioning the mythological representations offered to Tommaso de' Cavalieri: *Ganymede* – of which only copies survive – *Tityus, The Fall of Phaethon* and *Children's Bacchanal*.

It was probably in 1532 that Michelangelo made the acquaintance of Tommaso de' Cavalieri, a cultivated young Roman aristocrat and keen collector of antiques. He saw him as the incarnation of his ideal of beauty and spirituality and addressed to him letters and poems in which he expressed, in exalted terms, a Neoplatonic conception of beauty as a means of spiritual ascesis. Yet, beyond this smokescreen, the drawings betray the irresistible attraction the beauty of the masculine body held for Michelangelo, in forms which one would guess proceeded from the unconscious.

Drawing for the sculpture of *Day*, Tomb of Giuliano de' Medici

The figures of the *Slaves* still imprisoned in stone – like *Saint Matthew* – express, in their desperate efforts to free themselves, a sense of torment in the sheer struggle against the resistance and weight of matter. The incomplete character of these and other figures in the New Sacristy contrast with Michelangelo's graphic style in certain drawings of the risen Christ. The naked figure of the Redeemer,

Such aspects of the art and personality of Michelangelo did not wholly escape the notice of his contemporaries and gave rise to malicious insinuations on the part of Aretino and vehement protestations by Condivi: 'He loved the beauty of the body which he knew well as an artist. Certain carnal men who understand in the love of beauty only what is lascivious and indecent have been led to think and to speak ill of him . . . but I know, from having lived in

long and close proximity with Michelangelo, that I never heard anything but seemly words issue from his mouth, such as would extinguish all wild and uncontrolled desire in youth. No vile desires rise in him, as is proven by the love he bears not solely for human beauty but for all beautiful things, a beautiful horse, a beautiful dog, a beautiful landscape, a beautiful plant, a beautiful mountain, a beautiful forest, for all places and all things beautiful and rare of their kind.

Saint Bartholomew,
The Last Judgement

After a long sojourn in Rome, from summer 1532 to summer 1533, Michelangelo returned to Florence to finish work on the Old Sacristy and the Biblioteca Laurenziana. It was probably shortly after his departure that Clement VII had the idea of commissioning from him a fresco of *The Last Judgement* on the altar-wall of the Sistine. A meeting between the artist and the Pope tool place on the road to Nice, at San Miniato al Tedesco, the following September.

According to Vasari and Condivi, Michelangelo initially put forward strong opposition to the project because he was anxious to pursue his commission for the heirs of Julius II, on the basis of a new contract for the tomb dated April 1532.

However he was then seized by suspicion of Alessandro de' Medici, the new ruler of Florence, compounded by other difficulties and a feeling of lassitude and disaffection with Florentine works. Back again in Rome, from October 1533 to May 1534, Buonarroti negotiated the terms of his contract with the Pope and on 20 February an emissary of the Gonzagas reported that the Pope 'has so cleverly manoeuvred that Michelangelo has agreed to decorate the chapel and over the altar he will paint the Resurrection, even though the altar-piece has already been done'. The term 'Resurrection' here should be read as 'resurrection of the flesh' and thus refers to the representation of *The Last Judgement*.

Clement VII died on 25 September 1534, two days after the final return to Rome of Michelangelo who thought that he had disentangled himself from all his commitments and would be free to devote himself to work on the tomb. His hopes were once again to prove vain. Paul III Farnese, long a passionate admirer of Michelangelo's, confirmed his engagement, determined to have the work carried out and to accept no excuses: 'I have desired this for thirty years, and am I not to realise it now that I am Pope?'

Against his own wishes, therefore, Michelangelo embarked on preparatory work for the fresco which continued until spring 1536 when he at last climbed the scaffolding and began to paint.

While Buonarroti had originally envisaged keeping the altarpiece painted by Perugino which represented the *Assumption of the Virgin*, to whom the chapel was consecrated, and the lunettes by the same artist on the altar-wall, Clement VII's project marked the first stage of destruction in the history of the Sistine. Up to this point, for some four decades, from Sixtus IV to Julius II to Leo X, the decoration of the chapel used for the ceremonies of the papal court had been carried out entirely harmoniously, both in structural and iconographic terms. Michelangelo's frescos on the vaulted ceiling and the tapestries woven from Raphael's cartoons, according to Leo X's wishes, had admirably completed, while fully respecting, the original decoration of Sixtus IV. The new project, however, modified the architectural structure of the altar-wall and also the lighting of the chapel – two windows on this wall being blocked up. The first two episodes of the cycle, Moses and Christ, also disappeared, with the figures of the first martyr-popes and, in the final scheme, Perugino's altarpiece and the two lunettes on which the first *Ancestors of Christ* were represented.

The iconographic whole which had evolved in a perfectly coherent manner, by successive additions expressing the ideology and myths of Renaissance Rome in eloquent imagery, was thus fragmented and spoiled. It is significant that this resulted from the initiative of a Pope and by the agency of an artist who had lived through the stirring period of the dream of 'renovatio' of the papal city and the dramatic collapse of these aspirations on the outbreak of religious quarrels: this splendid city, 'caput mundi' and seat of the Vicar of Christ, now sacked and destroyed, had become, for a large section of Christianity, a 'new Babylon'.

Clement VII's decision and his choice of a subject as full of suffering as *The Last Judgement*, reveal, as observed by André Chastel, the pontiff's instinctive leaning towards a work 'which precisely illustrates the catastrophes of his pontificate'.

Preparatory sketches and drawings allow us to trace the development of this vast fresco. While taking earlier iconographic studies as his starting point, Michelangelo quickly abandoned traditional composition in favour of a freer and more dynamic arrangement which plays on the opposition and connection of movements and the attitudes of the figures and groups.

By covering the entire wall and thus breaking the sense of rhythmic continuity established by the previous compartments and divisions, Michelangelo isolated the side walls and the ceiling, opening, as is observed by J. Wilde, the space in the chapel to a 'second reality . . . facing us like a world governed by its own laws'. In the absence of any element of perspective and geometry the immeasurable spread of this 'second reality' is emphasised by foreshortening and vanishing perspectives, by discrepancies of proportion between the groups of figures caught up in a momentum which is carried from the surface to the depths, provoked and controlled by the central figure of Christ the Judge and his commanding gesture.

Even the beautiful wingless angels who, at the top of the wall, are bearing the instruments of the Passion, seem on the verge of being sucked into the whirlwind that dominates the whole scene, from the figures of the blessed who, down on the left, are painfully tearing themselves from the thankless earth, and having regained their bodies, surge towards the heights, to the damned who, on the other side, hurl themselves or are hurled into the flames of the infernal abyss and Charon's ferryboat. The Virgin is pictured beside the figure of Christ who rises – his right arm uplifted – in an attitude often

found in Buonarroti's work, in the central figure of *Battle of the Centaurs* as in the fulminating Zeus of *The Fall of Phaethon*.

Round the figures of Christ and the Virgin throngs a multitude of saints, patriarchs and prophets whose countenances express extreme distress and tension. Even in the case of the blessed, agitation and unease prevail over the rare manifestations of joy and exultation, peace and inner light.

The expression of emotion, always acute, turns to horror and despair in the crowds of the damned, dragged towards the abyss in a frenetic tangle of bodies by monstrous and bestial demons without any representation of physical torture. Here again breaking with iconographic tradition, Michelangelo envisages and represents damnation as an inner torment: remorse, despair, descent to the depths of bestiality or psychological annihilation. Any viewer of this immense fresco, not forewarned, has always been struck both by its intensity of expression and its structural unity, starting with Vasari who stresses the astonishing homogeneity of its execution: 'Over and above its extraordinary beauty, this work is painted and arranged so evenly that it seems to have been made in one day and as if no one else could ever accomplish so much; and indeed the multitude of figures, the terrible character and grandeur of the work are such that one cannot describe it because it is full of all the feelings a man can suffer and expresses them all admirably.'

Charon's Ferryboat,
The Last Judgement

The first criticisms and expressions of dissent were voiced even before the fresco was finished and unveiled in 1541 on the eve of All Saints' Day. Vasari relates an amusing anecdote confirmed by other sources. The Pope's master of ceremonies, Biagio da Cesena, 'a scrupulous man', who had been asked his opinion of the fresco, 'says that it was highly improper in such a chaste place to have painted so many nudes who shamelessly expose their private parts, that it was not a work for a papal chapel but for thermal baths or a disorderly house'. Michelangelo

Group of the resurrected,
The Last Judgement

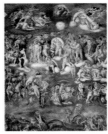
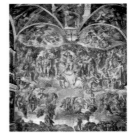

The Last Judgement
by Marcello Venusti

The Last Judgement

took his revenge on the unfortunate Biagio by portraying him in hell, giving his features to Minos 'with a great serpent entwining his legs in the middle of a pack of devils'. In truth, however, the papal official had expressed not so much a personal opinion as a widely held view and not one confined to the circles of the Curia. On 19 November 1541, a few weeks after the unveiling of *The Last Judgement*, N. Sernini wrote in a letter to Cardinal E. Gonzaga, ' . . . while the work is of a beauty you can well imagine, your Eminence, the hypocrites are the first to consider the nudes to be misplaced in such a context because they expose certain parts of their anatomy. Others say that Michelangelo has shown Christ without a beard, that he is too young and lacks the majesty that is fitting. So there is no shortage of people ready to criticise, but the Reverend Cornaro, having given long consideration to the work, has declared that if Michelangelo wishes to give him a picture representing a single one of the figures, he will pay him whatever he may ask and he is right because, in my view, there are things there not to be seen elsewhere.'

This letter gives the gist of the different attitudes adopted by the artist's contemporaries, as well as of the polemical discussions that ensued in the following decades: open and whole-hearted admiration on the part of art-lovers such as Cornaro, but also accusations of obscenity, of lack of 'decorum' and respect of the 'conventions'.

In Aretino's letter of November 1545 the attacks against the character and work of Michelangelo came to a crescendo: on the one hand, Aretino accused the artist of not having hesitated to provoke a scandal, driven only by his desire to demonstrate 'the perfection of painting'; on the other, he called for the outright destruction of the work in underhanded terms: ' . . . conscious that our souls are in greater need of the help of religion than of vigorous drawing, may God inspire his Holiness Pope Paul as he inspired the Blessed Gregory who chose, in his time, to rid Rome of the splendid statues of idols that adorned the city rather than see a loss of veneration for the humbler images of the saints.' Accusations of obscenity led on to suspicions of heresy, while increasingly insidious and determined opponents of the fresco took up their positions, among them the well-known Dominican Ambrogio Politi and Giovanni Andrea Gilio, author of a veritable, and systematic, indictment of the 'errors' of Buonarroti,

published in *Dialogues* after the artist's death but written in his lifetime. However vehement these accusations, they had no effect on Paul III or on his successor Julius III but, on the accession of the papacy of Paul IV, one of the most intransigent supporters of the Counter-Reformation, the situation was exacerbated. Pressed by order of the Pope to amend his fresco, Michelangelo replied ironically: 'Tell the Pope that it is a small matter and that one can easily amend it; let him amend the world as it is so easy to amend paintings.'

But times were changing and under the pontificate of Pius IV (January 1564), it was decided to 'correct' the fresco. The task was entrusted to Daniele da Volterra, who, as a great admirer of Michelangelo's work, did his best to limit the damage. This kind of tinkering did not, however, avert the threat of total destruction of the work, which periodically raised its head under the various pontificates. The disapproval felt on moral and theological grounds was, after Aretino's letter, compounded by criticisms of Michelangelo's artistic composition as a monotonous exhibition of anatomical virtuosity, lacking in 'variety', but also in 'proportion' and 'grace'. Vasari was quick to react and did so forcefully. He placed particular emphasis on the expressiveness, the sense of movement and the attitudes of the figures in Buonarroti's work.

The most extreme censures, like the highest praises, were born of an equal consternation before a work that could only be disconcerting to the artist's contemporaries. In effect, it overturned the essential laws of Renaissance art, abandoning the strict architectonic structure that in earlier works – the projects for the Medici tombs – had constituted the dialectic element, in its sense of order and proportion, the dynamic and forceful representation of the figures.

The composition of *The Last Judgement* as a whole, the systematic exaggeration of the gestures, the movements and expressions of the people, give the work a dark and dramatic character which must have seemed unbearable to many, its deepest meaning apparently misrepresented by accusations of obscenity, lack of decorum, orthodoxy and proportion. In fact, *The Last Judgement* portrays the wreck of a tormented and suffering humanity that has seen its moral and intellectual certainties eroded and waits fearfully for the promised Resurrection of the Just, in the presence of Christ the Redeemer, amidst the upheavals of the end of the world.

It would be in vain to look for indications of the artist's beliefs in either the Protestant doctrine of justification by faith or the Catholic doctrine of the value of one's deeds, or for allusions to the debate on predestination or veiled arguments against the Curia.

I n the years of Michelangelo's work on the fresco, the tearing apart of Christendom by religious quarrels did not yet seem inevitable and the dark and tragic age of intolerance and repression had yet to begin. Influenced by his circle of friends and particularly by the widowed Marchioness of Pescara, Vittoria Colonna, Michelangelo identified with the movement to bring internal reform to the Church. This group, tending to ideas of Protestant reform, made every effort to encourage attempts at reconciliation prior to the final break, which occurred with the Diet of Ratisbonne (1541).

In his *Rime*, Michelangelo explicitly communicated his distress and anguished participation in the spiritual uncertainties and dissension of the period. He was increasingly aware of the fragility of human nature, of the vanity of earthly things – art included – in the face of the threat of a 'second death'. He expressed himself in a voice sometimes dark and despairing, sometimes shot with fervour and anguished invocation, born of the contemplation of the sufferings of Christ. His spiritual worries, which range in his poems from an obsession with sin to hopes of salvation, find more dramatic and universal expression in *The Last Judgement* where the artist portrays the troubles and hopes of a whole age through his own unhappy experiences.

The scaffolding used by Michelangelo in painting *The Last Judgement* had hardly been taken down when Paul III began to contemplate a fresh commission for the artist. In the letter previously quoted, N. Sernini, having told Cardinal Gonzaga of the first reactions to *The Last Judgement*, added: 'It is said that your Eminence wants him to paint the other little chapel that has been built . . . ' The little chapel in question was the Pauline Chapel recently built for the Pope by Antonio da Sangallo the Younger. The painting of two frescos on its side walls was apparently to postpone the epilogue of the 'tragedy of the tomb' yet again. Buonarroti's letters at this period are full of a bitterness and anguish which go beyond the fear of infringing the new contract signed for the tomb of Julius II. In October 1542, while lamenting that the plaster was not yet dry so he was unable to start work, despite the Pope's pressing requests, he wrote: 'There is one other thing which causes me greater worry than the plaster and which stops me not only painting but living. It is that no gratification comes to me as was promised so I am left in great despair. . . . Painting and sculpture, work and religion, have exhausted me and everything goes from bad to worse. I would have done better to make matches in my youth, I would not be in such misery.'

W ork on the frescos was prolonged. The first was not finished until July 1545. The second, begun in spring 1546, was incomplete in October 1549 when the Pope, a few weeks before his death, came to view the chapel. In the original project, the *Conversion of Saint Paul* was to form a pair with the 'Giving of the Keys to Peter' on the opposite wall. The latter was changed, however, to the *Crucifixion of Saint Peter*. The subject of the investiture of Peter and his successors by Christ, loaded with ideological significance at a moment when the argument with

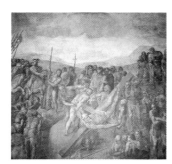

Crucifixion of Saint Peter

the Protestants was at its most bitter, was replaced by the martyrdom of the saint, conceived as a profound tribute to faith. The association – wholly unusual – of the stories of the two Apostles was intended to extol 'grace' (the fall and enlightenment of Paul) and 'faith' (the martyrdom of Peter) as the supreme Christian virtues, promising redemption and salvation. Michelangelo was allying himself to the supporters of internal reform in the Church, the 'circle of Viterbo' gathered round Cardinals Pole and Contarini and including Vittoria Colonna.

Both in their composition and their detail the two frescos have elements in common with *The Last Judgement* and thus continue the move away from the conventions of Renaissance art, particularly where the relationship between figures and space is concerned. The staggering of the figures in relation to the chapel's symmetry axis points to the altar as the ideal viewpoint – this chapel being reserved for the Pope rather than intended for official ceremonies. The frescos of the Pauline Chapel portray for the celebrant two crucial moments in the life of a Christian, conversion and martyrdom, manifestations of 'grace' and 'faith'. The two personae are represented as old men with, in the case of Paul, a very free interpretation of 'historical truth', a licence naturally criticised by Gilio and added to the list of 'errors' attributed to the artist, but in accord with the old Pope's wish to identify with the saint whose name he had taken at the moment of his conversion.

edly went back to 1537 and concerned renovations to the Capitoline Hill. The artist's plans reveal a scenographic conception of civic architecture which invests strategic points in the urban framework with specific ideological and symbolical significance. The renovation of the Porta Pia was similarly planned as a spectacular feature of the urban fabric, being a thoroughfare intended by Pope Pius IV to link the Palazzo Venezia to the Via Nomentana.

In 1546, on the death of Antonio da Sangallo the Younger, Michelangelo was asked to take charge of the building-yards for Saint Peter's and the Palazzo Farnese. In the latter case he completely transformed his predecessor's work by means of a few key modifications, replacing the monotony of a modular system with a predominance of horizontal elements directly inspired by Vitruvius.

The great cornice, designed in proportion to the building as a whole rather than as a crowning of the top floor, the raising of the height of the first floor and the central window topped by a coat of arms, give the façade a powerful relief and vertical reach. In the courtyard, Sangallo's project was embellished by a frieze decorated with masks and swags and above all by the design of the upper-storey windows, worked in travertine which accentuates their beauty.

According to Michelangelo's plans, the Palazzo Farnese was to follow a line 400 metres long, reaching from the Campo dei Fiori to the Farnese gardens on the opposite bank of the Tiber.

In the last thirty years of his life Michelangelo's activities were essentially concentrated on architecture. His work constituted a decisive turning point in the figurative art of the second half of the sixteenth century, even though none of the projects commissioned was completed before his death and all were subsequently altered.

Of the great Roman projects, the earliest undoubt-

Turning to religious buildings, one should mention the plans for the central structure of San Giovanni dei Fiorentini and the grandiose designs for the conversion of the Baths of Diocletian into a church dedicated to Santa Maria degli Angeli. However, what occupied Michelangelo above all else at this period was the enormous task of the recon-

struction of Saint Peter's. Now that Michelangelo was concentrating on architectural work, Paul III gave him tremendous powers. The artist refused all payment, however, and wanted to work only for the 'love of God'.

His clashes with Sangallo's pupils and what Vasari contemptuously termed 'Sangallo's sect' were violent and acrimonious from the start. On his very first visit to the site, he bluntly criticised his predecessor's work insisting that 'he had carried it out blindly, that he had too many rows of superimposed columns, and that with such a quantity of projections and spires, he adhered more to German style than to the antique or to the grace and beauty of the modern manner'.

While he condemned Sangallo's transformation of the church, Michelangelo held Bramante's original design in high regard: 'One cannot deny that Bramante is as worthy an architect as any since ancient times. It was he who laid down the first plan of Saint Peter's, not muddled but clear, precise and full of light, a building standing on its own so that nothing could damage it. It was esteemed beautiful as is still manifest, showing that whoever departs from Bramante's conception departs from the truth.'

In December 1546 Buonarroti made a clay model of Saint Peter's and a year later a more detailed wooden one, envisaging a return to Bramante's plan – a Greek cross on a square – but in a more compact and unified version, achieved by eliminating four minor crosses and the corner towers.

Parts of Sangallo's work were demolished while the new external elevation of the basilica gradually took shape up to the stage of the dome, a handsome model of which was made in lime between 1558 and 1561.

Despite later modifications and changes to the building, the force and originality of Michelangelo's plan can still be seen today when the basilica is viewed from the Vatican gardens. It is a powerful incarnation of Michelangelo's essentially anthropomorphic idea, expressed in the tension of the ribs, in the giant order of the attic storey, the drum and dome. The basis of it is not abstract calculations of proportion but a deep knowledge of anatomy derived from a dynamic and expressive conception of the body in movement: 'It is certain that the architectural ribs have a relation to the physical parts of man. He who does not know how to reproduce the

human figure does not know anything of architecture.'

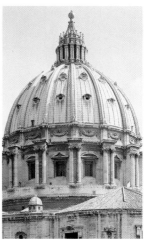

Dome of Saint Peter's

The period in which Michelangelo concentrated his activities in architecture corresponded to that of his increasing interest in poetry. He had written poems from his youth, but in an occasional and dilettante manner. Now, under the influence of Cavalieri and Vittoria Colonna, his verse became increasingly important to him. Towards 1546, yielding to pressure from his friends Riccio and Giannotti and with their collaboration, the artist drew up a selection of his *Rime* for publication. At this period he favoured the madrigal form, the structure of which allowed particular freedom and flexibility, following a varied rhythm, with a well-elaborated play of words and subjects. The poems are essentially variations on the theme 'love/death', rich in metaphor which works to a vivid and dramatic effect, often suggesting a feigned detachment, passionate and ironic at the same time:

So much out of herself
Has kind fair lady pledged,
That I in my slow age,
Watching her, might become as once I was.
But, envious fatal Death
Being at all hours lodged
Between my mournful and her kindly gaze,
I only keep ablaze
The little while his features are forgot.
But when the evil thought
Comes back again to its familiar place,
the lovely fire is quenched by his grim ice.

(trans. by Creighton Gilbert)

In contrast to the madrigals, in the poetry of Buonarroti's last years, the religious element already apparent in his earliest works came to predominate.

In the poem beginning 'I live shut up here, like the doughy middle inside the bread crust' Michelangelo returned to a burlesque theme already handled in

his earlier works, but this time seeking to find there the detachment he needed to express the wretchedness of the human condition that was his own:

Love and the flowered grottoes, and the muse,
My scrawls for tambourines or dunces' caps,
Go to innkeepers, toilets, bawdy houses.

What use to want to make so many puppets,
If they have made me in the end like him
Who crossed the water, and then drowned in slops?

My honoured art, wherein I was for a time in such esteem,
has brought me down to this:
Poor and old, under another's thumb.

I am undone if I do not die fast.

(trans. by Creighton Gilbert)

The caricatural tone poorly masks the artist's deep bitterness and anxiety about his ill health. This is expressed with greater directness and feeling in other works:

The fresh green years cannot, O my dear Lord,
Feel how much at the final step we change
Our tastes and our love, our thoughts, our will.

The soul gains more the more it's lost the world,
And death and art do not go well together.
What should I of myself then hope for still?

(trans. by Creighton Gilbert)

According to Condivi, at the request of Vittoria Colonna Michelangelo produced a 'naked Christ, taken down from the cross' and a 'drawing of Christ on the cross which does not, as is generally the case, have the appearance of death but of the Son of God, his countenance lifted towards his Father'.

These two works seem to correspond to well-defined practices of meditation and concentration. There exist many charcoal versions, executed according to the technique of the 'fogli maggisterali' (master's sheets). Behind the figure of the Virgin in the *Pietà* can be read the words of Dante: NON VI SI PENSA QUANTO SANGUE COSTA (Little do you think what His blood has cost).

After the death of Vittoria Colonna, the subject of Christ on the cross with Mary and John on either side reappeared in Michelangelo's drawings. These were executed in charcoal or pencil and paid less attention to precise anatomical detail than to an extreme delicacy of expression in handling the sorrow of the figures beholding the Passion of Christ.

Buonarroti's last sculptures date from the same period. They portray lamentation over the dead body of Christ in a form very different to that of the Vatican *Pietà* which was a juvenile work. In the *Pietà* for Florence Cathedral on which Michelangelo worked in 1552-3, the abandoned body of Christ is supported at each extremity by the Virgin and by Mary Magdalen and in the centre by Nicodemus who dominates the other figures, giving the whole work an austere pyramidal structure.

If Condivi is to be believed, the artist started to sculpt this *Pietà* for himself, with the intention of giving it to 'a church and having himself buried at the foot of the altar on which it was placed'. But when progress on the statue was well advanced, he attacked it with blows of the hammer, breaking the left leg and one of Christ's arms to pieces, smashing the Virgin's hand. None of the theories advanced to explain his action ring very true, and the reason probably lies once again in the artist's incurable sense of dissatisfaction with his work. The *Pietà*, which Michelangelo gave to his assistant Urbino, was later clumsily reworked by Tiberio Calcagni. As a result the figure of Mary Magdalen lacks the expressive intensity of the other three, particularly evident in the heads of the Virgin and her Son, bent towards each other, both unfinished.

Another *Pietà*, comprising only the figures of the Virgin and Christ, was certainly begun before 1554 by Michelangelo but remained unfinished. According to Vasari, in the last years of the artist's life his friends placed a piece of marble between his hands 'so that he might spend his time wielding the chisel'.

Not wholly bereft of his strength, Michelangelo continued to sculpt every day. 'He stoops', writes another of his contemporaries, 'and has difficulty in raising his head, but continues to wield the chisel when he is at home.'

In the original version of the *Pietà Rondanini* the abandoned body of Christ, sagging forward, con-

trasts with the upright figure of the Virgin who is trying to support him. When Michelangelo returned to the work, doubtless a number of years later, he wrought a complete transformation: the head and torso of Christ, which had already been sculpted, were eliminated while the legs and a section of arm on the left were preserved. The upper part of the bodies of the two figures was carved from a piece of marble intended originally for the body of the Virgin. The result was an interpenetration of the two figures – as if to express their indissoluble union, beyond the bounds of suffering and death. This effect is accentuated by the ascending rhythm given to the statue – freed of the burden of flesh, immaterial – and by the manner in which the surfaces are worked as if penetrated by an intense and luminous vibration.

As in his later drawings of the crucifixion, Michelangelo's attention is no longer concentrated on the beauty of form and the image becomes to an extent a direct projection of an inner vision derived of a deep and constant adherence to the sufferings of Christ.

Michelangelo continued to work to the very last. In a letter to Vasari, Daniele da Volterra wrote: 'He worked all day the Saturday before the Monday on which he fell ill. And on Sunday, forgetting that it was Sunday, he wanted to work, until Antonio reminded him.' A few days later, on 18 February 1564, Michelangelo died at the age of nearly ninety, in his house in the Macel de Corvi in Rome.

PIERLUIGI DE VECCHI

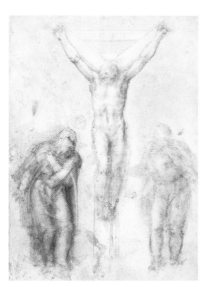

Crucifixion with the Virgin and Saint John

The Ghirlandaio workshop

Michelangelo's genius was commonly attributed to his lucky stars: his two contemporary biographers. Giorgio Vasari and Ascanio Condivi, a pupil of the artist's, both stressed the importance of his horoscope. In 1568 Vasari observed that 'Mercury, followed by Venus, received him in benefic phase into the house of Jupiter, heralding marvellous and startling works of manual talent.' The point of this anecdote is that Michelangelo's exceptional gifts were immediately recognised by his contemporaries.

Born on 6 March 1475 in Caprese, a small town near Arezzo, Michelangelo was the second son of a family of five boys, the Buonarotti Simoni who were of old Florentine stock and connected to the Guelph party. The Buonarroti family moved to the villa Settignano on the outskirts of Florence when Michelangelo's father who was *podesta*, or mayor, of Chiusi and Caprese completed his term of office.

His biographers claim that Michelangelo showed an early talent for drawing which he practised at home, in secret because his family wished him to be a scholar and had enrolled him in grammar classes given by the humanist Francesco Galata da Urbino. His meeting with the painter Francesco Granacci, a few years older than himself, was to prove a decisive influence on his development. Granacci, who was himself a pupil in Domenico Ghirlandaio's workshop, recognised his talent and encouraged him to paint. Michelangelo's father accordingly placed his son, then aged thirteen, in the studio of this well-known artist. The great masters who would have been familiar to Michelangelo at this early stage were those of the Quattrocento: Giotto, Masaccio, Donatello, whose influence is apparent in his first drawings.

After the first year he decided to leave the Ghirlandaio workshop for the museum-garden of San Marco, where he drew antique sculptures in the collection.

1
In his frescos Domenico Ghirlandaio blends everyday Florentine life with sacred scenes. *The Birth of John the Baptist* is set in a palace, the characters attired in contemporary dress. Though Domenico himself was a good draughtsman, he quickly recognised, according to Vasari, that 'Michelangelo knew more than he.' It was nevertheless from him that Michelangelo learnt the techniques of fresco.

2
This drawing, regarded as one of the finest of Michelangelo's juvenile period, has this in common with the one that follows: only the figure in the foreground is elaborated and the interest Michelangelo shows in the plastic study of form heralds his genius as a sculptor.

3
This study of two men is after a fresco by Giotto, *The Ascension of John the Baptist* in the Peruzzi Chapel at Santa Croce. The figure in the foreground, more fully modelled, introduces variations on the original. The fine cross-hatching is taken from Ghirlandaio's drawings of that period.

If Vasari is to be believed, it was as an infant at Settignano that Michelangelo first encountered stone-carving since his father had given him into the care of a wet-nurse married to a stonemason. Vasari quotes here Michelangelo's own words: 'Giorgio, if there is anything worthwhile in my spirit, I owe it to my birth in the fine air of your native Arezzo, for I got from my nurse's milk the chisel and hammer I use for my figures.' His vocation as a sculptor effectively began in 1489 – he was then fifteen

The very flat relief of this work brings to mind that of Donatello and illustrates his influence on the young sculptor. The way the Virgin is presented, seated in profile, occupying most of the space, evokes the ancient art of funerary steles. Also of note is how keen Michelangelo was to depict the sturdiness of the infant Jesus' back and arms.

1
Lorenzo *il Magnifico* enjoyed talking to young artists about their work. The scene reproduced here was also recorded by Vasari. When Michelangelo was working on a marble copy of a head of 'an ancient, wrinkled faun with a broken nose, who was laughing', he hollowed out the mouth to reveal the tongue and the teeth. Lorenzo pointed out that the old never have all their teeth. 'As soon as he left, Michelangelo, out of respectful affection for the prince, broke a tooth and made a hole in the gum.'

– when Lorenzo *il Magnifico*, one of the Medicis and ruler of Florence, gave him permission to draw his sculptures, newly installed in the garden of the Casino Mediceo. They formed part of a collection of antiques in the charge of the sculptor Bertoldo di Giovanni, a former pupil of Donatello. For the following two years Michelangelo lived in the Medici palace in Via Larga, where he was constantly mingling with the humanists in Lorenzo's circle: Poliziano, Landino, Pico della Mirandola and Marsilio Ficin. This élite comprised the Platonist Academy who had assigned themselves the task of popularising the writings of the Ancients, particularly Plato, translated into Latin. Until the death of Lorenzo, in 1492, the young Michelangelo grew up as part of the privileged and cultivated group surrounding his benefactor, himself a writer of poetry. It is not surprising to observe through the course of Michelangelo's working life the extent to which he was imbued with Neo-platonic ideas of love and harmony.

2
This bas-relief by Donatello may have belonged to the Medicis and been in their palace when Michelangelo was a guest there. The attempt to render the perspective and geometry of the architectural elements, combined with an expressive and masterly handling of the figures, noteworthy for the quality of their modelling and spatial integration, make this a veritable masterpiece.

1 *Lorenzo* il Magnifico *among Florentine artists*, 1638-42, Ottavio Vannini. Fresco
Salle degli Argenti, Palazzo Pitti, Florence

2 *Feast of Herod*, c. 1435, Donatello
Marble, 0.50 × 0.71 cm
Musée des Beaux-Arts, Lille

3 *Madonna of the Steps*, c. 1490-2
Bas-relief in marble, 55.5 × 40 cm
Casa Buonarroti, Florence

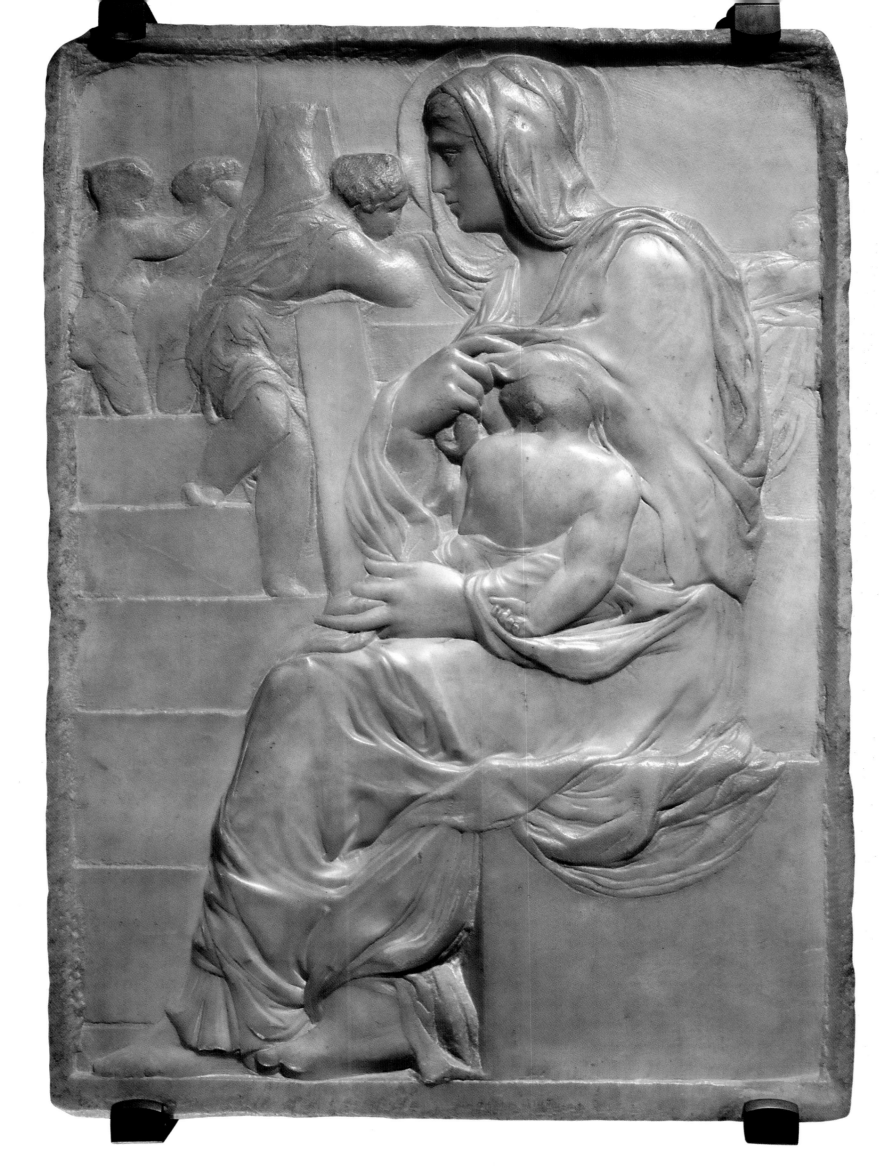

According to Vasari, 'Following the advice of the great poet Poliziano, Michelangelo sculpted the battle of Hercules and the centaurs in a block of marble provided by Lorenzo; it is so beautiful that as one gazes on it one sees there, not the work of an adolescent, but that of an esteemed, accomplished and well-practised master.' In fact, the episode represented is probably the abduction of Hippodameia by the centaur Eurythion, taken from Ovid's *Metamorphoses*. Michelangelo interprets this unusually violent battle between the centaurs and the Lapithae as a dense composition in which the different attitudes of the figures impose a rotational rhythm around the central combatant. The mythological subject gives him a pretext for representing nude bodies in motion and his portrayal of them as powerfully muscled is justified because the warriors are shown in a state of physical effort. Antique reliefs of battles between Romans and barbarians have clearly again served Michelangelo as a source of inspiration. The relief adopted here, more pronounced than in *Madonna of the Steps*, allows the sculptor at least three suc-

1
The dynamic element of this *mezzo-rilievo*, seen in the central line of composition, is to recur in *The Last Judgement*.

2
Granacci, a companion of Michelangelo's in the Ghirlandaio workshop and the Casino Mediceo, is here portraying an anti-Medicean occasion: the arrival in Florence of Charles VIII, King of France, which was followed by the fall of the Medicis, driven from the city for eighteen years.

3
The dynamism of the *Battle of the Centaurs* is again apparent in this study of a man in motion. Michelangelo drew his inspiration from a figure of Hercules on the relief of a sarcophagus of late period. He had planned to include this study in the group of bathers in the centre of the *Battle of Cascina*, but abandoned the idea.

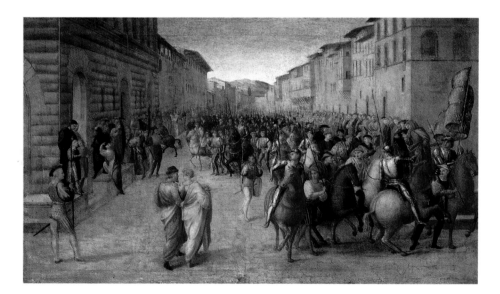

cessive levels on which to present his figures; nonetheless he does not completely detach those in the foreground: they are anchored solidly to the base of the block of marble by their feet. This technique had already been put to brilliant use by Ghiberti in Florence when he executed the bronze doors of the Baptistry. On the death of Lorenzo *il Magnifico*, Michelangelo went back to live with his father. The unrest in Florence, caused by the Dominican Savonarola's preaching, which Michelangelo had attended, intensified at the news of Charles VIII's arrival with his army. In a fit of panic, shortly before 14 October 1494, Michelangelo fled towards north Italy.

1 *Battle of the Centaurs*, 1492
Marble, 81 × 88.5 cm
Casa Buonarroti, Florence

2 *Charles VIII arriving in Florence*, c. 1527
Francesco Granacci
Oil on wood, 75 × 122 cm
Uffizi, Florence

3 *Male nude seen from back*, c. 1504
Pen & ink on black chalk outline, 40.9 × 28.5 cm
Casa Buonarroti, Florence

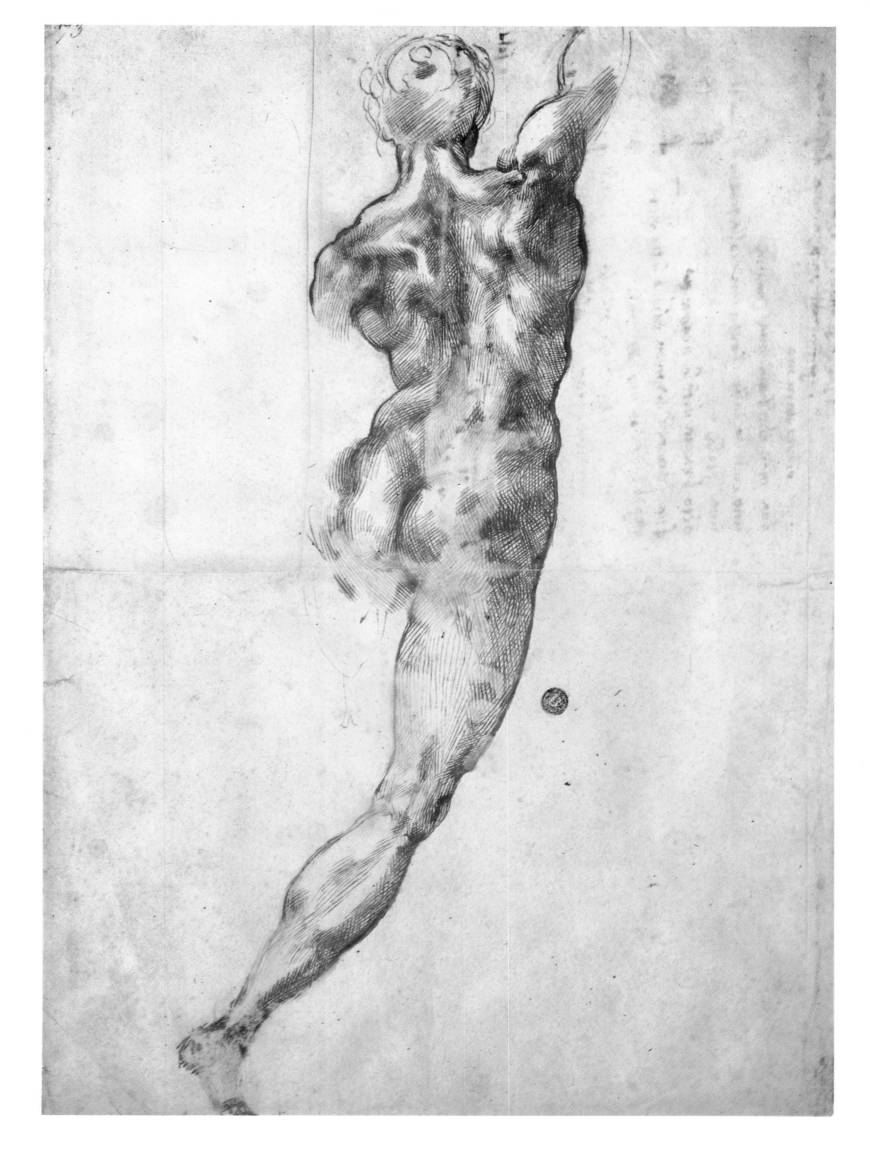

Michelangelo then left Florence for Venice, and went on to Bologna where he stayed as the guest of a Bolognese gentleman, Gianfrancesco Aldovrandi, for about a year. Vasari relates: 'One day Aldovrandi took him to see the *Shrine of Saint Dominic*, the creation . . . of sculptors of days gone by: the workshop of Nicola Pisano in the thirteenth century and Niccolò dell'Arca (1469-73); an angel bearing a candlestick and a Saint Petronius were missing'. These statuettes were commissioned from Michelangelo who, in fact, also executed a third, of Saint Proculus, not mentioned by Vasari. The uncertain character of the three statuettes is explained by the restrictions to which Michelangelo was subject: his task was to complete the sculptural decoration of the tomb left unfinished by Niccolò dell'Arca while staying true to the latter's style. The study of these two great sculptors of the Quattrocento, Jacopo della Quercia and Niccolò dell'Arca, who had done much work in Bologna, left its mark on the young sculptor, then twenty years old. This is particularly evident in the expressions of the figures and style of the drapery. The eloquent and pathetic gestures of Niccolò recur later in the decorative cycle of the Sistine. Michelan-

1
Jacopo della Quercia was one of the most important sculptors of marble in the first half of the Quattrocento. From March 1425, he worked on the decoration of the principal door of San Petronio in Bologna, which occupied him until his death. The decoration comprises three cycles of bas-reliefs: the scenes drawn from Genesis, the childhood of Christ and the busts of the prophets. The vivacity and expressiveness with which Jacopo della Quercia's forceful figures are imbued herald the art of Michelangelo.

2
Niccolò dell'Arca, a Bolognese sculptor, produced many works in his native city. The most famous is the *Deposition from the Cross* in painted terracotta for the church of Santa Maria della Vita, Bologna. It is masterly in its movement and expression and deeply influenced by contemporary French art.

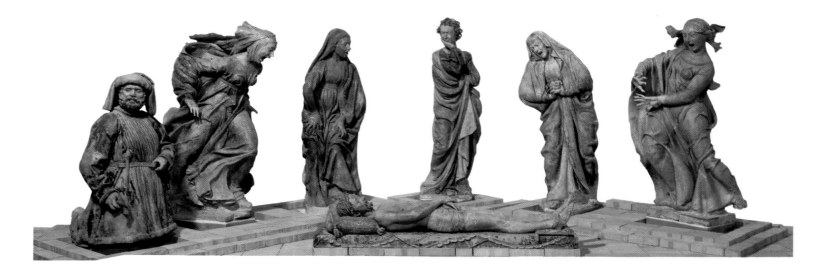

gelo clearly went to see Niccolò's *Deposition from the Cross*, executed for the church of Santa Maria della Vita in Bologna. Its expansive style was to be echoed in his future work. Again according to Vasari and Condivi, the period he spent with Gianfrancesco Aldovrandi was devoted to reading Dante, Petrarch and Boccaccio: glints of their writings are to be seen in his own poetry. His first verses, written a few years later, owed a particular debt to Petrarch.

1 *Sacrifice of Isaac*, 1425-38. Jacopo della Quercia
Bas-relief
Portal of San Petronio, Bologna

2 *Deposition from the Cross*, c. 1485. Niccolò dell'Arca
Painted terracotta
Pinacoteca, Bologna

3 *Saint Proculus*, c. 1494-5
Marble, H: 58.5 cm with base
San Domenico, Bologna

3
Saint Proculus was damaged and not very skilfully repaired in 1572; this is very apparent in the legs. If the pose of the statue evokes that of Donatello's *Saint George* (Bargello), Michelangelo invests his figure with a sense of mission that anticipates that of David. It is expressed in the saint's determined look and stance, the right fist resolutely closed.

At the end of 1495 Michelangelo decided to return to Florence where calm had been restored. During his absence the republic had been established. Its sole preoccupation, influenced by Savonarola, was the moral and political reform of Florence. Interest in the arts was negligible and Michelangelo found himself without work. He sold his *Cupid* (this and *Saint John the Baptist* are the two works, now lost, which date from his period in Florence) to a Roman dealer, who resold it as an antique to Cardinal Riario. Six months after his return to Florence Michelangelo left for Rome where he remained for five years.

His first commissions in Rome came not from Pope Alexander VI Borgia but, privately, from Cardinal Riario and Jacopo Galli, a banker and collector of antiques. It was for the latter that he sculpted *Bacchus*, a statue which is appropriately of antique inspiration. Bacchus, the god of wine, is characterised by vine leaves and bunches of grapes framing his face. He is accompanied by a little satyr who is stealing a bunch of grapes from him, behind which appears the mask of a tiger (or leopard?). Condivi enlightens us as to the symbolism: 'On his [Bacchus'] left arm, there is the skin of a tiger, this animal being associated with him because of its marked taste for

1/2/3/5
Bacchus was intended to stand in the middle of a garden of antiques.

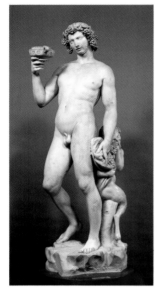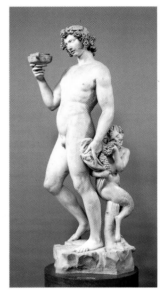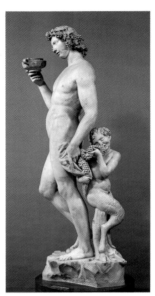

'*One finds in this statue a marvellous harmony, due notably to his association of the slimness of the young man to rounded and full feminine forms.*' (*Vasari*)

grapes. The skin alone is represented because Michelangelo wanted to show that those who are enslaved by passion for the fruit and its liquor finish by quitting this life.' Though Michelangelo was evidently inspired by the antique here, he added a note of overall softness suited to Bacchus' drunkenness, as well as a rotundity that Vasari had already remarked in his biography. Designed to be viewed from all possible angles, the statue is ideally placed in a garden of antiques.

4
Marteen van Heemskerck, a painter and native of Haarlem, lived in Rome from 1532 to 1536. There he drew from the antique and the works of Michelangelo, as this drawing shows. Heemskerck's Bacchus has a truncated right hand, the better to satisfy current tastes for the antique.

1/2/3/5 *Bacchus*, 1496-7
Polished marble. H: 2.03 m. including base
Bargello, Florence

4 Drawing of a Garden of Antiques
Marteen van Heemskerck
Kupferstichkabinett, Berlin

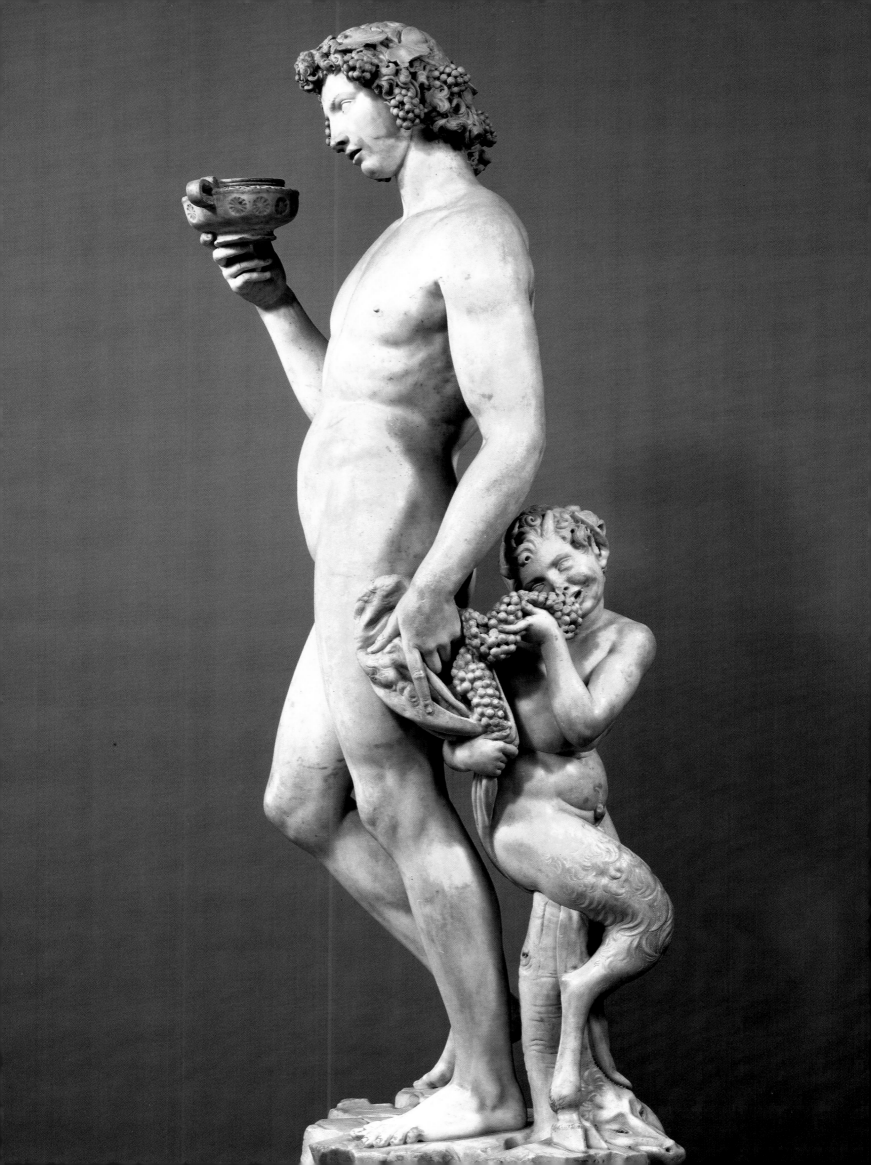

Pietà

*B*acchus was followed by a *Pietà*, commissioned this time by a Frenchman, Cardinal Jean Bilhères de Lagraulas. His contract with Michelangelo was dated 27 August 1498 and the sculpture was completed the following year. Bilhères de Lagraulas was the French King Charles VIII's legate to Pope Alexander Borgia. The sculpture was intended for the chapel of Saint Petronella, or the chapel of the kings of France, in Saint Peter's. It was moved several times, until in 1749 it was placed in the first chapel on the right of the nave. Michelangelo's biographers have in their time praised the beauty of this *Pietà* which won universal admiration: 'It is a work to which no sculptor, or great artist, could possibly add anything, such is the gracefulness of the design, nor could they even try to equal the skill

'Some have blundered in criticising it,
saying that he made the Virgin too young.
Did they not know or have they forgotten
that virgin spirits free of stain
preserve their physiognomy intact
for longer, contrary to those
who have suffered like Christ?' (*Vasari*)

with which Michelangelo has carved and polished the marble: there all the grandeur, all the riches of art are enshrined.' Such were the praises of Vasari, a keen admirer of Michelangelo's work. It is true that Michelangelo was in perpetual search of Ideal Beauty. His starting point was nature, the accurate observation of which he had learned in Ghirlandaio's workshop, but he transcended it to attain his ideal. Thus, by achieving what Blunt saw as a beauty superior to that of nature, Michelangelo could be regarded as a Neo-platonist, and indeed his poems express such an aspiration on several occasions. In one of his first sonnets, he addresses himself to Love: 'Nay, prithee tell me, Love, when I behold my lady, do my eyes her beauty see in truth, or dwells that loveliness in me which multiplies her grace a thousandfold?' And Love replies: 'The beauty thou discernest all is hers; but grows in radiance as it soars on high through mortal eyes unto the soul above: 'tis there transfigured; for the soul confers on

1
Deposition from the Cross, executed *c.* 1542-5 by Bronzino for the alter of Eleanora di Toledo's chapel in the Palazzo Vecchio, shows the artist's knowledge of and admiration for Michelangelo's group. The broken and serpentine line of Christ's body corresponds perfectly to the aesthetics of Mannerism becoming current in Florence at the time.

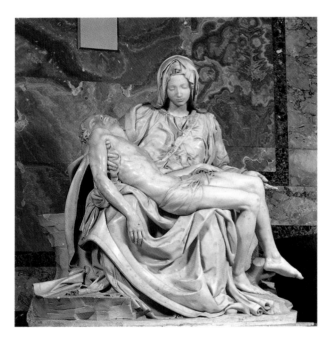

2/3
Michelangelo's *Pietà* is the artist's most 'finished' work and the only one to be signed 'Michaelangelus Bonarottus Florentin (us). Faciebat' (on the band the Virgin wears diagonally across her breast). The gentleness and refinement of the faces bring to mind the art of Leonardo, an undoubted influence on Michelangelo at this stage. The pyramidal composition, with the elegant arrangement of the drapery, achieves an expression of deep harmony between the figures.

1 *Deposition from the Cross*, c. 1542-5. Bronzino
Oil on wood, 268 × 173 cm
Musée des Beaux-Arts, Besançon

2 *Pietà*, 1499
Marble, H: 174 cm. including base 195 cm
Saint Peter's, Vatican

3 *Pietà* (detail of Virgin's face)
Saint Peter's, Vatican

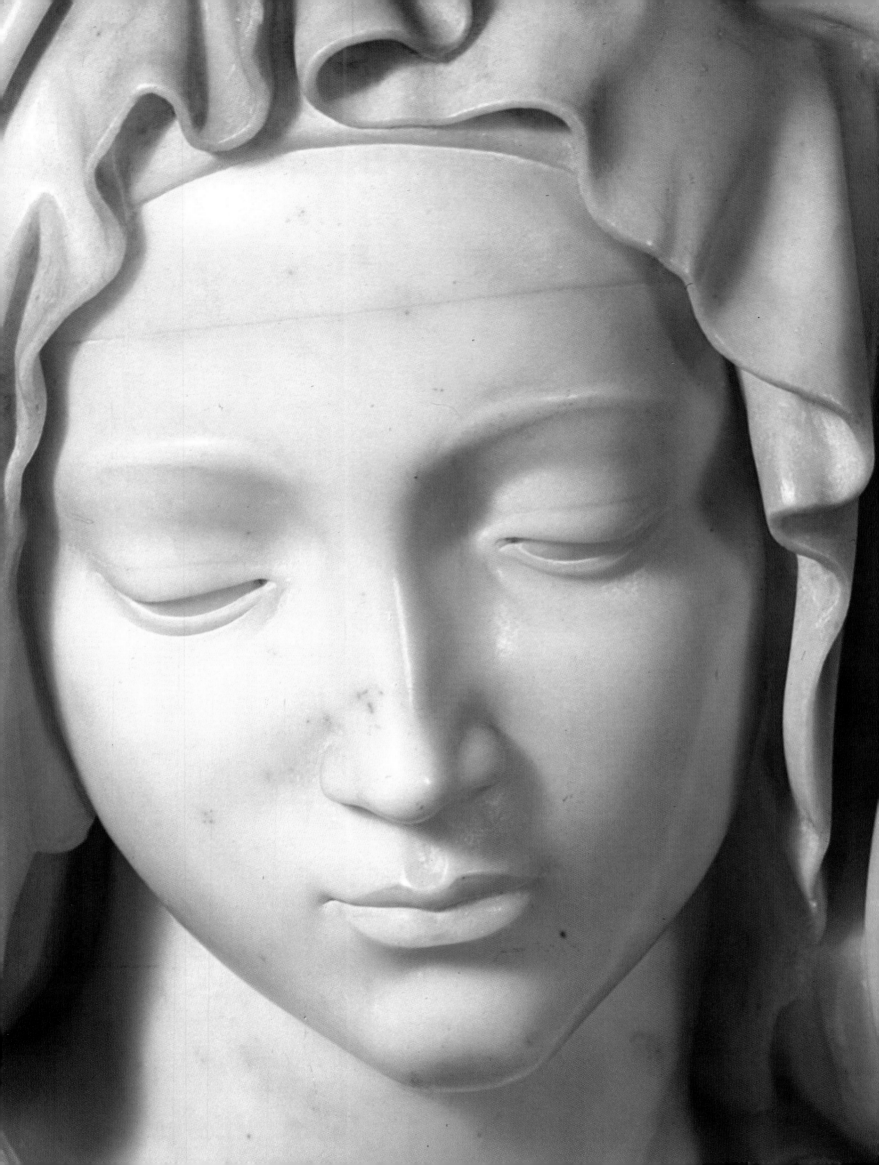

what she holds, her own divinity: and this transfigured beauty wins thy love.' The *Pietà* made Michelangelo widely known when he was still only twenty-four. The iconographic type of the Virgin of piety, or *Pietà*, that Michelangelo had in mind dated from the thirteenth and fourteenth centuries and, before spreading to Italy, originated in Germany and France. Indeed, this commission was carried out for a French cardinal. The subject was Christ after the crucifixion lying in

'... the body of the dead Christ:
one cannot imagine a nude so well conceived
in the muscles, veins and nerves
covering the bones, nor a dead body
more like a dead body.' (Vasari)

his mother's lap. Up to the fifteenth century the Christ figure tended to be the size of a child. This corresponded to the ideas of the Franciscan mystics: the Virgin, distraught with grief, dreams that she is cradling her infant son in her arms, while he is actually a corpse in a shroud. Michelangelo diverged from the norm by portraying Christ as an adult, while the Virgin remained as young as before. Generally depicted alone, she was sometimes shown accompanied by Saint John, Mary Magdalene, the three Marys or even the donors of the work, as in Enguerrand Quarton's *Pietà*. Later, in the sixteenth century, the iconography of the *Pietà* with two figures became confused with that of the 'lamentation at the foot of the cross' which comprised many characters, as seen in Bronzino's painting (see p. 38).

1
Attributed to Enguerrand Quarton, a painter who worked in Provence from 1444 to 1466, the *Avignon Pietà* is a masterpiece of fifteenth-century painting. Defined by the gold background, the characters are stamped with a realism that is channelled to religious ends. The spareness of the scene draws attention to the strained expression of the faces and the dramatisation of the central figures of the group, the Virgin and Son.

1 *Avignon Pietà*, c. 1455
Enguerrand Quarton
Oil on canvas, 163 × 218 cm
Musée du Louvre, Paris (RMN)

2 *Hand of Christ*, detail of *Pietà*
Saint Peter's, Vatican

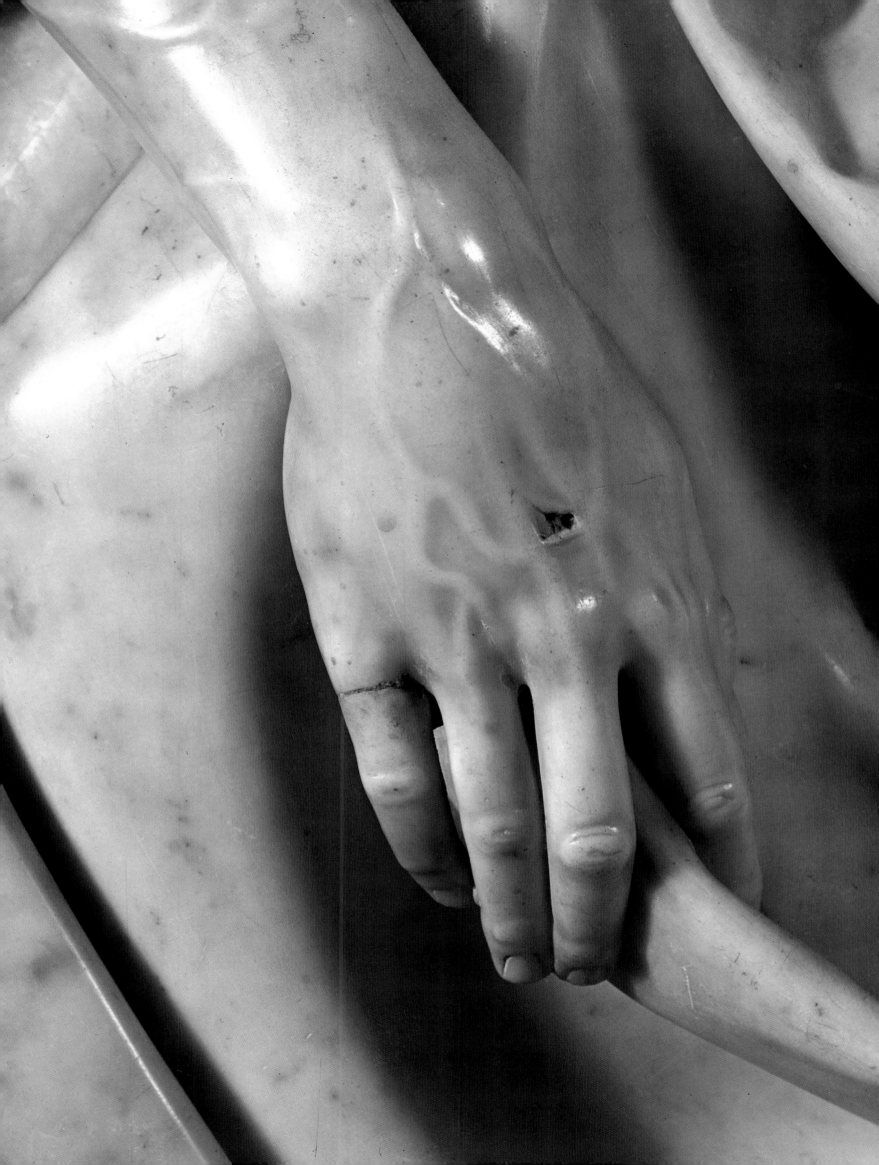

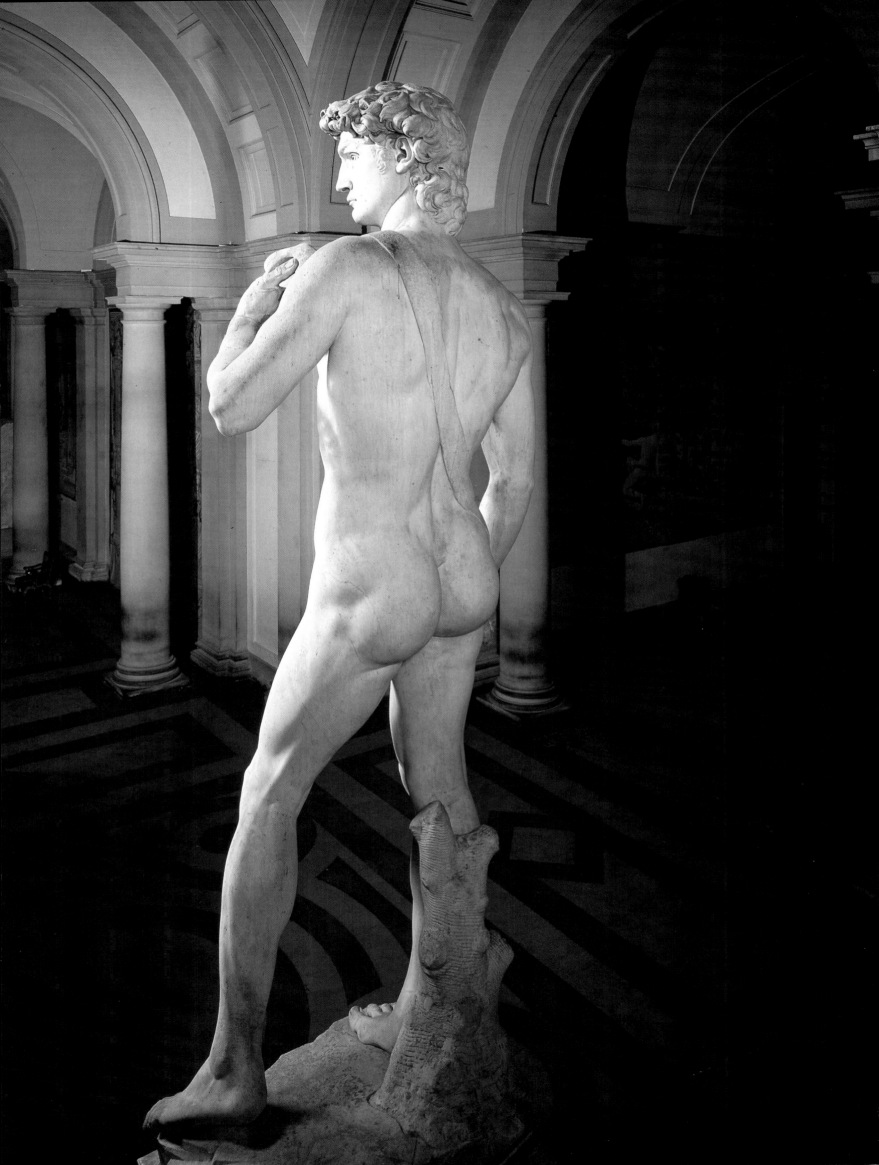

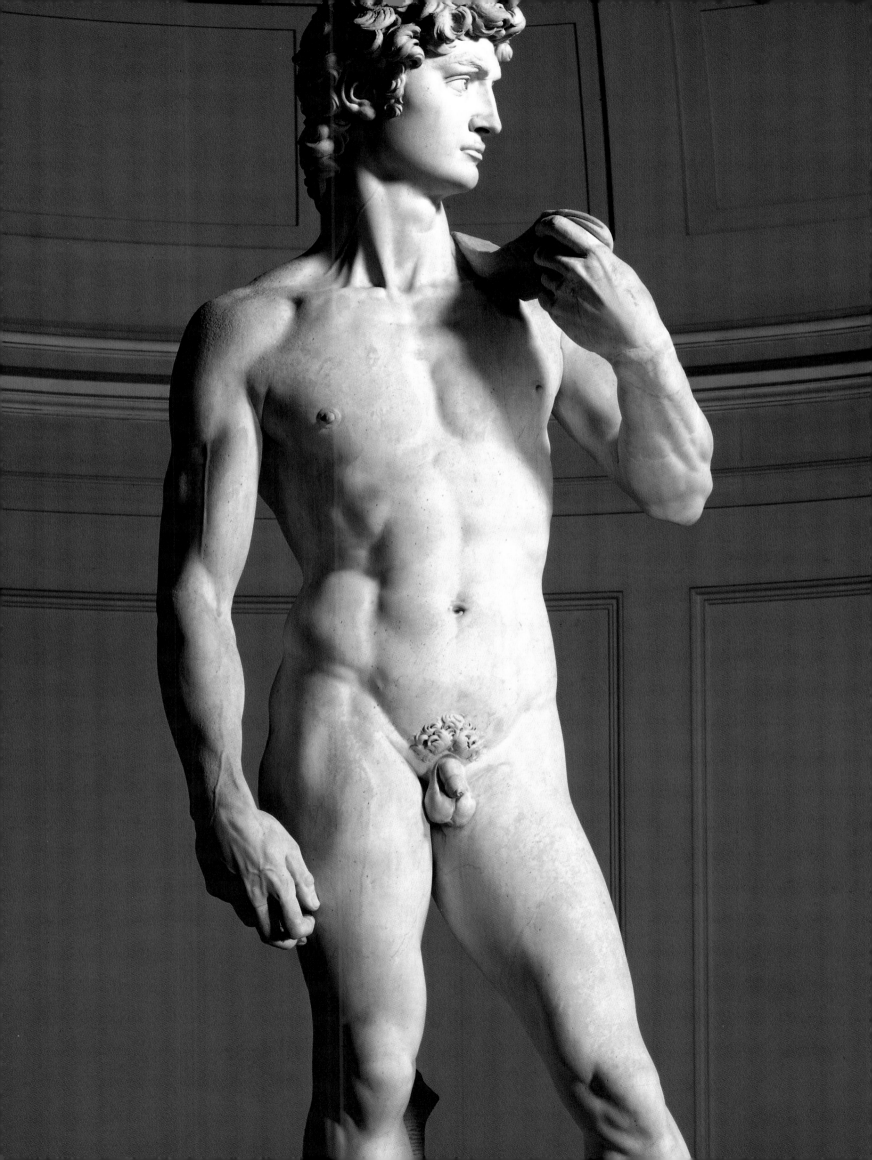

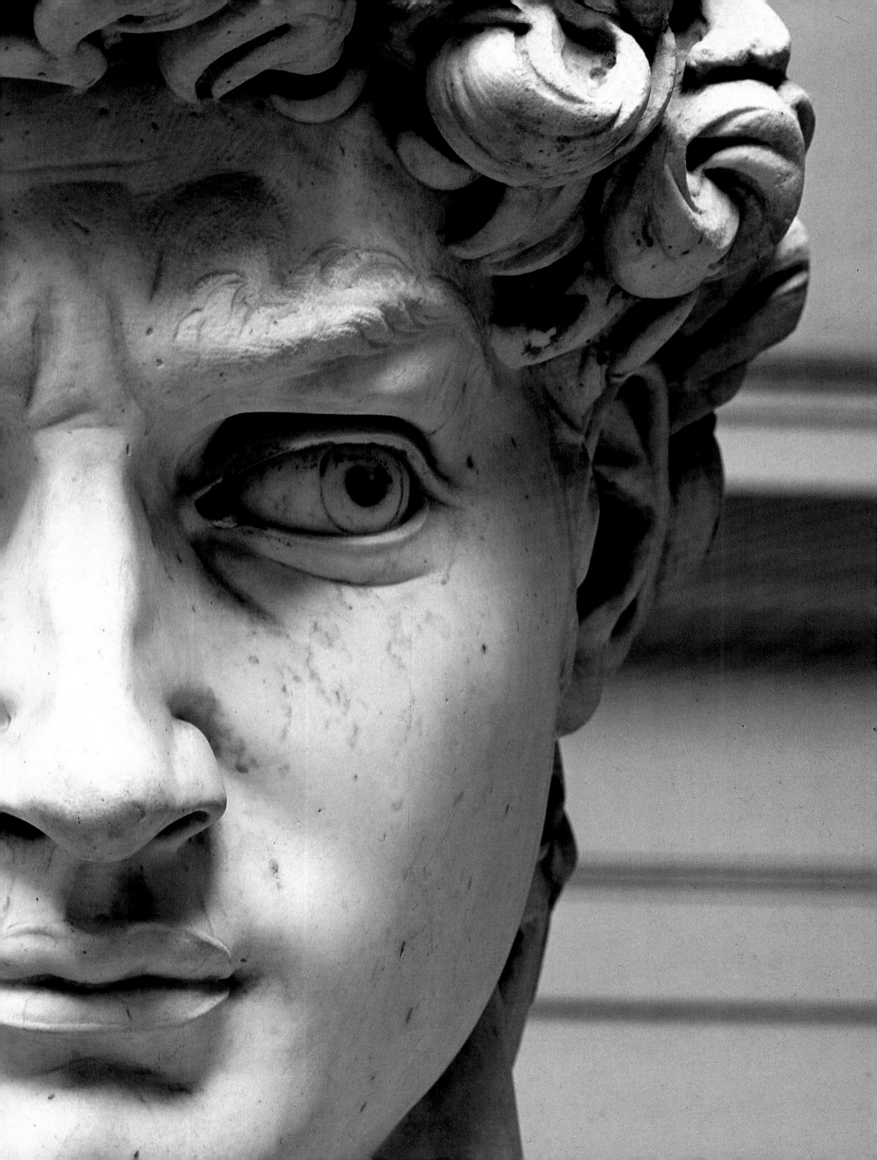

Raphael made this drawing of *David* during his first period in Florence, probably soon after the statue was put in place in 1504. The master, a native of Urbino, was a member of the committee of artists who chose the location of the statue.

1

The determined, sideways look, the frowning eyebrows, are expressions of the *terribilità* peculiar to Michelangelo's art and add a psychological dimension to its sculptural perfection.

A commission from the republic of Florence: *David*

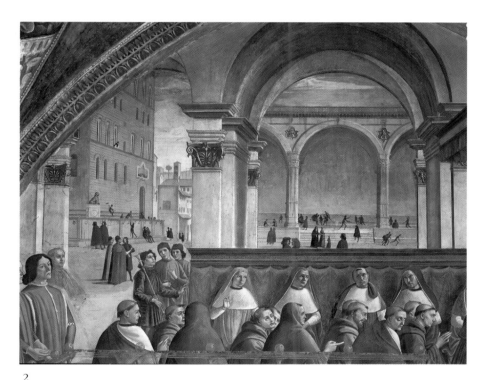

2

About 1485, Ghirlandaio executed the frescos for Francesco Sassetti at Santa Trinita. Situating the scenes in Florence itself, he produced veritable topographic views of the city. *Pope Honorius III ratifying the rule of the Order of Saint Francis* is situated on the bank of the Arno, Piazzo della Signoria. On the left, the Palazzo Vecchio, in front of which *David* was positioned, and opposite it the Loggia dei Lanzi, later to be peopled with statues.

Preceding pages:
David, front and back views, 1501-4
Marble, H: 434 cm including base
Galleria dell'Accademia, Florence

1 *David* (head, front view)
Galleria dell'Accademia, Florence

2 *Ratification of the Order*, before 1485. D. Ghirlandaio
Fresco: detail of Palazzo Vecchio and Loggia dei Lanzi
Sassetti Chapel, Santa Trinita, Florence

3 *David seen from back*, after Michelangelo, 1504-8
Raphael. Pen & brown ink on black chalk outline
39.3 × 21.9 cm
British Museum, London

I n 1501 Michelangelo was back in Florence where he was entrusted with a block of marble on which Agostino di Duccio had started to work nearly forty years earlier, in 1463. Michelangelo had long had his eye on this giant block which belonged to the Cathedral's Office of Works: according to Vasari, he suggested his own name when the Cathedral authorities were looking for someone to finish the statue. Piero Soderini, elected Gonfalonier of the republic of Florence for life (in fact from 1502 until the return of the Medici in 1512), followed the progress of work closely. The sculpture, completed in April 1504, was placed in front of the Palazzo della Signoria instead of Donatello's *Judith*. The consummate skill with which Michelangelo reworked the block of marble and extracted from it the masterpiece we can now see in the Accademia, won the admiration of the Florentines. In representing *David* Michelangelo returned to the *contrapposto* beloved of antiquity (in which one part of the body is twisted in the opposite direction from that of the other), but he softened the musculature so that David appears relaxed, even as one senses him poised to turn with his sling. The contrast between the calm right side, which is under divine protection, and the vulnerable left side, which is exposed to the forces of evil, corresponds to the moral distinction current in the Middle Ages and has often been observed (Tolnay). Michelangelo makes an innovation by choosing not to represent David as a victor, but to make him a symbol of *fortezza* (strength) and of *l'ira* (anger), regarded as civic virtues in Florence.

Hercules and Cacus

Some years later, after 1508, the Florentine republic commissioned Michelangelo to sculpt a *Hercules and Antaeus* to form a pair with *David* in front of the main entrance of the Palazzo della Signoria. Since the Middle Ages Hercules had effectively been considered the patron saint of Florence and defender of liberty. All that remains of this commission is a few drawings and a clay model in broken condition apparently representing *Hercules and Cacus*. The sculpture was to be in marble, the only material worthy of sculpture in Michelangelo's eyes. 'The best of artists hath no thought to show which the rough stone in its superfluous shell doth not include; to break the marble spell is all the hand that serves the brain can do,' he wrote in one of his sonnets. His definition of sculpture itself is found in a letter to Varchi in 1549: 'By sculpture I mean what one makes by dint of removal because what is made by dint of addi-

'By sculpture I mean what one makes by dint of removal because what is made by dint of addition is akin to painting.'

1

In December 1494 a Great Council was established in Florence on the precedent set by Venice, Savonarola the supposed founder. Denouncing luxury and the corruption of morals, he exercised a form of moral dictatorship, burning all that did not conform to his ideal of austerity and simplicity, books and works of art first and foremost. Excommunicated by Alexander VI, he was arrested and condemned to the stake in May 1498.

2

Ghirlandaio painted the Piazza Santa Trinita as it was in 1485 with the utmost precision, leaving us another topographical view of Florence. On the left is the Palazzo Spini and at the end the Ponte Santa Trinita. The little stone benches along the length of the palazzo served as places for people to meet and chat.

tion is akin to painting.' *Hercules and Cacus* gives us an insight into Michelangelo's working methods. He first made various studies, in the form of drawings or rough clay models, then began to sculpt in marble as soon as he had visualised his idea. The theories of proportion developed by Alberti, Leonardo and Dürer were of little interest to him. His own opinion was that one cannot 'lay down fixed rules and create human forms with the regularity of posts' (Condivi).

3
This sculpture was to have been carved from a monumental block of marble 5 metres high. However the model, belatedly executed (*c.* 1528), proved to be the last stage of Michelangelo's project. It was Bandinelli who eventually produced a *Hercules and Cacus* from the block of marble. This statue now stands in front of the Palazzo della Signoria.

1 *Martyrdom of Savonarola, c.* 1500. Anonymous
Museo di San Marco, Florence

2 *Miracle of the Child* (detail of Palazzo Spini and Ponte Santa Trinita), before 1485. D. Ghirlandaio
Fresco
Sassetti Chapel, Santa Trinita, Florence

3 *Hercules and Cacus, c.* 1528
Clay, H: 41 cm
Casa Buonarroti, Florence

The Bruges Madonna

The public exhibition in Florence in spring 1501 of a cartoon by Leonardo da Vinci for *Saint Anne and Saint John the Baptist* coincided with the return of Michelangelo. The latter, fascinated by the sinuous composition of the entwined bodies in Leonardo's picture made a drawing after it (now in the Ashmolean Museum, Oxford), showing his admiration for the Florentine painter, his contemporary. Echoes of this work recur in the *Bruges Madonna*, started in 1501 and finished probably before 1504.

The Madonna, portrayed from the front, assumes the pose of the Virgin in the *Pietà*, which would seem to confirm that this work was begun not long after the latter was completed. We find here none of Leonardo's gracious inclinations of the head or mysteriously suggested smiles. In the frowning eyebrows, the tight mouth, the slight tilting of the head, the Madonna's face conveys an acceptance of divine destiny. The child is properly presented as a child: chubby and playful, he seems on the point of getting down from the pedestal, gripping his mother's hand and thigh. Yet one senses no closeness between the Virgin and her Son. Stiff and distant, she seems locked in solitude. The child, standing, caught between her legs, is an iconographic innovation. This was an image remembered by Raphael who represented the young Jesus thus in a number of compositions. The monumentality of the *Bruges Madonna* also had an influence on his later works.

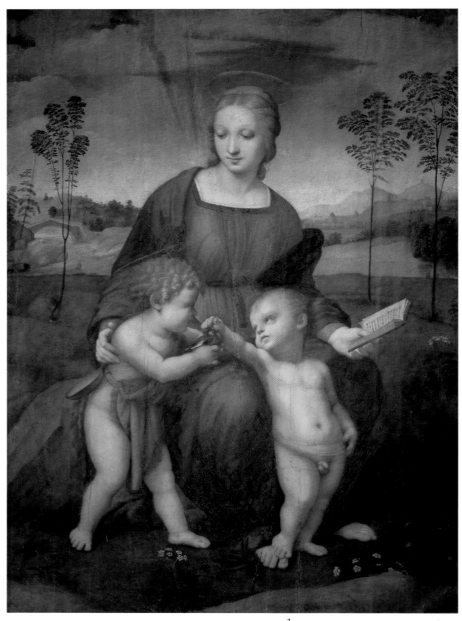

1
The Madonna with the Goldfinch was painted by Raphael in 1506-7 in Florence. The pyramidal structure is owed to Leonardo, while the upright stance of the little Jesus between his mother's legs harks back to the *Bruges Madonna*. The gentleness of the countenance evokes the faces of Leonardo.

1 *The Madonna with the Goldfinch, c.* 1506. Raphael
Oil on canvas, 107 × 77.2 cm
Uffizi, Florence

2 *Virgin and Child with Saint Anne and Saint John the Baptist, c.* 1498. Leonardo da Vinci
Cartoon, charcoal touched up with white,
141.5 × 104.6 cm
National Gallery, London

3 *Bruges Madonna, c.* 1504
Marble, H: 128 cm with base
Notre-Dame, Bruges

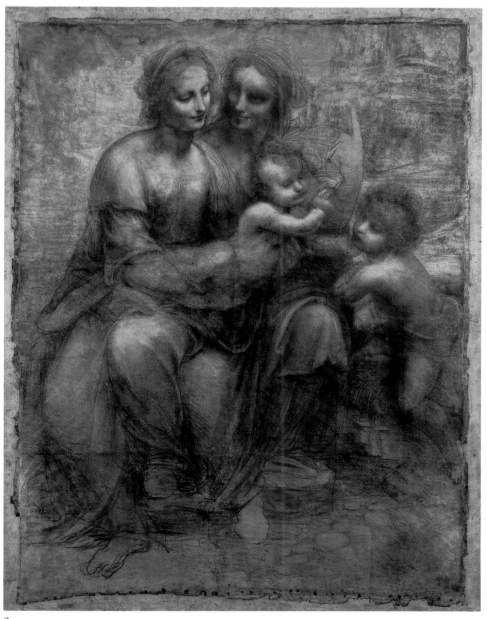

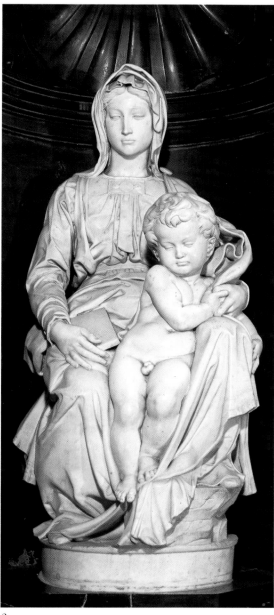

2
This cartoon is one of the few
Leonardo did for his principal
works to have survived. The
unfinished painted composition is
now in the Louvre. The cartoon,
made shortly before 1500, offers a
new definition of forms and the
interpenetration of their volumes.
The drawing – so important in
Florence – that defines the
contours is softened by a diffuse
light.

3
In style and technique the Virgin
approximates closely to the Virgin
of the *Pietà*. Michelangelo
reworks Leonardo's motif in the
figure of the infant Jesus standing
between his mother's knees, a
pose that departs from tradition.

The Sculpted Tondi

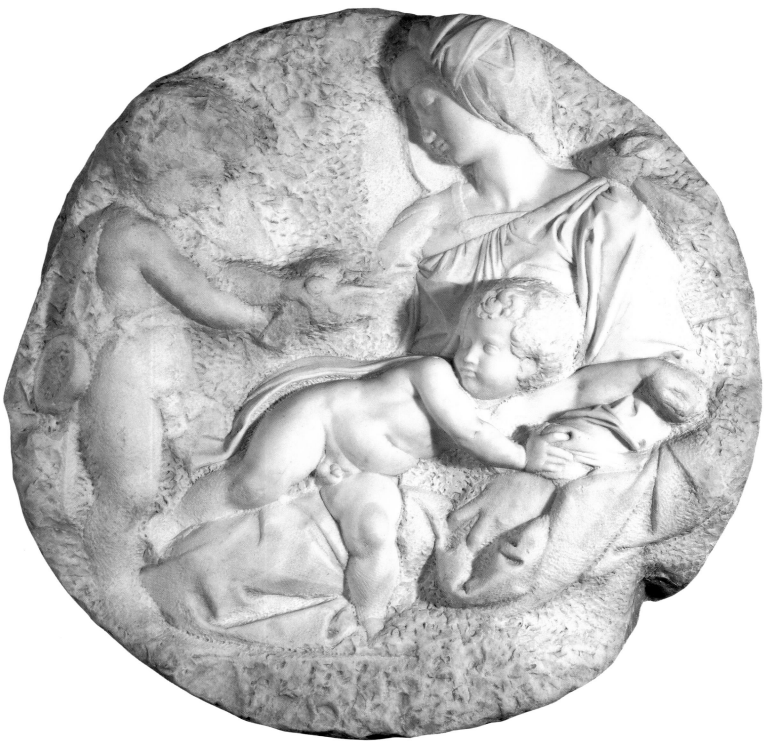

*'He embarked on two marble tondi
which he did not finish, one for Taddeo Taddei,
which remains in his possession, and the other
for Bartolommeo Pitti, which his brother Miniato Pitti
of Monte Oliveto, the learned cosmographer and lover
of painting, gave to his great friend Luigi Guicciardini.
These works were judged remarkable.'* (Vasari)

1
The *Taddei tondo* adopts as its
motif the little Saint John offering
a bird, probably a goldfinch, to
the infant Jesus. The latter, taking
fright, seeks refuge in his mother's
arms. His movement evokes that
of the children on the ancient
sarcophagi of Medea. This work is
more fully worked out than the
Pitti tondo. Drawings by Raphael
in the Uffizi and the *Bridgewater
Madonna* in the National Gallery
of Scotland, Edinburgh, show that
he must have studied the
horizontal composition of this
Madonna and Child.

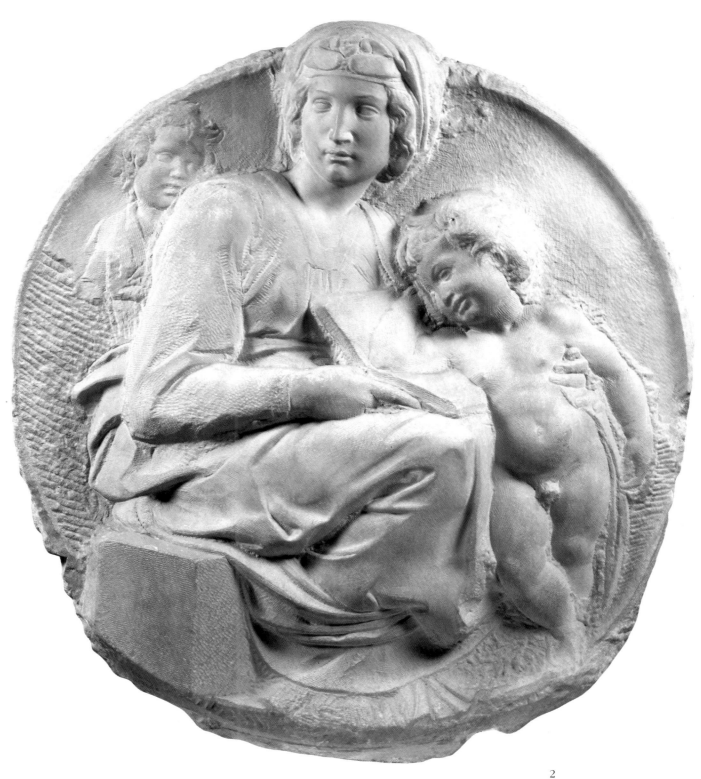

1 *Madonna and Child* (tondo for Taddeo Taddei),
c. 1503-6. Bas-relief in marble
Diam: 109 cm, 104 × 106.5 cm
Royal Academy of Arts, London

2 *Madonna and Child with the Infant Saint John*
(tondo for B. Pitti). *c.* 1504-5
Bas-relief in marble. Diam: 85.5 × 82 cm
Bargello, Florence

2
The Virgin, seated on a block,
turns her head as she looks into
the distance. What does she see?
The prophetic character of her
gaze is symbolised by the cherub
on her forehead signifying 'the gift
of superior understanding'. She
seems to be protecting the infant
Jesus whom she covers with a
cloth. The child's pose is inspired
by that of the spirits of mourning
who figure on sarcophagi. In the
little Saint John, only the face is
sculpted. The tondo seems the
perfect form for this composition.

51

The commissioning of a tondo by Agnolo Doni was recorded by Vasari: 'His friend the Florentine Agnolo Doni, a great lover of beautiful objects both antique and modern, wished to have a piece of work by Michelangelo who undertook to paint a tondo of the Madonna.' The carved frame, made in the workshop of the Del Tasso family around the years 1506-8, bears the arms of Maddalena Strozzi. Produced for the wedding of Agnolo and Maddalena, the tondo – a form characteristic of the Renaissance – is the only known and authenticated painting by Michelangelo. Agnolo Doni was one of the foremost patrons of the arts in early sixteenth-century Florence. He commissioned work from Raphael, Fra Bartolommeo and Michelangelo, as well as collecting antiques and precious stones. Many different interpretations have been advanced to explain this enigmatic and learned painting. The Virgin, more monumental than in the *Bruges Madonna*, heralds the Sibyls in stature and scarcely accords to the canons of classicism. The infant Jesus, resting on the shoulders of his mother who holds him up to Joseph, corresponds in symbolism to the victory of a new principle over an old principle. Christ no longer appears as a playful little child, but sports on his forehead the ribbon worn by victorious athletes (Tolnay). In the background, two groups of *ignudi* are an allusion to the world before the law of Moses, while the little Saint John belongs to the Old Testament, but turns towards the Holy Family who represent the moment of the Incarnation. The cool, acid colours are applied with scarcely any chiaroscuro leading the way to the flat spreads of colour in the work of Pontormo, Rosso and Bronzino.

'I say that painting seems to me the more perfect the closer it draws to sculptural relief, and sculptural relief the more imperfect the closer it draws to painting. I am used to consider sculpture as the blazing glory of painting and to think that there is as much difference between them as between the sun and the moon.'
(*Letter from Rome to Benedetto Varchi in 1546*)

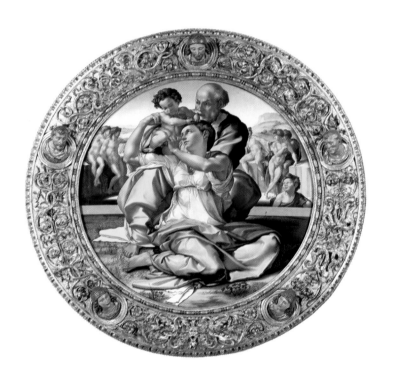

1 *Portrait of Agnolo Doni. c.* 1506-7. Raphael
Oil on panel, 65 × 45.7 cm
Galleria Palatina, Florence

2 *Portrait of Maddalena Doni, c.* 1506-7, Raphael
Oil on panel, 65 × 45.8 cm
Galleria Palatina, Florence

3 *The Holy Family with Saint John the Baptist*
(*Doni tondo*), 1504
Tempera on circular panel. Diam: 91 × 80 cm
Uffizi, Florence

4 *The Holy Family with Saint John the Baptist*
(detail of Virgin's dress)

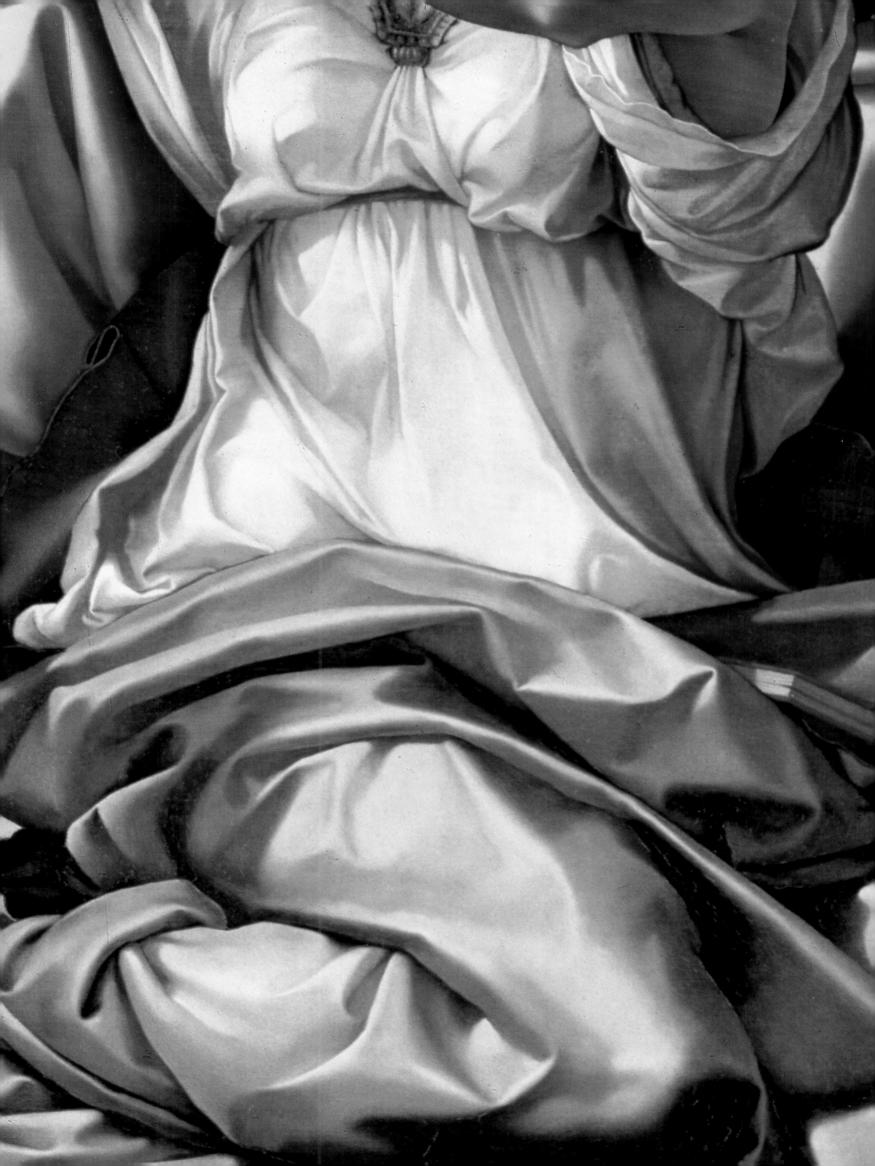

Decoration of the Palazzo Vecchio

Before the end of 1503, Piero Soderini decided to commission wall paintings of Florentine victories to decorate the Great Council chamber in the Palazzo Vecchio. Leonardo da Vinci was accordingly asked to paint the battle of Anghiari on one of the walls, representing a Florentine victory over the Milanese. But it was Michelangelo, whose reputation in Florence was now soaring, whom Soderini commissioned to paint a fresco of the Pisan war, or rather the victory of the Florentines over the Pisan army at Cascina in 1364. In contrast to Leonardo, Michelangelo gave predominance to the incidents preceding the battle rather than to the battle itself. While the soldiers were bathing in the river because of the heat, the alarm was raised: the enemy was about to attack. Filippo Villani described the incident in his *Chronicle*: Manno Donati appeared amidst his companions crying 'siamo perduti' (we are lost). Michelangelo started to work on the cartoon from December 1504 and modified it again after his return from Rome in 1506. Leonardo had stopped work in May 1506, having painted on the wall the celebrated episode of the seizing of the standard. The famous cartoons by the two artists were dismembered, and then lost. The scenes begun on the walls were overlaid in 1557 by Vasari's frescos. Only copies, partial in the case of Leonardo, remain to give us an idea of the original compositions. Aristotile da Sangallo's copy allows us to visualise the description given by Vasari: 'Soldiers came out of the water to dress themselves and the artist's wonderful representation shows some buckling their breast-plates, many donning their gear ... There was an elderly man wearing an ivy crown on his head for shade; sitting down to draw on his breeches, he could not manage because of his wet legs; hearing the noise of the soldiers, the cries, the beating of drums, he pulled hard and hurriedly at one leg.'

1
On Vasari's instigation, Aristotile painted a copy of part of the cartoon of the *Battle of Cascina*. The scene gave Michelangelo yet another pretext for representing the naked body in movement: 'one saw there muscles and nerves in their entirety ... incredible positions: standing, kneeling, bending, lying, getting up, with skilful foreshortening'. (Vasari)

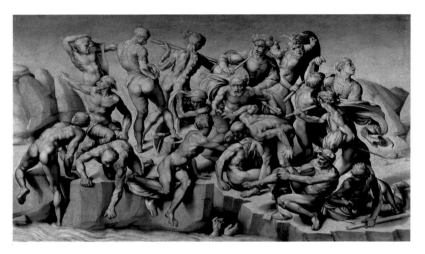

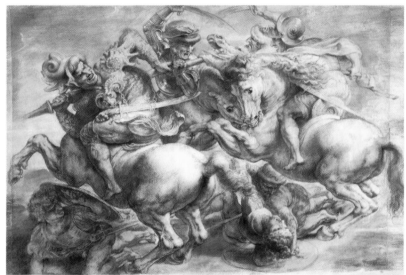

2
Rubens doubtless realised this copy from a 1558 engraving by L. Zacchia. There is no drawing of the whole cartoon in existence, nor confirmed sources for the lateral episodes. Apart from the spirited central section, the composition as a whole has been lost with the cartoon.

1 *Battle of Cascina*, after Michelangelo, 1542?
Aristotile da Sangallo
Oil on panel, 76.5 × 130 cm
Holkham Hall, Norfolk

2 *Fight for the Standard*,
after Leonardo da Vinci. Rubens
45.2 × 63.7 cm
Musée du Louvre, cabinet des dessins, Paris (RMN)

3 *Male Nude and two studies of details*, c. 1504
Black chalk, light touches of white, 40.5 × 22.6 cm
Teylers Museum, Haarlem

3
This life drawing does not exactly correspond to the figure ultimately executed in the cartoon: Michelangelo modified the position of the arms. His drawings were done prior to embarking on the cartoon, to determine the different attitudes of the soldiers emerging from the water.

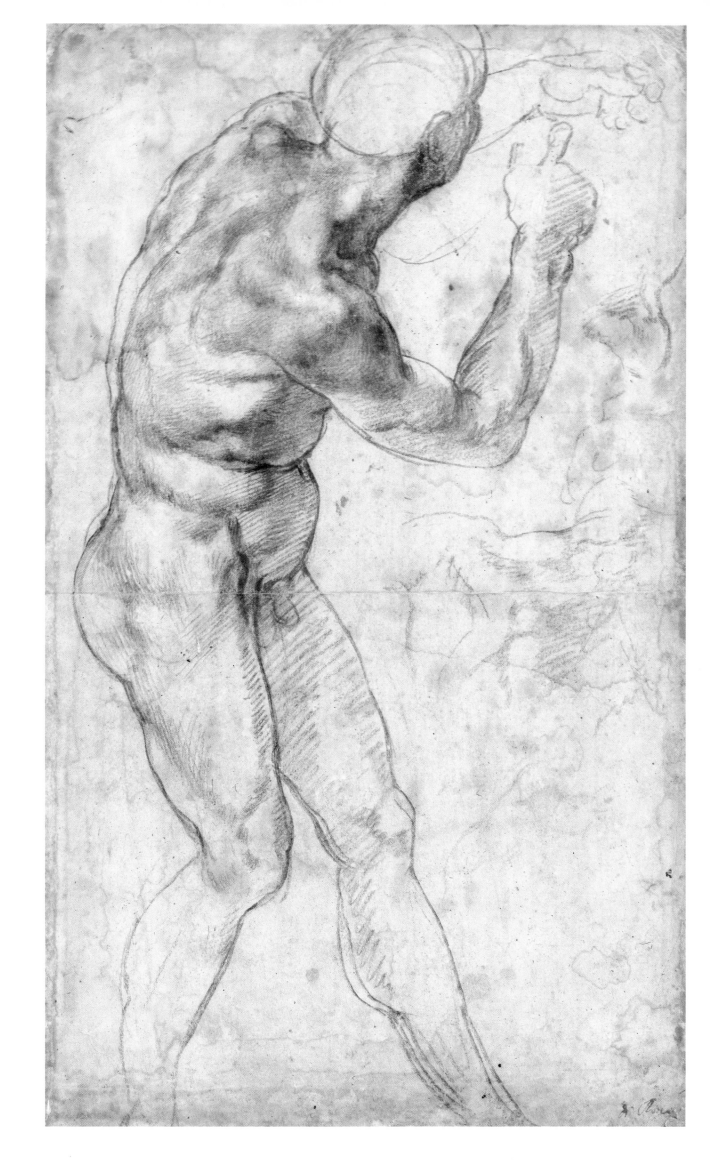

Sistine Chapel in the Vatican

'**A**t the age of about twenty-nine, Michelangelo was greatly favoured by Julius II who asked him to design a tomb for him,' wrote Vasari. This was the first commission to be given to him by the Pope, a great patron who gathered round him in Rome the best artists of the period: Raphael worked on the Stanze at the same time as Michelangelo worked on the Sistine. In March 1505, Michelangelo embarked on the mausoleum, a project which the Pope then abandoned. Instead he asked him to decorate the vaulted ceiling of the Sistine Chapel with frescos. Michelangelo's quarrel with the Pope, his flight to Florence and the two men's reconciliation culminated in a contract for the Sistine vault dated 10 May 1508. Michelangelo initially set to work on the ceiling against his own wishes. The first project was to feature the figures of the twelve Apostles and geometric decorations on the centre of the vault. With the Pope's agreement Michelangelo changed the scheme: the lunettes, spandrels and double spandrels were also to be covered with frescos and linked to the Quattrocento decoration painted on the walls. The Sistine Chapel had been built by Sixtus IV between 1477 and 1481 and dedicated to the Assumption. On the wall later covered by *The Last Judgement*, there was an *Assumption* by Perugino who had also painted two other frescos, *Moses saved from the waters* and *The Nativity of Christ*, and pictures of the first popes on the upper level. Michelangelo was working within an overall iconographic scheme developed on the walls up to the end of the fifteenth century. Apart from a vault featuring a sky scattered with stars, the walls were covered with scenes from the Old and New Testament painted by Perugino, Botticelli, Ghirlandaio, Rosselli, Signorelli, and others. The new decoration of the vault was to cover 1000 square metres and comprise some 300 figures. For the artist this meant unremitting and solitary work which was to occupy him from 1508 to 1512.

2 *Libyan Sibyl* (detail), 1511
Fresco, 395 × 380 cm
Sistine ceiling, Vatican

1
Plan of the vault of the Sistine Chapel. The iconographic cycle began at the end of the chapel and finished above the entrance. Michelangelo started by painting the final scenes, however. The present commentary follows the order in which the artist worked rather than the chronological order according to *Genesis*. (The entrance is at the bottom of the plan.)

2
The *Libyan Sibyl* was in Vasari's eyes trying both 'to rise up and to close the book', while the modern interpretation is rather that she is trying to seize the book. To Tolnay, she represented 'the loss of the visionary faculty: resigned, she closes the great volume, while her genii abandon her'. This figure belongs to the final section of the vault and shows Michelangelo's masterly skill in the last stages of his monumental work. The play of fine hatching on the face is very characteristic of his painting at this point.

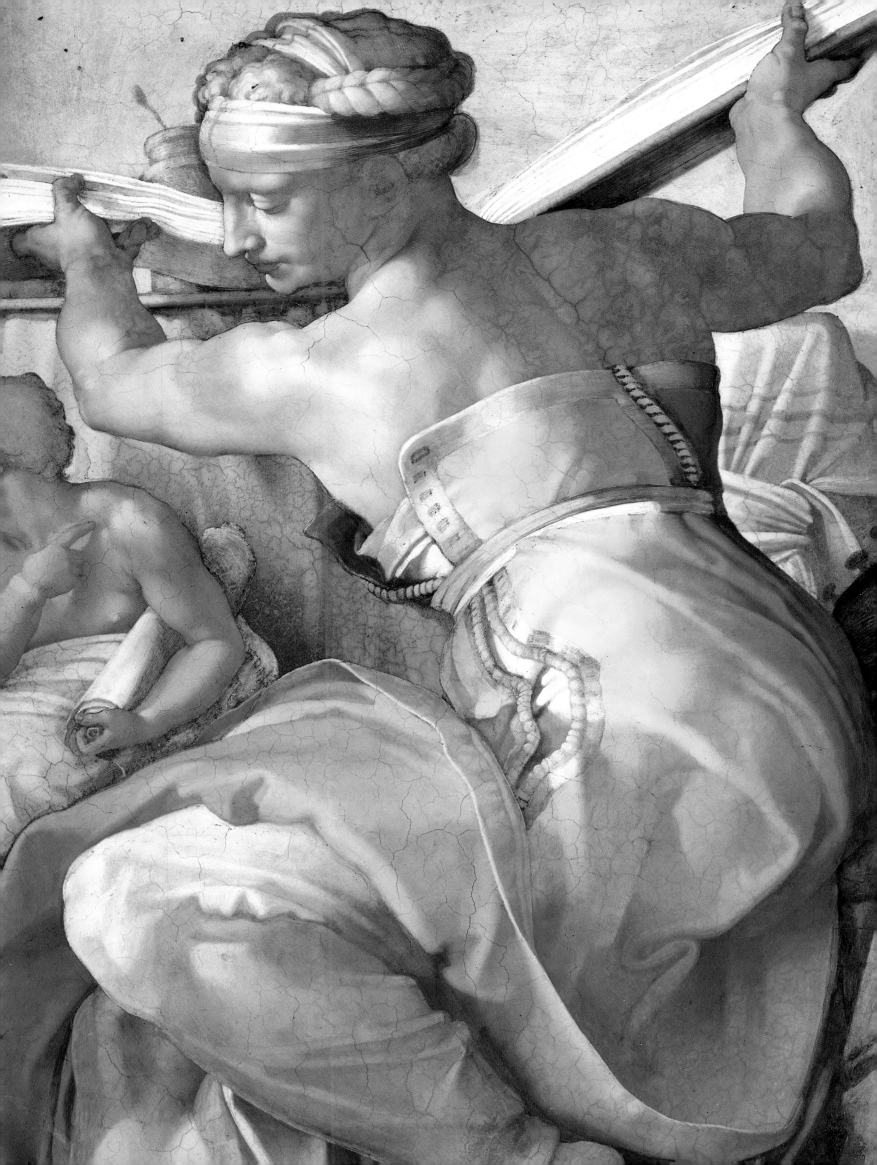

The decoration of the vault is arranged on three levels differentiated by a framework of pilasters and cornices. On the upper part of the walls, Michelangelo decorated the rounded sections over the windows – the lunettes – with images of Christ's ancestors, taken from the gospel of Saint Matthew. Above these one finds the draperies and the pendentives on which the Seers (Prophets

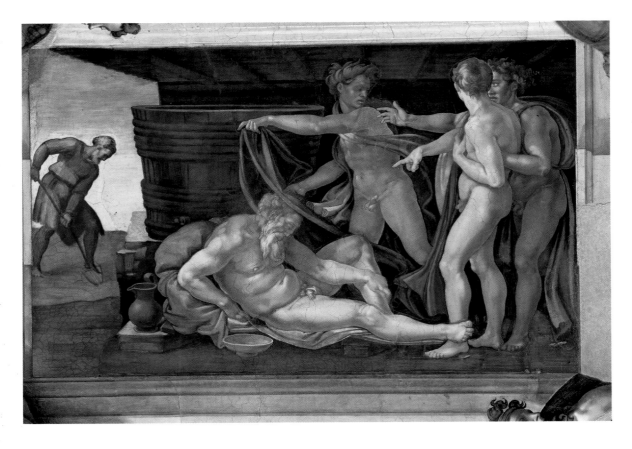

1
Noah, accompanied by his three sons whom the wrath of God has spared, plants the vine after the Flood and becomes drunk. While he sleeps Japheth, one of his sons, comes to cover his nakedness with his coat. In the foreground Ham makes fun of him, while Shem reproves him. The use of light lines or hatching to model the faces brings to mind the technique of distemper-painting.

and Sibyls) are represented. These figures surround the central part of the vault which is divided into nine rectangular panels featuring biblical scenes. Small panels alternate with large one. Each of the former is framed by four *ignudi*, the remaining empty space being occupied by *putti* (some holding up name-tablets); over the pendentives the artist has painted bronze-coloured nudes. The architectural framework, both actual and feigned, imposes a rhythm and order on the overall scheme, which is peopled with giant figures. The arrangement of the three zones described has a hierarchical significance. At the bottom, man is in a state of unconsciousness, still deprived of divine light. In the middle are the Seers whose supernatural powers give them an awareness of the divine; and finally we come to divine revelation and understanding, represented in the last panel by the cosmic figure of God dividing light from darkness.

'There is in Saint Peter's in Rome, fountain head and authority of the Church, a great ceiling on which Michelangelo has divinely portrayed how God first created the world; and he divided the painting into narratives, with many images of sibyls and figures who are ornamental and artistic in the highest degree.' (Francisco da Hollanda)

1 *Drunkenness of Noah*, 1509
Fresco, panel, Sistine ceiling, 170 × 260 cm

2 *Judith and Holofernes*, 1509
Fresco, pendentive, Sistine, 570 × 970 cm

2
The story of *Judith and Holofernes* comes from the Old Testament. Judith, a young widow from Bethulia, went with her servant to the camp of Holofernes, Nebuchadnezzar's general who was laying siege to her town. She seduced the general and made him drunk, then cut his throat. This act of hers gave courage to her fellow citizens who then succeeded in driving off their assailants.

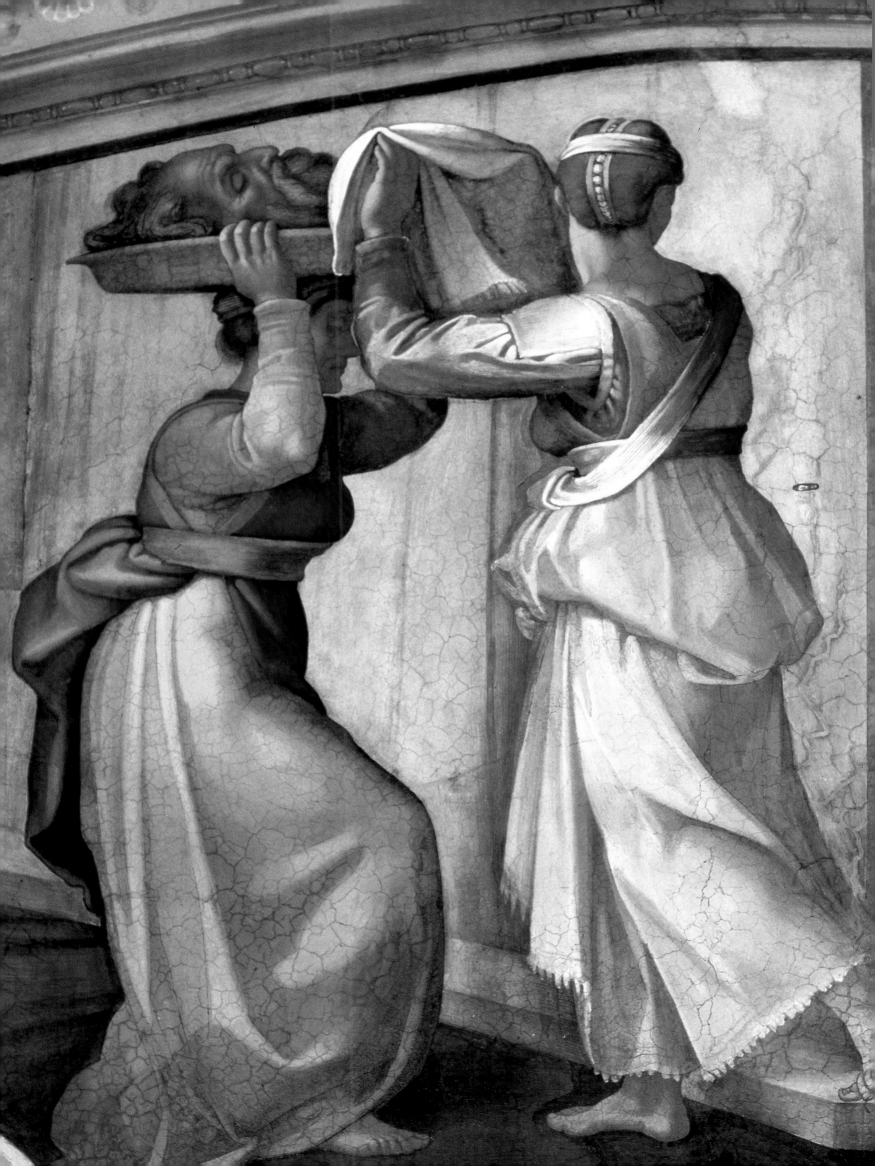

When Michelangelo came to paint the frescos on the vault of the Sistine, he faced a great many technical problems. First, he needed to work from a scaffolding which was not anchored to the vault itself, unlike that which the architect Bramante had had erected. This gave him the idea of 'getting support from props without touching the wall' (Vasari). Next, realising the magnitude of the task before him, he called on Florentine artists more experienced than himself in fresco techniques: Granacci, Giuliano Bugiardini, Jacopo di Sandro, the elder Indaco, Agnolo di Donnino and Aristotile were approached to help him execute the work. Fresco requires great technical mastery, a subject on which Vasari has left valuable information: 'it involves carrying out in a single day all the work programmed. . . . The paint is applied to lime that is still wet, without respite, until the section designated for that day is complete.' Furthermore, 'the effect produced by colours applied to a damp wall alters when they dry'. Vasari equally emphasises the fact that in fresco painting, unlike other techniques – oil, distemper – the work cannot be touched up, unless this is done dry (to darken it, for example). But while colours which dry at the same time as the base are indelible, those added after are not permanent: 'what has been painted in fresco remains and what has been reworked in a dry state can be wiped off with a wet sponge.'

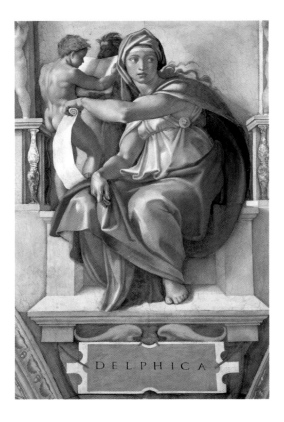

1/2
Blue poses a technical problem in fresco painting: it is achieved by applying smalt to a wet base. Furthermore, the colour operates differently to others: there is little vividness in the blue of this coat. This was one of the characteristics of Michelangelo's work as a fresco painter. The gold-leaf finish on the balusters on both sides of the Sibyl was another. This figure has not stood up well to periodical restoration over the ages. Stylistically, the *Delphic Sibyl* brings to mind the first Virgins sculpted by Michelangelo.

1 *Delphic Sibyl*, 1509
Fresco, Sistine ceiling, 350 × 380 cm

2 *Delphic Sibyl* (detail of head)

Following pages:
3 *Ignudi* (detail of pair above *Isaiah*), 1509
Fresco, Sistine ceiling, 190 × 395 cm

4 *Ignudi* (detail above *Erythraean Sibyl*), 1509
Fresco, Sistine ceiling, 190 × 390 cm

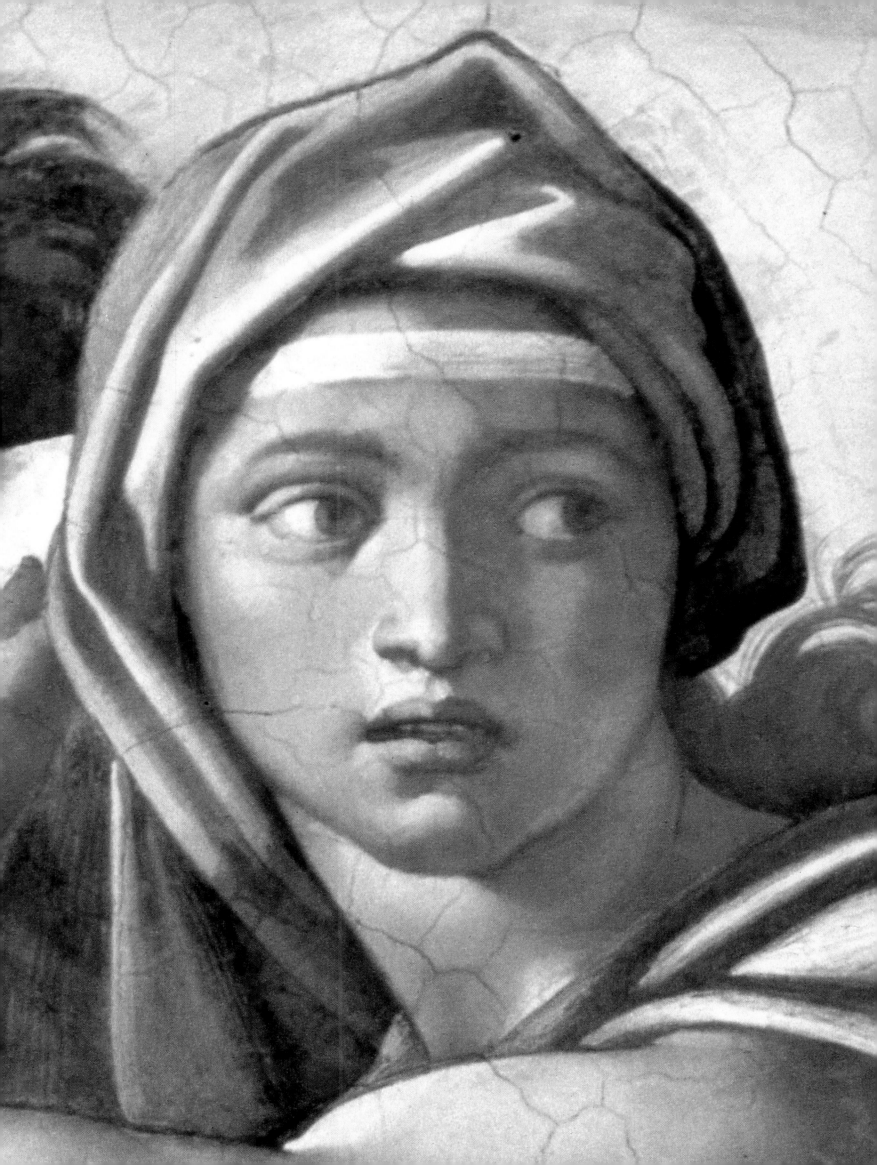

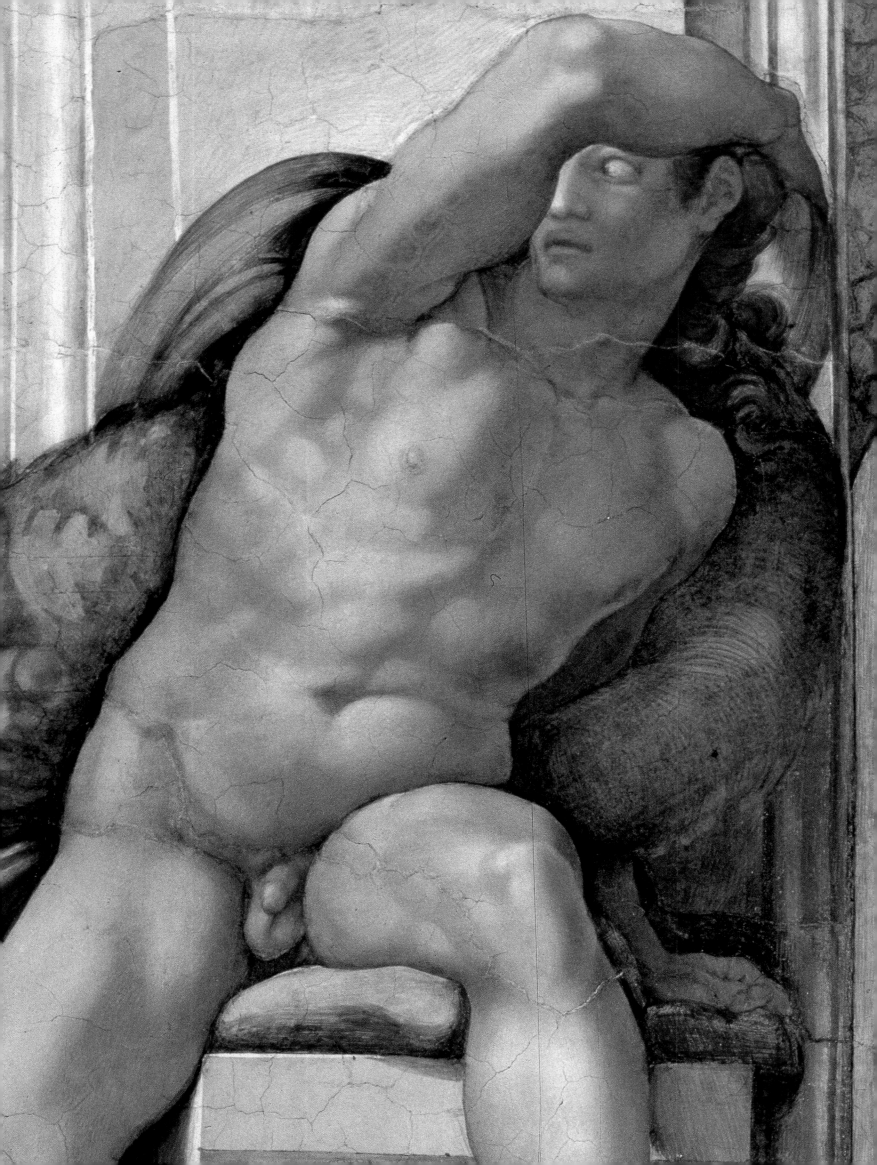

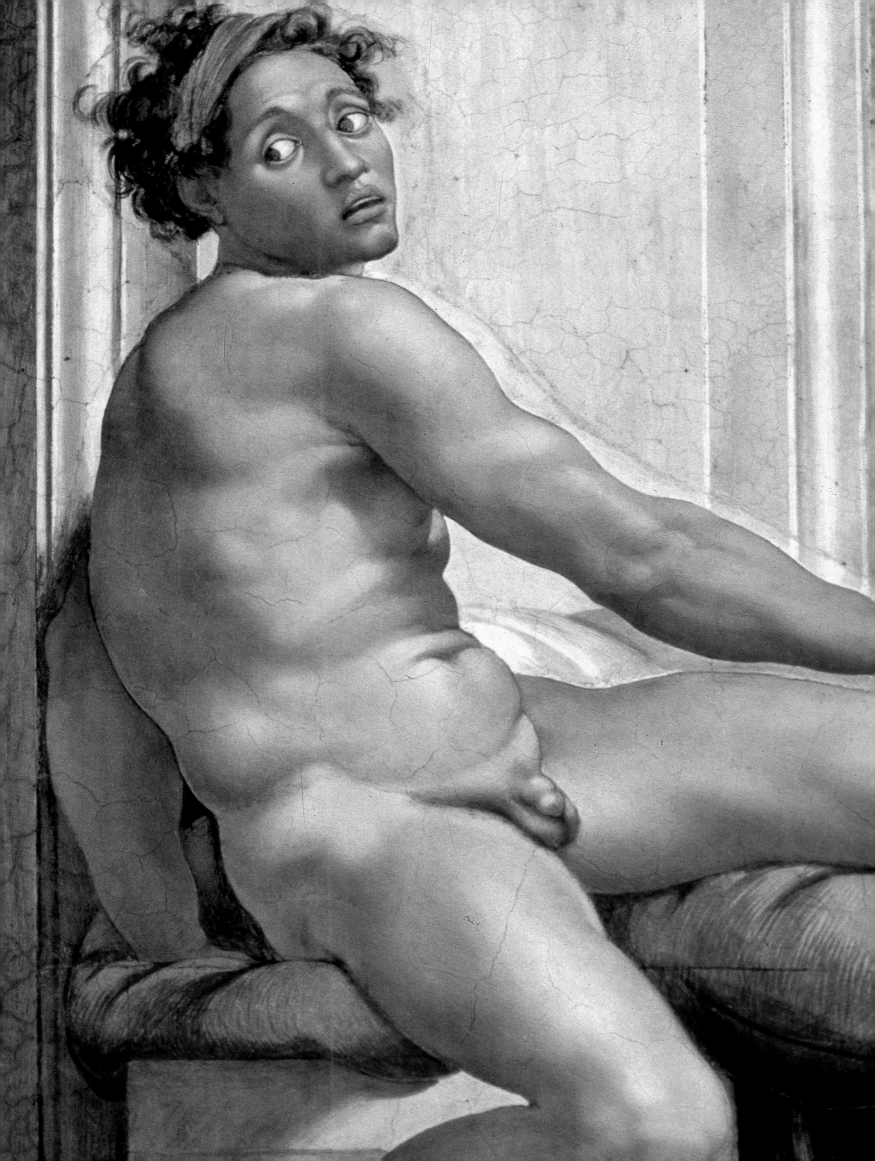

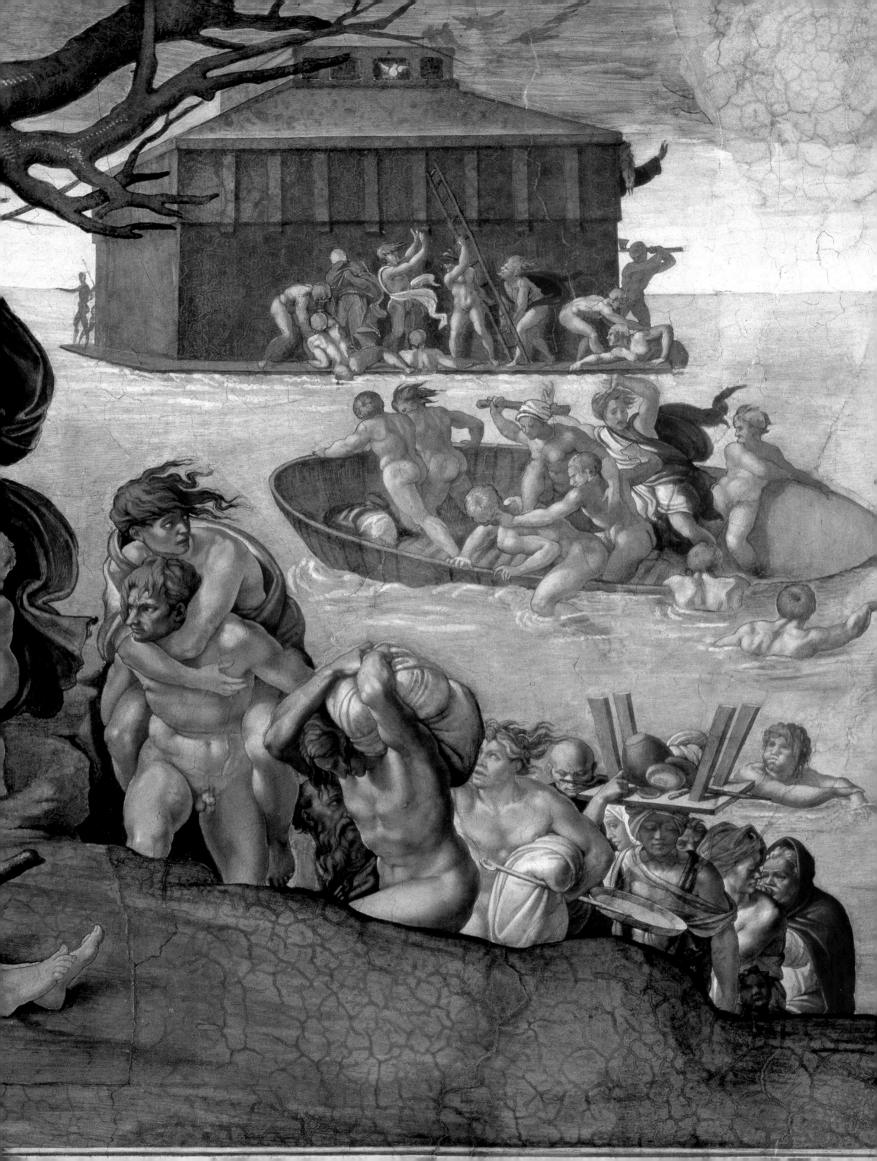

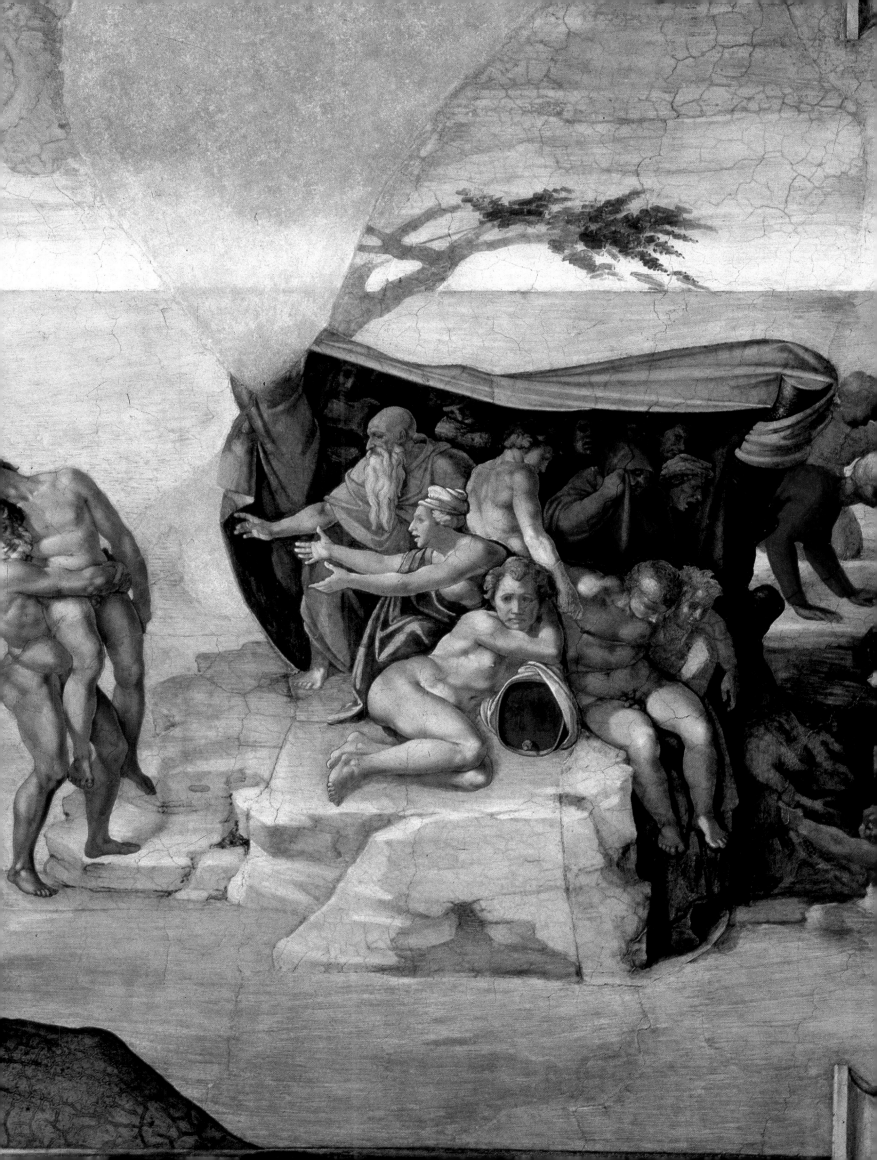

'There are acts of compassion: people pull each other to the top of a rock in order to escape. One clutches a half-dead man trying to rescue him; reality is no more explicit,' wrote Vasari. All the people are shown in a state of extreme and desperate agitation, for the wrath of God spared only the occupants of the Ark. The scene is charged with dramatic intensity the more powerful for the fact that the viewer knows the fatal outcome.

It seems that *The Deluge* was the first scene Michelangelo painted. His assistants contributed extensively to the work, particularly Granacci and Bugiardini in the case of the figures in the foreground and on the left. What is special about this scene is that it does not confine itself to the motif of the Ark: it is composed of different groups who are seeking to escape the cataclysm by climbing a rock, making for a boat, or for the Ark itself. As the waters rise the people, gripped by panic, 'try to save their lives by all possible means; their expressions convey that their very being is threatened by death, as well as a terrifying panic and fear of abandonment' (Vasari). This is yet another instance where Michelangelo chose to portray terror and anguish (as in the earlier *Battle of Cascina*), rather than simply the story of the Ark. According to Michelangelo's biographers, he decided early on to dispense with his assistants as their work did not meet with his approval. It is in fact likely that he retained some of them to prepare colours or paint secondary figures.

In the first section of the vault, Michelangelo encountered a new problem: according to Condivi, mould began to appear in *The Deluge* because the lime base had not dried sufficiently quickly. In desperation Michelangelo contemplated abandoning the project. He discussed the problem with the Pope who summoned the architect Giuliano da Sangallo to help find a solution. This skilful technician succeeded in getting rid of the mould.

1/2
This fresco has particularly suffered the ravages of time, specifically mould and an explosion in the Castel Sant' Angelo in 1797 which brought down part of the plaster above the tent. Today one can no longer see the thunderbolt, symbol of divine wrath, which originally crashed down on the tent; this detail, recorded by Condivi, is confirmed by a sixteenth-century copy.

1/2 and preceding pages:
The Deluge (detail), 1508-9
Fresco, panel, Sistine, 280 × 570 cm

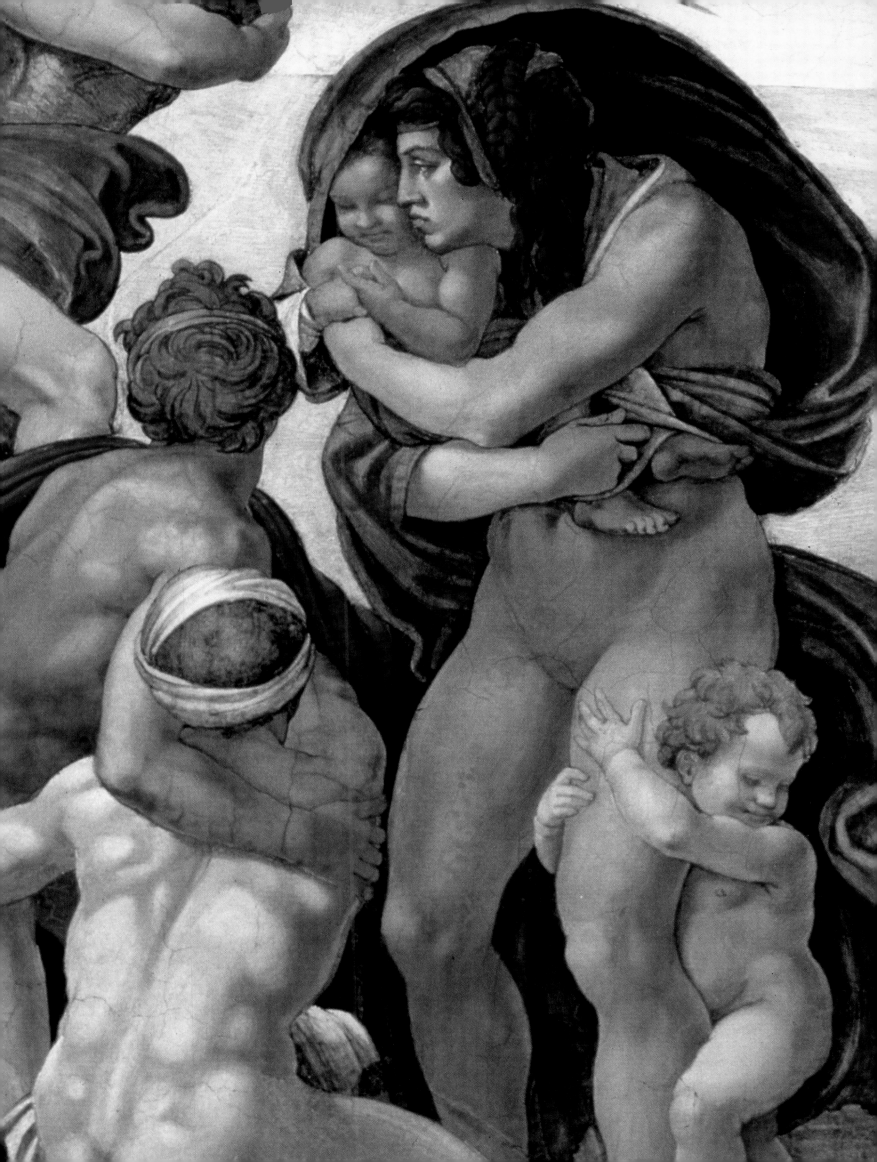

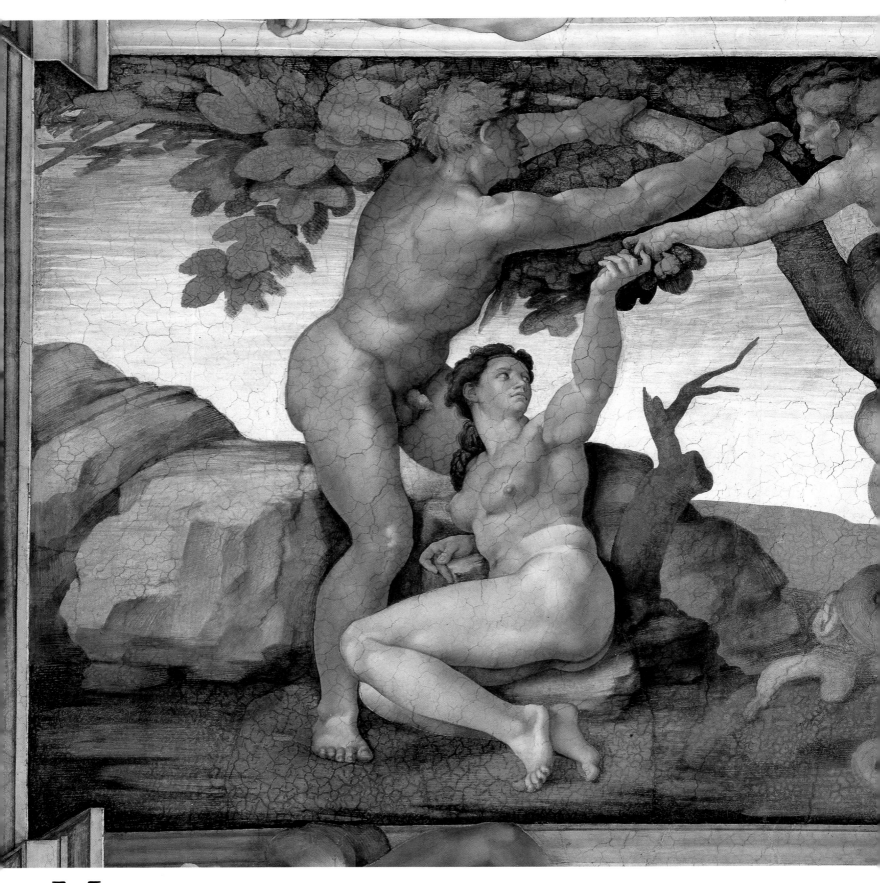

Michelangelo envisaged *The Fall and Expulsion* as two distinct stages separated symmetrically by the tree of knowledge. On the left is the temptation: here it is Adam who is seeking to pick the forbidden fruit. Eve, in a pose that was erotic in antiquity, waits impassively for the devil – symbolised by a woman's head – to give her the apple. On the right, Adam and Eve are driven from Paradise and a rocky and luxuriant vegetation is re-placed by a deserted landscape. Adam pro-tects himself from the divine wrath by holding his arms out behind him, as in frescos by Masaccio (Brancacci Chapel, Carmine, Florence) and the bas-relief by Jacopo della Quercia (San Petronio, Bologna). The heraldic acorns and leaves of Julius II over-hanging the scene of the expulsion appear to be a reference to the mission of salvation assumed by the Pope.

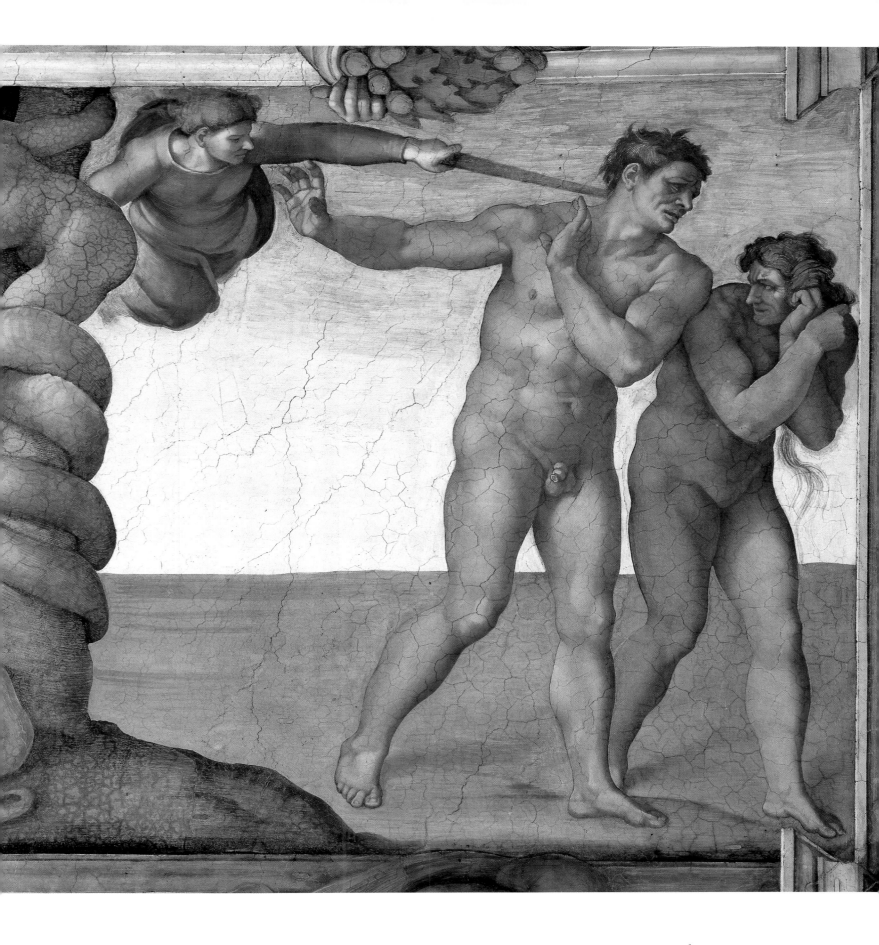

1 and preceding pages (detail):
The Fall and Expulsion, 1509-10
Fresco, panel, Sistine, 280 × 270 cm

1
The scene of *The Fall and Expulsion* was carried out in eight or nine days. It follows an arc running from left to right, starting at the sinuous and graceful body of Eve, passing through the siren-serpent, to close on the naked bodies of Adam and Eve driven from Paradise.

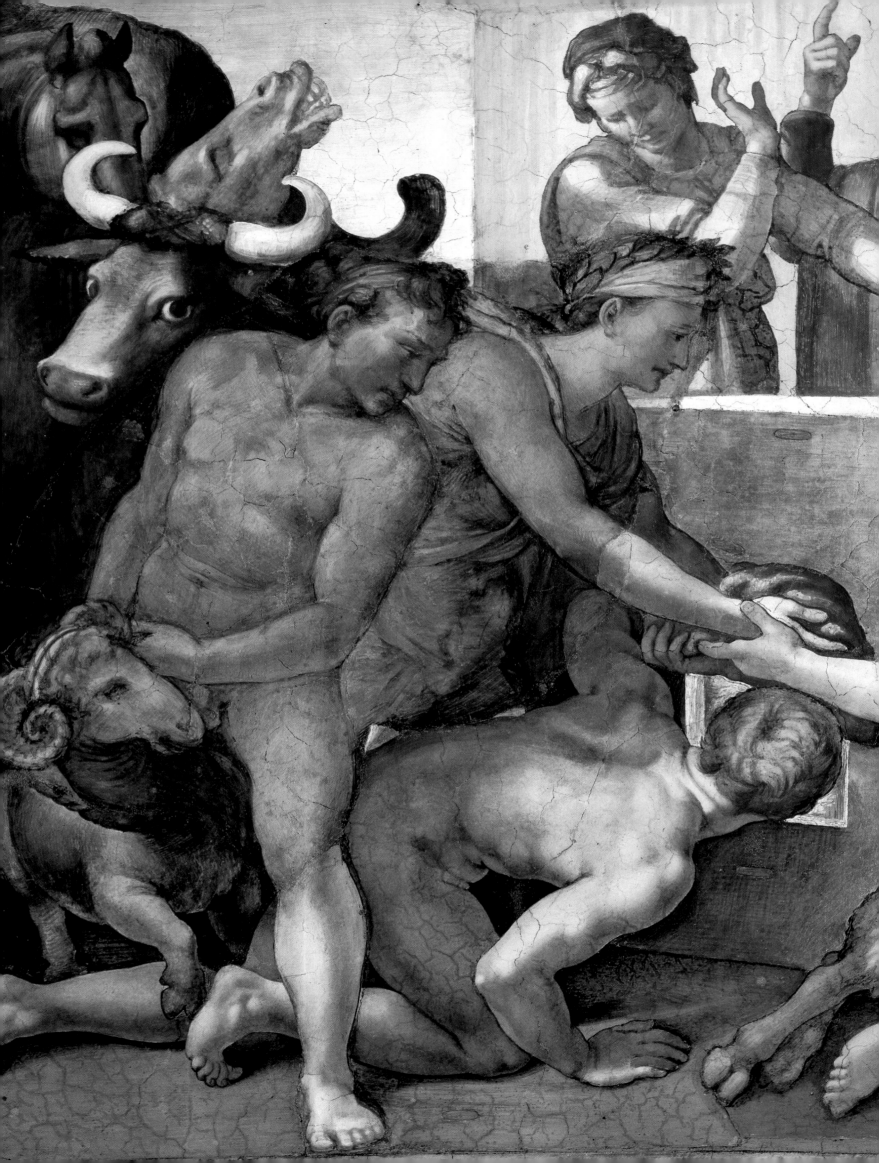

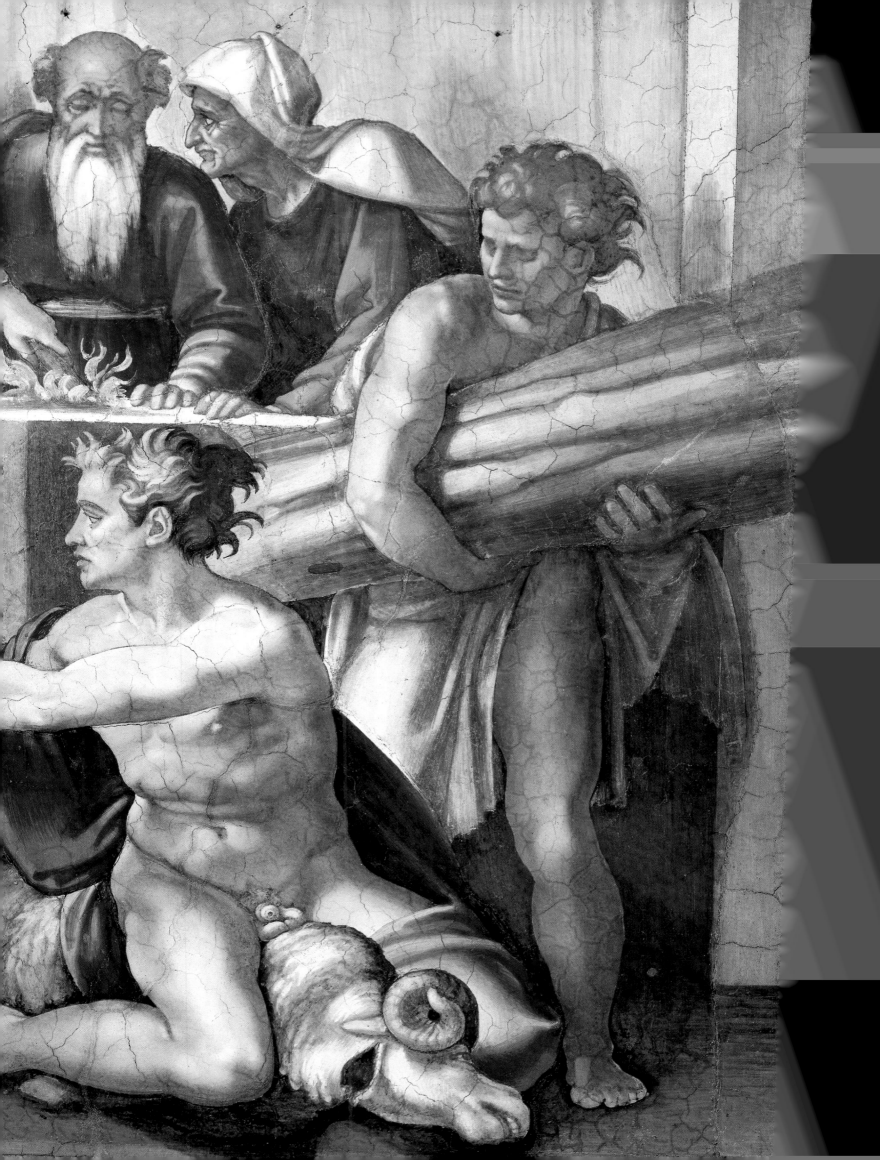

The year 1509 was a particularly difficult one for Michelangelo who faced an endless succession of new problems in mastering the techniques of fresco painting. Moreover the artist complained in writing to his father that the Pope was negligent in paying him: 'It is now a year since I received "a big sum" from the Pope. I do not ask him for anything because my work is not progressing enough to warrant payment . . . So I am uselessly wasting my time' (27 January 1509). Meanwhile the Pope, eager to observe the progress of the decoration of the vault, had no hesitation in personally climbing the scaffolding, which he repeated on several occasions. In the month of August 1510, work was interrupted for nearly a year because of lack of funds. Julius II was far from Rome, waging war against the French. The unveiling of the first part of the ceiling took place on 15 August 1511.

It was *The Creation of Eve* which inaugurated the second part of the vault: God draws Eve from Adam's side while the latter is sleeping. This scene is, from a chromatic point of view, one of the richest on the ceiling. The blue of the sky harmonises closely with the subtle rose-violet of the great coat worn by God the Father. The browns overlie each other, tone superimposed on tone, between the naked bodies in the foreground and the blue sky in the background.

Previous pages:
Noah's whole family is gathered round the altar on which the ram is to be sacrificed. One of his sons is carrying wood for the fire on the altar. The warm colours of Noah's and his wife's garments remind us that Michelangelo was a colourist despite the criticisms levelled at him in this respect.

Previous pages:
The Sacrifice of Noah, 1509
Fresco, 170 × 260 cm
Panel, Sistine ceiling, Vatican

1 *The Creation of Eve*, 1509-10
Fresco, 170 × 260 cm
Panel, Sistine ceiling, Vatican

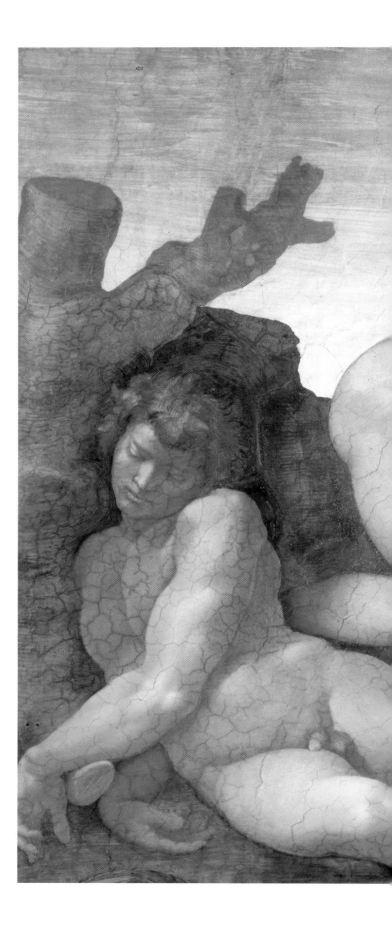

'I am dissatisfied . . . alone and penniless.'
(*Letter to his father, Feb.-Mar. 1509*)

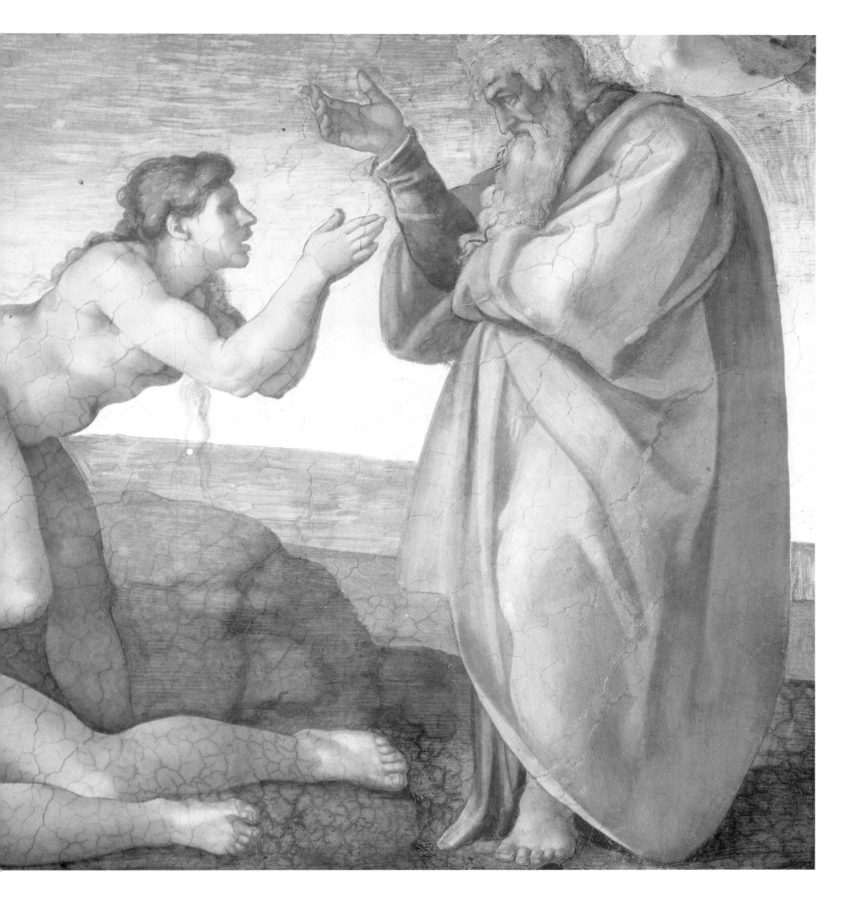

1
The massiveness of the figure of
God the Father harks back to
Masaccio and Giotto and the first
drawings done by the artist after
these masters. Michelangelo's style
in *The Creation of Eve* is still
imbued with the art of Della
Quercia. The figures are arranged
in a triangular composition and
occupy almost all the available
space.

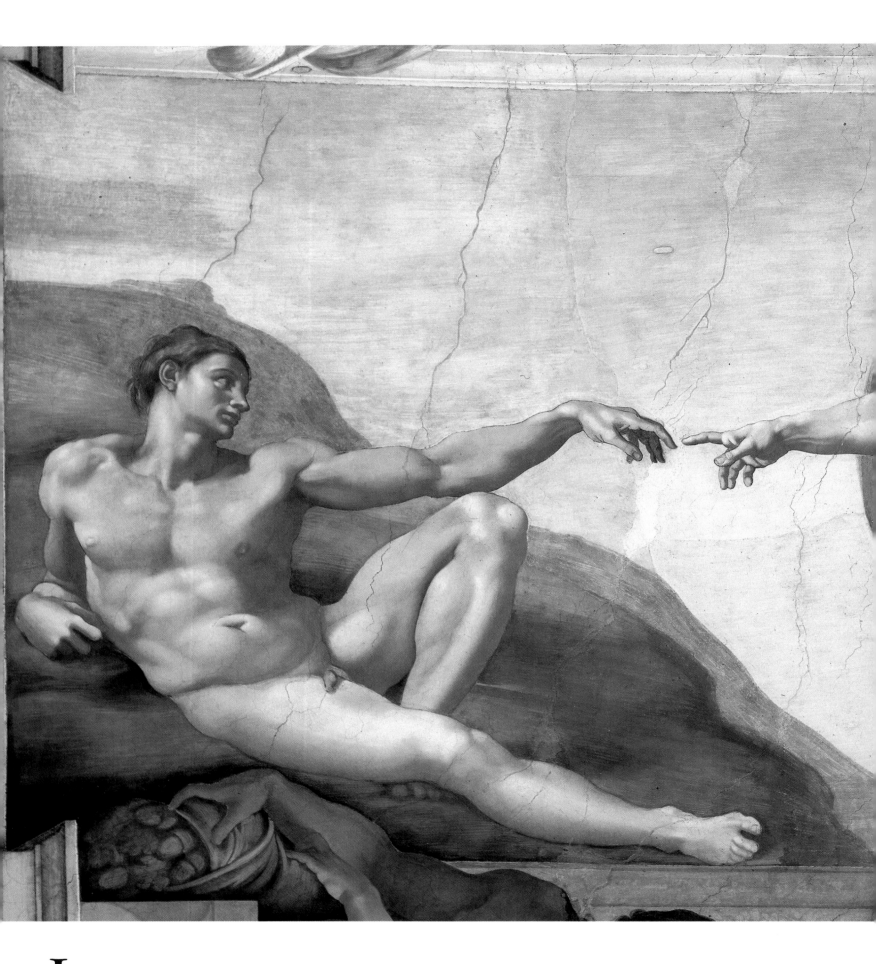

In his celebrated *The Creation of Adam* Michelangelo portrays 'God borne by a group of young and naked angels who seem to be carrying not one figure alone but the weight of the entire world, such is the effect they create of impressive majesty and dynamic movement; with one arm he encircles the *putti* as if seeking support while on the other side he offers his right hand to Adam, an Adam whose beauty, whose pose, whose appearance suggests a new work by his original creator rather than the brush of a great artist' (Vasari).

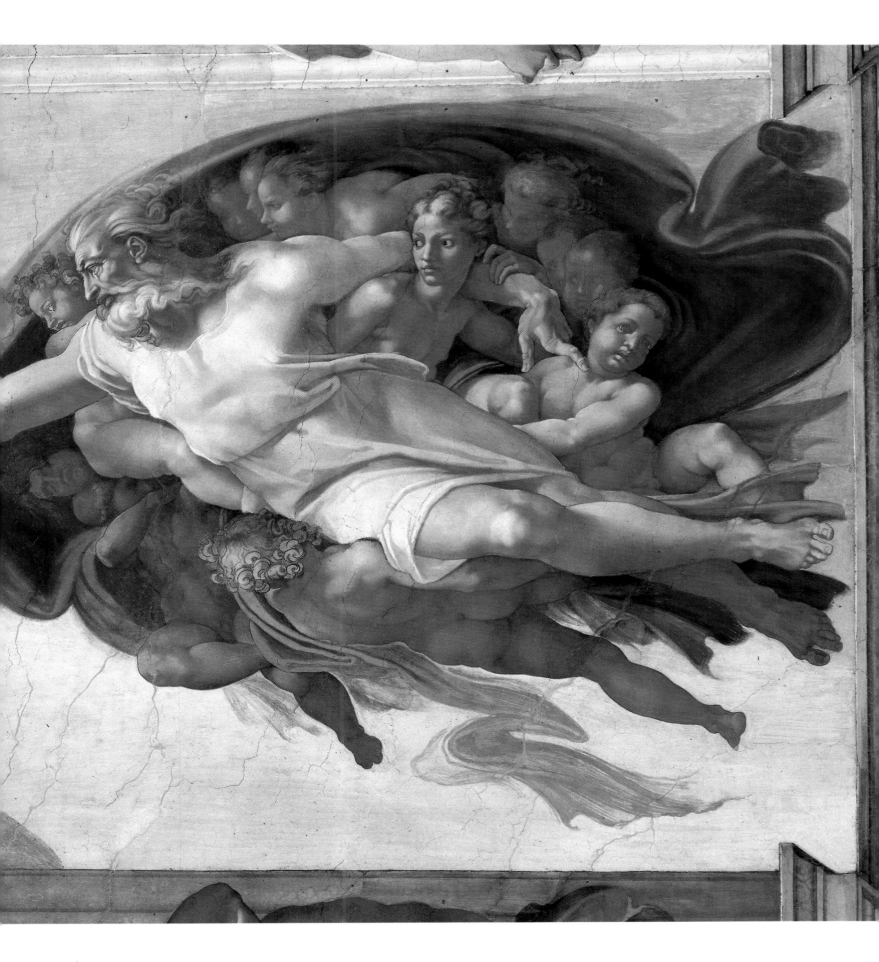

1

The fullness with which this scene is produced shows the extent to which Michelangelo has mastered the fresco technique. *The Creation of Adam*, notable in its play of hands brushing each other with pointed fingers, drew its inspiration from hymns in celebration of God 'lighting the light of the senses'.

1 *The Creation of Adam*, 1510
Fresco, 280 × 570 cm
Panel, Sistine ceiling, Vatican

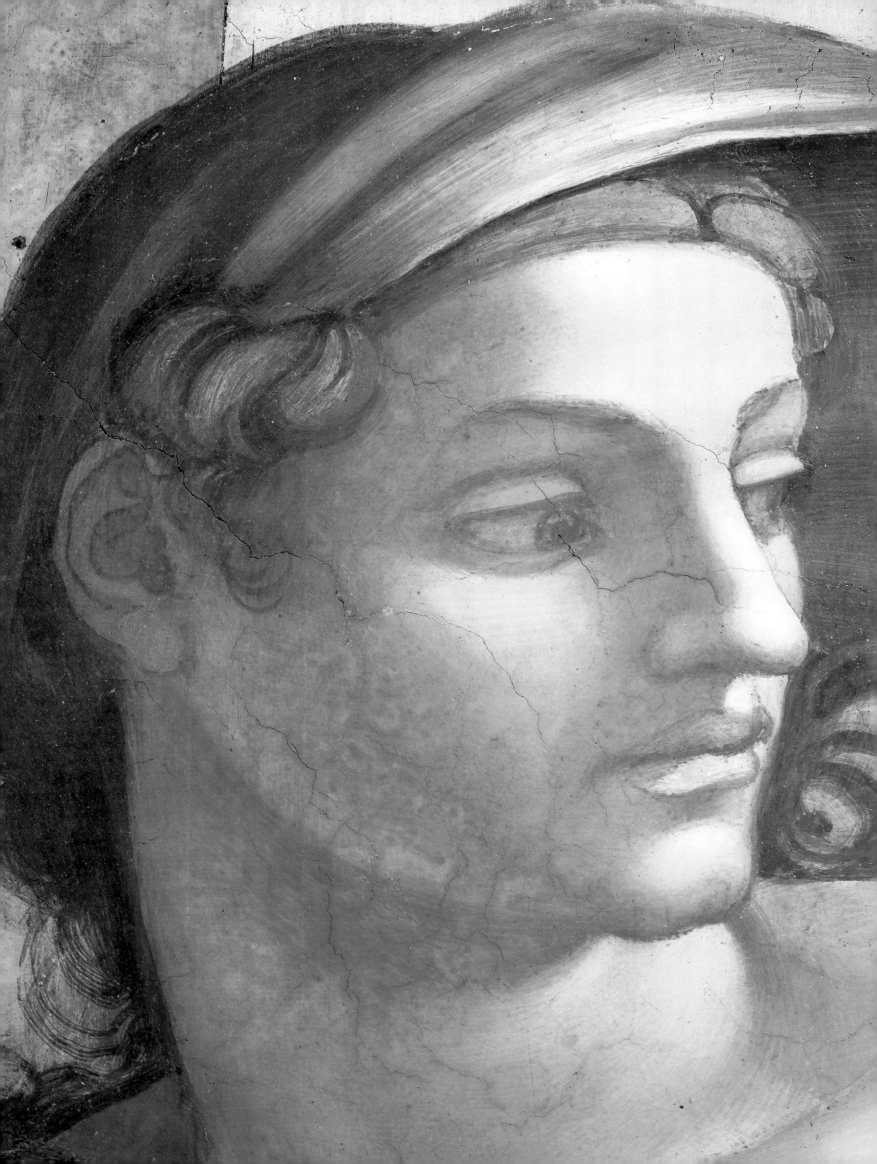

'The love he bears
not solely for human beauty
but for all beautiful things,
a beautiful horse,
a beautiful dog,
a beautiful landscape,
a beautiful plant,
a beautiful mountain,
a beautiful forest,
for all places
and all things beautiful and rare
of their kind.
Thus he gathers beauty
from nature, as the bee
gathers honey from flowers
to then make use of it
in his works.' (*Condivi*)

The figure of God is omnipresent in the second part of the vault, which is imbued with a dynamism not to be found in the scenes of the first part. The visitor, whose eyes first light on *The Drunkenness of Noah*, in other words on Man (over the door of entry), then moves towards God as the source of all things and above all of the human soil. The scene represented here, *God Separating Earth from Water*, is not subject to general unanimity; even Michelangelo's biographers advanced different interpretations: Vasari saw here the division of land and water, while Condivi spoke of the creation of fishes and birds.

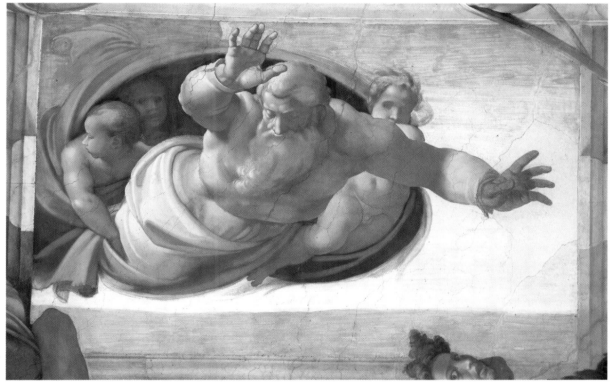

2
'In the following scene, *God Separating Earth from Water*, there are splendid figures and startling treasures, fittingly the work of Michelangelo's divine hands' (Vasari). God seems to be floating between sky and water, caught up in the whirlwind of his mantle.

1 *Ignudi* (detail of pair above *Persian Sibyl*), 1511
Fresco, 200 × 395 cm
Panel, Sistine ceiling, Vatican

2 *God Separating Earth from Water*, 1511
Fresco, 155 × 270 cm
Panel, Sistine ceiling, Vatican

1

The head of this *ignudo*, of a masterly freeness, is plunged in shade. The distraught profile is opposed in its expressiveness and movement to the calm and sensual countenance of the *ignudo* facing it and, in contrast, caught by the light (see page opposite). These two *ignudi* illustrate the artist's inventiveness in avoiding a monotonous repetition of images. Their different attitudes and expressions represent the full gamut of emotion.

2

'In the second scene, he portrays with a brilliant and perfect touch *The Creation of the Sun, Moon and Stars*; the Lord is supported by a throng of *putti*, the foreshortening of whose arms and legs conveys their awesome dimension' (Vasari). Michelangelo often made use of foreshortening in painting figures for the final scenes on the ceiling.

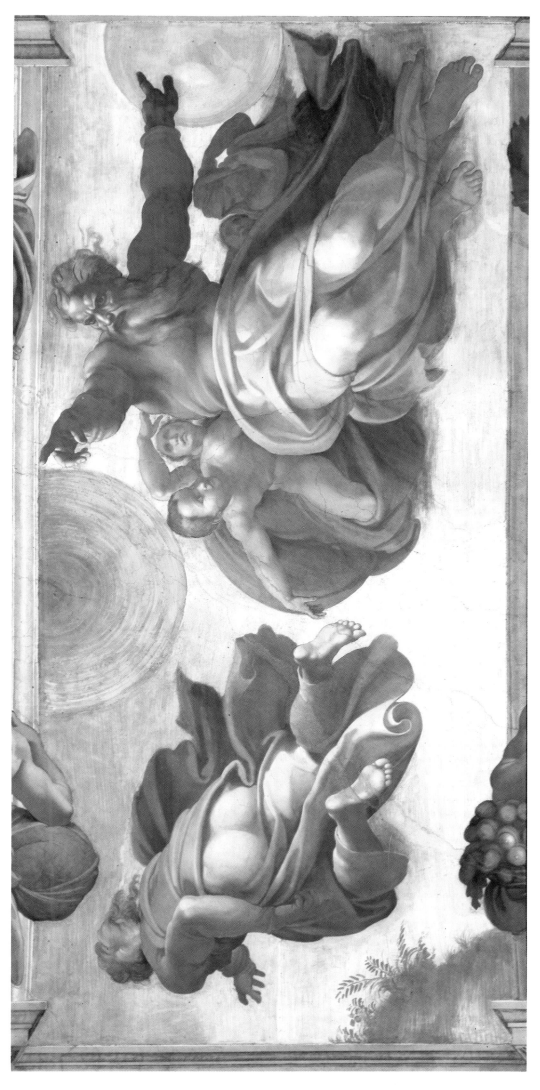

Previous pages:
Persian Sibyl, 1511
Fresco, 400 × 380 cm
Panel, Sistine ceiling, Vatican

1 *Ignudi* (detail of pair above *Persian Sibyl*), 1511.
Fresco, 200 × 395 cm
Panel, Sistine ceiling, Vatican

2 *The Creation of the Sun, Moon and Stars*, 1511
Fresco, 280 × 570 cm
Panel, Sistine ceiling, Vatican

'At the unveiling, people came running from all the corners of the earth; this great work stopped them in amazement, left them wondering and lost for words. The Pope, his greatness fed by this success which encouraged him to further initiatives, rewarded Michelangelo with money and splendid presents.' (Vasari)

1/3
'Here is Jeremiah, his legs crossed, one hand at his beard, his elbow on his knee, the other hand hanging into his lap, his head bent in an attitude that speaks of melancholic thoughts, the bitter reflection engendered by his people.' (Vasari)

Under pressure from Pope Julius II, Michelangelo finished the Sistine ceiling in tremendous haste. The vault was finally unveiled officially on 31 October 1512, the eve of All Saints, and was the subject of widespread admiration. Michelangelo was left exhausted by this titanic work: 'A great inconvenience of the project was that it forced him to paint with his head lifted, he ruined his eyesight to the extent that he could not read letters or look at drawings unless they were in the air and this lasted for several months' (Vasari). The Sistine became, according to Vasari, a form of 'academy of drawing' for artists visiting Rome who saw it as a mandatory point of reference. The frescos were copied in drawings and engravings which were circulated to those who could not come to view the originals *in situ*. The Sistine thus proved a source of inspiration to many artists, well beyond the sixteenth century. Engravers as famous as Marcantonio Raimondi and later Giorgio Ghisi, or again Cherubino Alberti, played a key role in making Michelangelo's iconography known to a wider public.

1 *Jeremiah*, 1511
Fresco, 390 × 380 cm
Panel, Sistine ceiling, Vatican

2 *God Separating Light from Darkness*, 1511
Fresco, 180 × 260 cm
Panel, Sistine ceiling, Vatican

Following pages:
Eleazar and Mathan, 1511-12
Fresco, 215 × 430 cm
Lunette, Sistine ceiling, Vatican

2
An extreme freeness of touch and a daring use of foreshortening in *God Separating Light from Darkness* seem a summing up of Michelangelo's technical mastery.

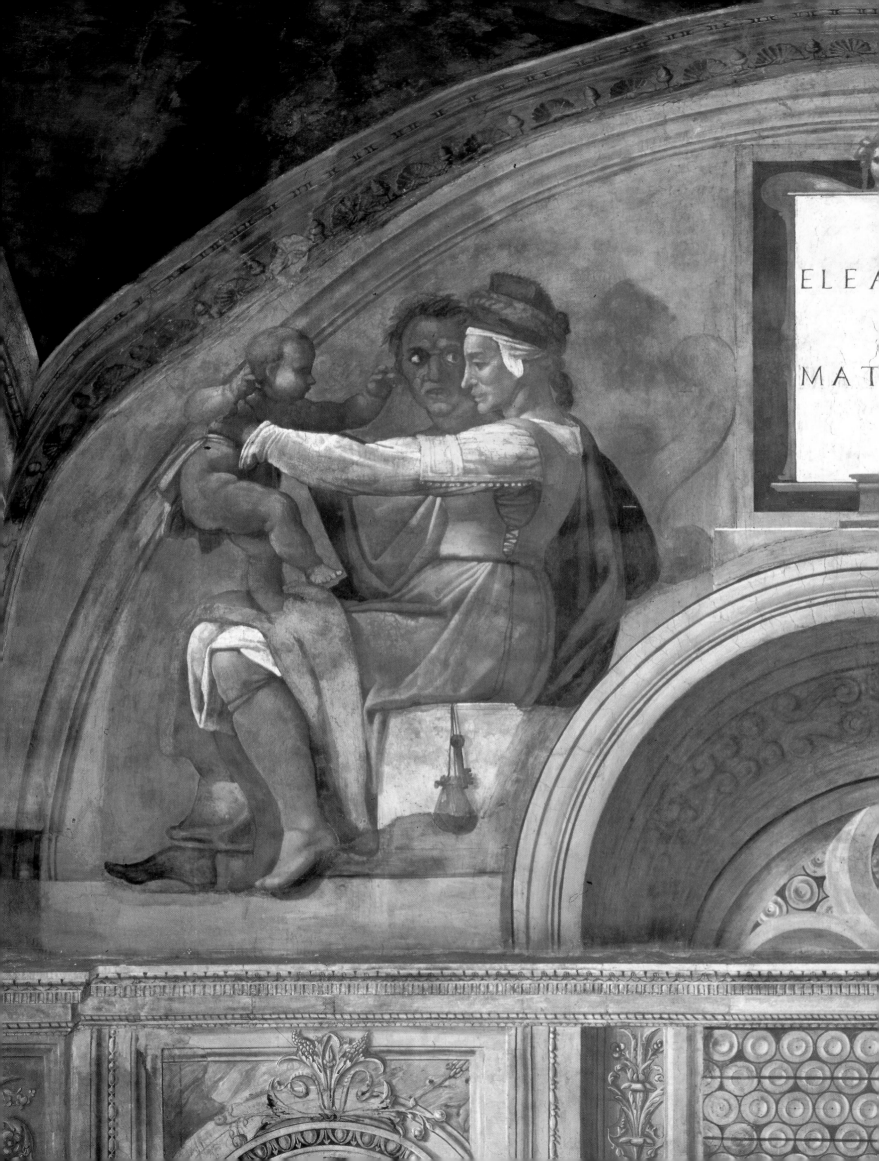

ELEA
MAT

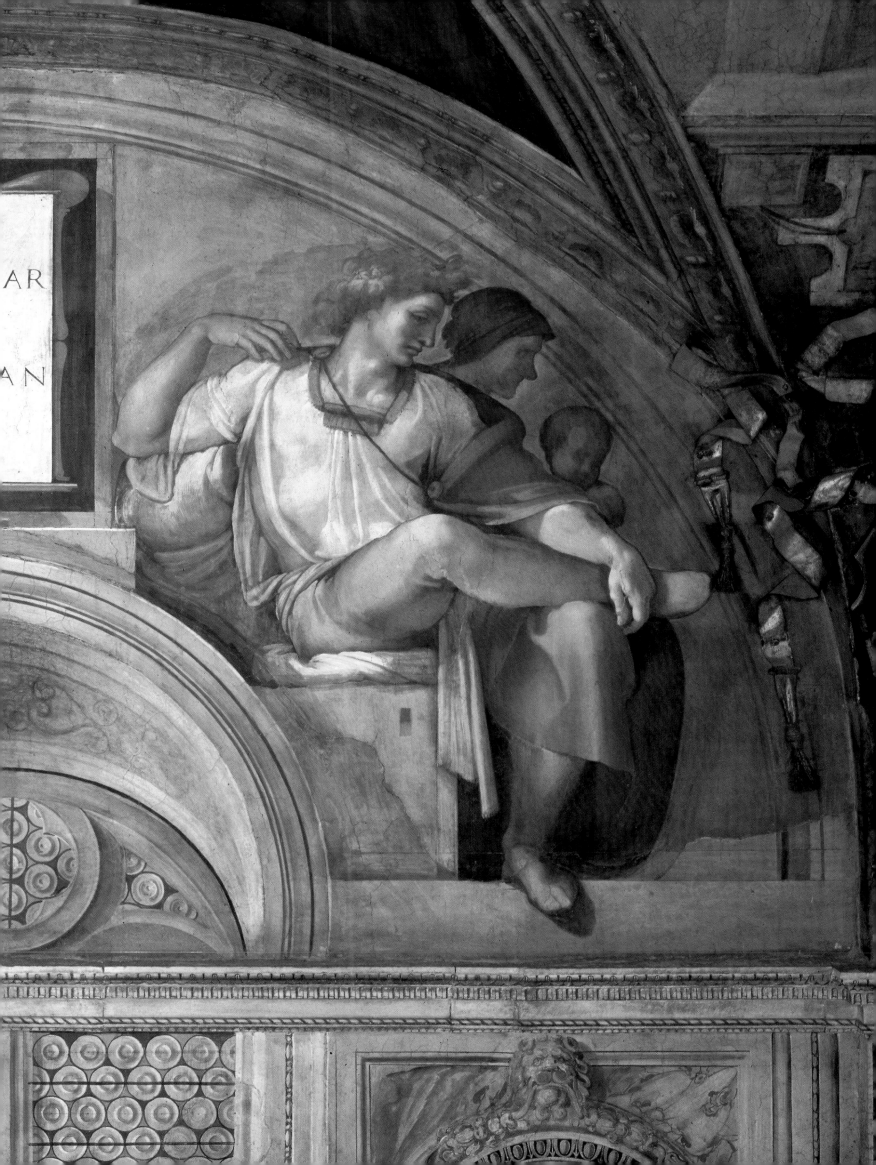

Studies for the Sistine

1
The Portrait of Pope Julius II
by Raphael is notable as a
psychological study; it is the
Pope's introspectiveness that
comes to the fore. This great
patron of the arts commissioned
Michelangelo to work on his tomb
and the Sistine ceiling. He died in
1513, not long after the Sistine was
completed.

Drawing is of crucial significance in
Michelangelo's *oeuvre*. Employing a wide
variety of techniques throughout his long
career, he produced a great range of work,
from anatomical and life studies to the most
accomplished compositions and finished
drawings intended for such as Tommaso de'
Cavalieri. The studies of single figures exe-
cuted for the Sistine are essentially done in
red chalk, a technique which replaced the
pen and black chalk of his first drawings.
These early studies from life already por-
trayed the corporal dilations that characterise
the human figures we now see in the Sistine.
They enabled the artist to determine move-
ments and expressions before he came to
execute the final cartoon. The five studies for
Haman (*The Crucifixion of Haman* occupies
one of the pendentives over the altar) illus-
trate Michelangelo's perfection of touch in
rendering the extremities of the human form,
which he elaborated separately and in close
detail. He often worked in this way on the
body and its hands and feet. The drawing of a
seated male nude is a preparatory study for
the *ignudo* above the *Persian Sibyl*. The hea-
viness and the foreshortening are transferred
to the image on the fresco. The drawing of
Adam is an even more eloquent illustration of
Michelangelo's methods of carrying out his
figures in the Sistine. The study of the body is
identical to Adam's, one might say almost to
the muscle, though the face and hands and
feet are not shown. Only the right hand is in-
dividually worked out. Each figure is
elaborated in a fragmentary manner, so that
the same head can be used several times in
the artist's work.

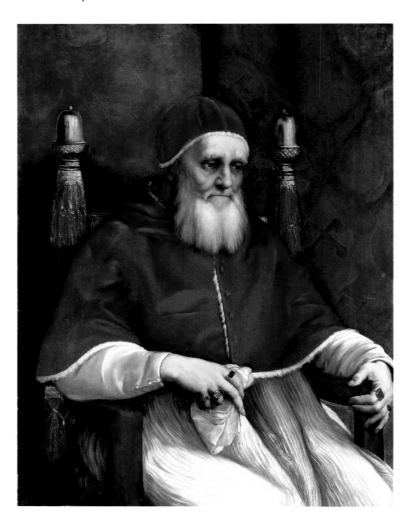

2 and following pages:
Michelangelo handles red chalk as
painstakingly as if he were
determining the final colours on
the vault. The gradations of tone,
the emphatic contours, the
shading that fades away, all show
an extreme sensibility. The
touches of light are produced with
white lead.

1 *Portrait of Pope Julius II*, *c.* 1511-12, Raphael
Wood, 108 × 80.7 cm
National Gallery, London

2 *Studies for the Crucified Haman*
in the Sistine Chapel, 1511
Two tones of red chalk & black chalk.
25.2 × 20.5 cm
Teylers Museum, Haarlem

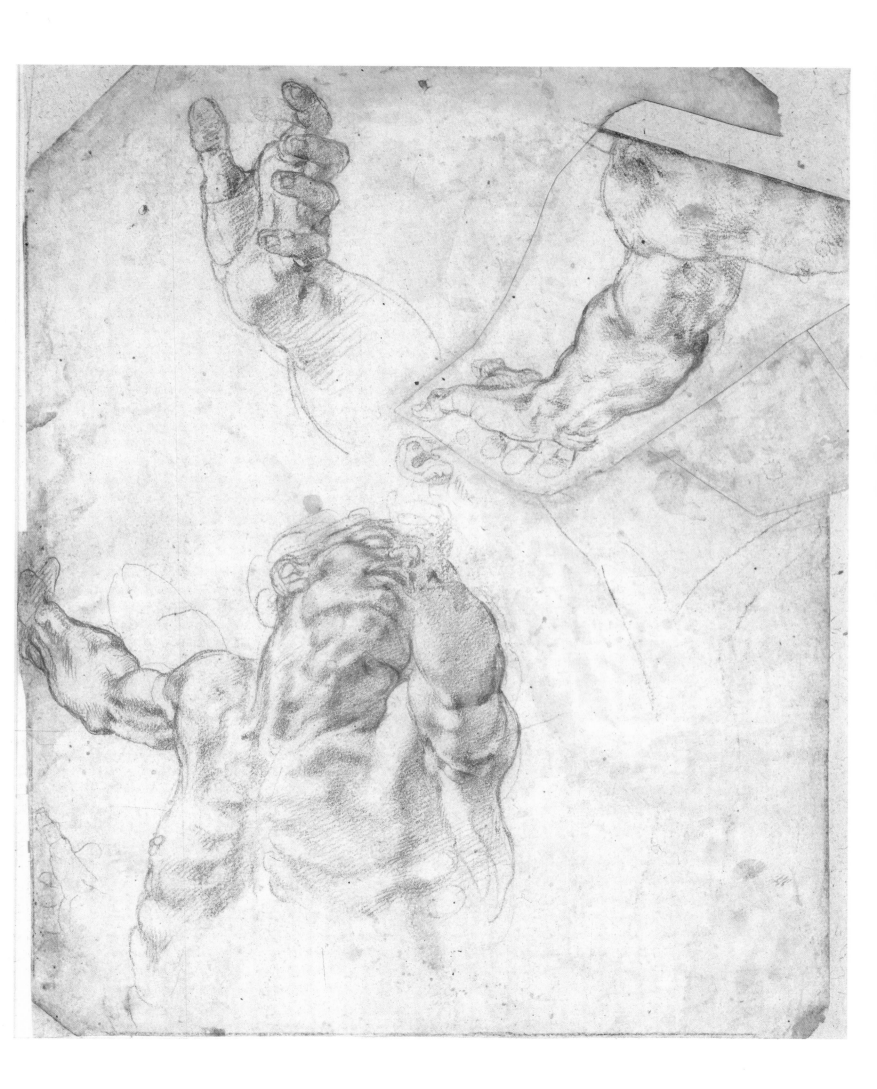

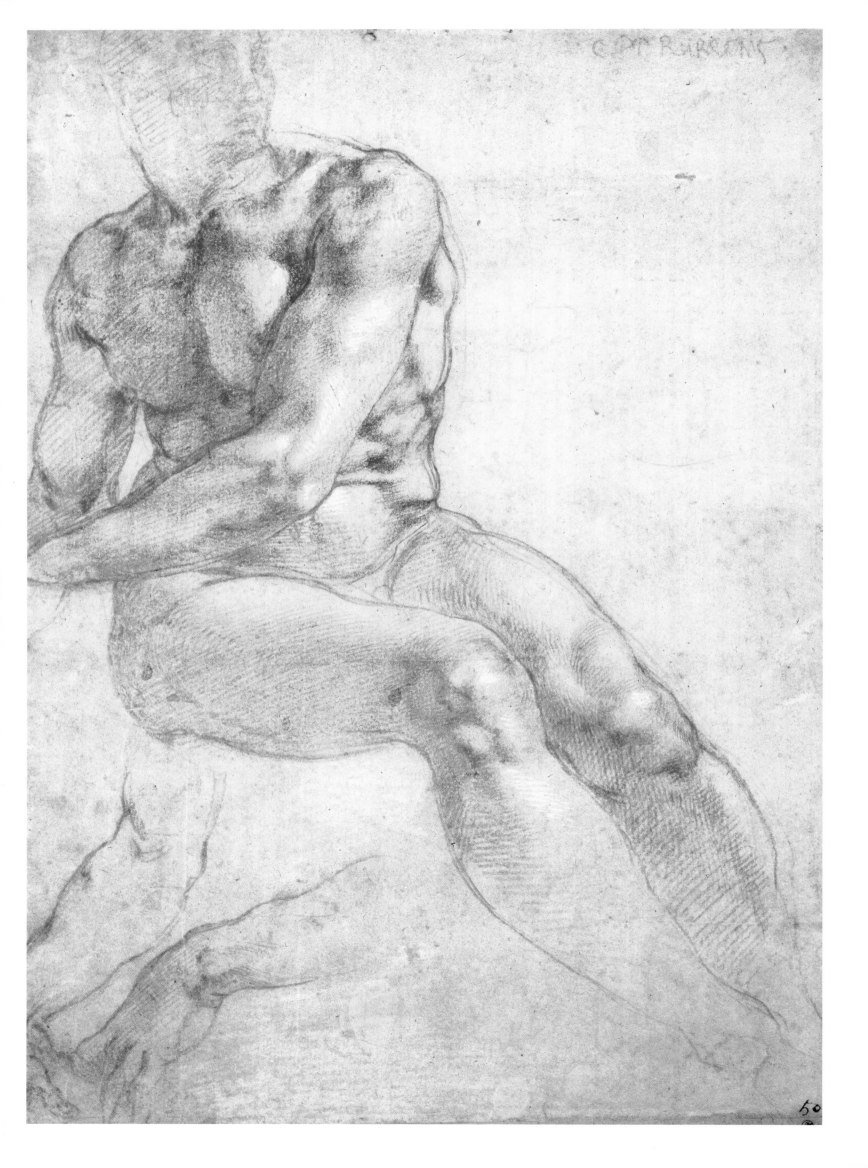

*'Painting, architecture and sculpture
find in drawing their culmination.
There lie the first sources
of all manners of painting
and the root of all knowledge.'
(Remark of Michelangelo's recorded by Francisco da Hollanda)*

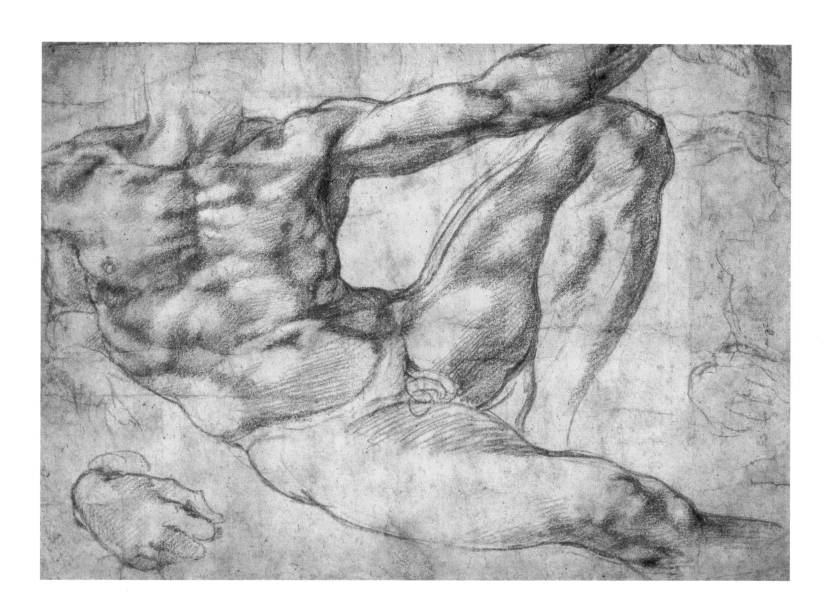

1 *Study of seated male nude and two hands,* c. 1510
Red chalk heightened with white lead, 26.8 × 18.6 cm
Albertina, Vienna

2 *Studies for The Creation of Adam* (recto), c. 1510
Red chalk, 19.3 × 25.9 cm
British Museum, London

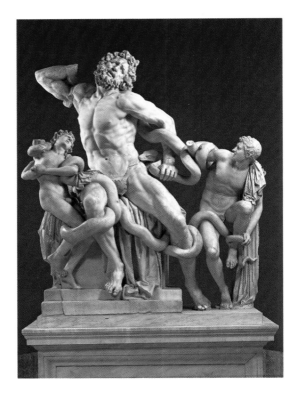

1
The well-known Laocoön group represented Apollo's vengeance on the Trojan priest Laocoön, accused of having desecrated his temple. Apollo sent two snakes to attack the sons of Laocoön and all three men were strangled to death.

2
The authenticity of this drawing is no longer subject to question. On the back of it are studies of the *Battle of Cascina* which suggests a tentative date before 1503 or 1504. The drawing shows Mary Magdalene holding a crown of thorns in her right hand and nails in her left.

*T*he *Entombment* poses problems of attribution and dating to art historians. Only Nicodemus among the figures represented shows an obvious relationship to the *Doni tondo*. With him are portrayed Mary Magdalene, seated on the ground, Joseph of Arimathaea and John the Baptist, who holds the body of Christ, Mary Salome, the mother of Saint John, a holy woman and, in the foreground, scarcely begun, the kneeling Virgin. Some have put forward the hypothesis that some of the figures are not by Michelangelo's hand but the work of a pupil; they would in this case have been painted after Nicodemus and Mary Magdalene. The existence of preparatory drawings, such as that in the Louvre, tends to disprove the theory. However, as Michelangelo never finished his work it is not out of the question that another artist continued it after him. The serpentine figures of Mary Salome and the holy woman, depicted in motion, suggests the style of Pontormo. Professor Michael Hirst considers that this was an altar painting, started in Rome for the church of San Agostino between the end of 1500 and the beginning of 1501 and left unfinished on Michelangelo's return to Florence. Other authorities suggest a date between 1504 and 1508. Another relevant point is that the painting has clearly been influenced by the Laocoön group found on the Esquiline hill in Rome in 1506.

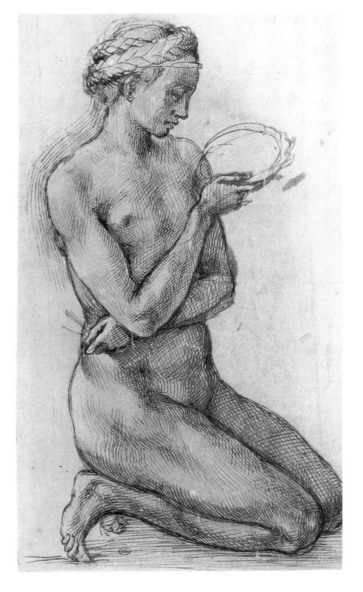

1 *Laocoön Group*
Museo Pio Clementino, Belvedere, Vatican

2 *Young female nude kneeling*
(towards the right), *c.* 1503-4
Black chalk, two tones of ink, 27 × 15 cm
Musée du Louvre, cabinet des dessins, Paris (RMN)

3 *The Entombment* (unfinished)
Wood, 161.7 × 149.9 cm
National Gallery, London

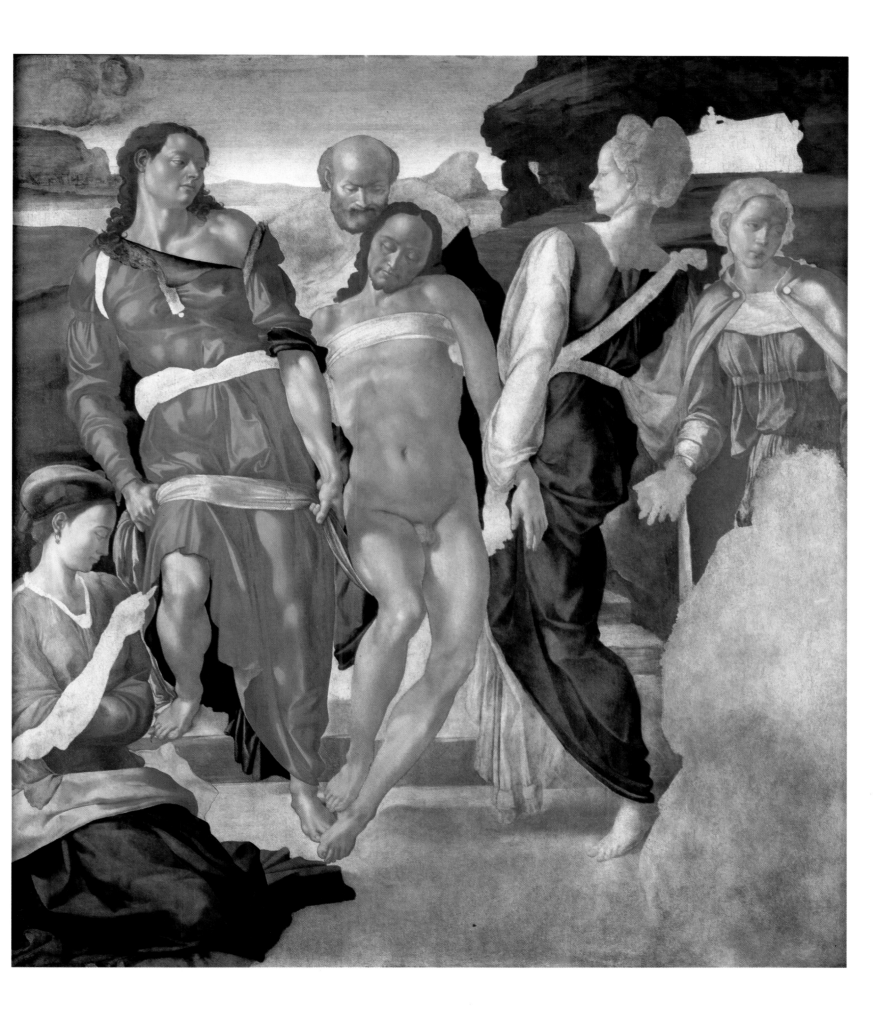

Tomb of Julius II

The story of the tomb of Julius II extends over forty years, from 1505, the date of the first project, to 1545, the date on which the tomb was finally completed. In effect there were six different schemes for this monument which makes its history exceedingly complicated. However the story of the tomb is also a perfect summary of the evolution of Michelangelo's art.

The first project conceived by the artist, starting in 1505, was highly ambitious. The descriptions left by Condivi and Vasari speak of a free-standing construction which could be viewed from all four sides and was richly decorated with statues: 'In all, the work included forty marble statues, as well as scenes, *putti*, decorations, sculpted cornices and architectural features' (Vasari). Inside it was an oval funerary chamber designed to house a sarcophagus. After the signing of the contract, in April 1505, the artist spent eight months in Carrara selecting marble. In the first project Michelangelo drew his inspiration from antique funerary architecture. This ambitious monument was not conceived independently of its architectural surroundings. Michelangelo envisaged placing it in the choir of Saint Peter's, the reconstruction of which had been undertaken by Rossellino in the fifteenth century. However the architect Giuliano da Sangallo preferred to put it in a funerary chapel.

A grandiose project was then conceived: to rebuild Saint Peter's to a central plan covered by a dome resembling the funerary shrines or mausoleums of the Imperial period. Work started on the new building under the direction of Bramante on 18 April 1506. But the latter opposed the construction of the Julius tomb as conceived by Michelangelo. Thwarted and unhappy, Michelangelo left for Florence the day of the laying of the first stone. The Julius tomb project was not to be resumed until the death of the Pope in 1513, under the direction of the deceased's executors.

1/2

From the earliest days of the tomb project in 1505, Michelangelo had envisaged sculptures of the *Contemplative Life*, *Active Life* and *Moses*. The first two statues were not produced until the final stage of the work, in 1542. Moses is thus flanked by Rachel and Leah who represent Faith and Charity. The sense of calm and reflection in these two figures contrasts with the impetuosity of *Moses*, executed nearly twenty years previously.

3

Moses seated is an imposing figure, originally intended to be viewed from below and at an angle. The statue was executed at the time of the second tomb project in 1513. Moses is represented as a figure 'trembling with indignation' and 'managing to control his outburst of anger' (Tolnay). While his gaze is directed to the left, his body turns towards the right. We see here the opposition of the two sides already observed in *David*. Vasari, full of admiration, declared: 'He has so excellently rendered in marble the divine character imprinted by God on this great and saintly countenance; apart from the accomplishment of the deep folds and the superb volutes at the edges, the muscles in the arms, the bones and nerves in the hands are so beautifully and perfectly executed, legs, knees and sandalled feet so fittingly handled.'

1 *Rachel (Contemplative Life)*
detail of Tomb of Julius II, 1542
Marble, H: 197 cm
San Pietro in Vincoli, Rome

2 *Leah (Active Life)*
detail of Tomb of Julius II, 1542
Marble, H: 209 cm
San Pietro in Vincoli, Rome

3 *Moses*, detail of Tomb of Julius II, *c.* 1515-16
Marble, H: 235 cm
San Pietro in Vincoli, Rome

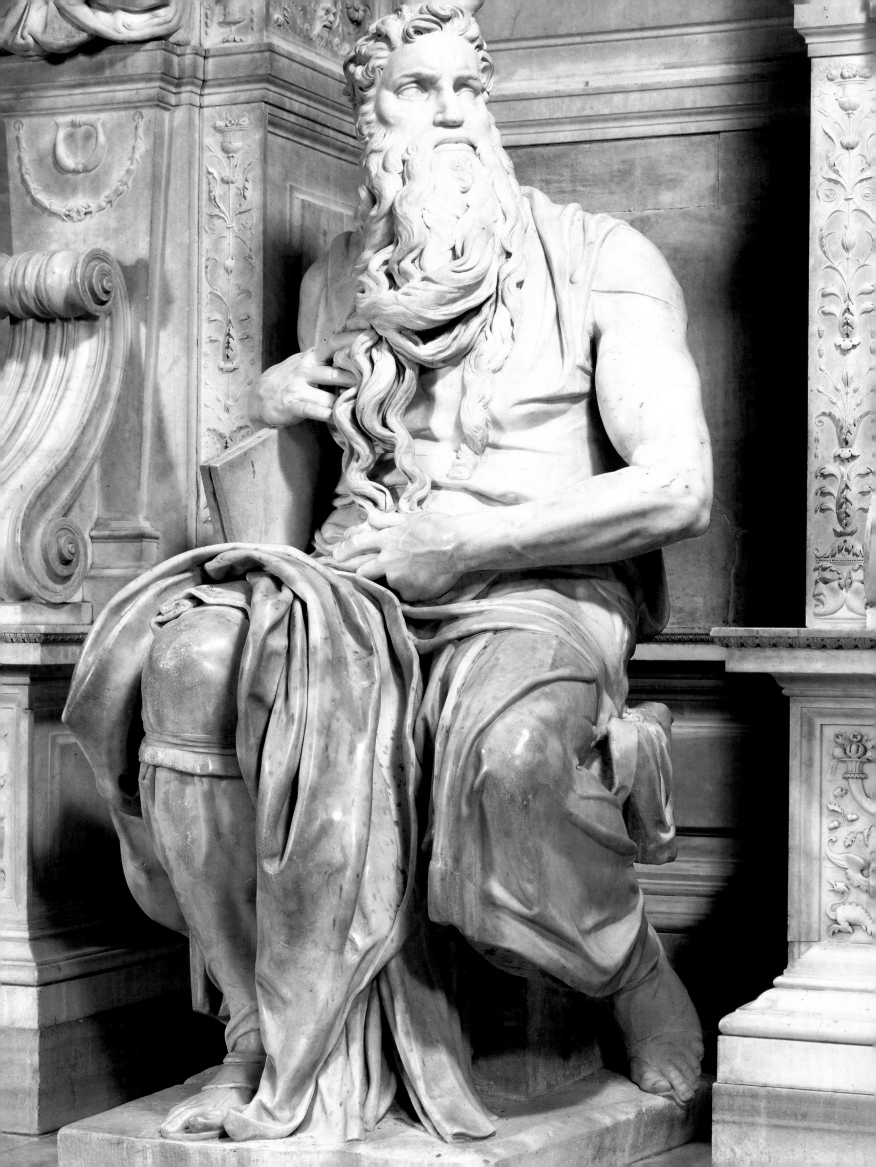

The Slaves

The iconographic plan of the mausoleum was to illustrate the triumph of the Church over the pagan world. On the bottom level there were to be statues of *Victories* and *Slaves*. The latter were, according to Vasari, 'provinces subjugated by the pontiff [Julius II] and subject to the apostolic Church'. But while the two slaves appear to symbolise pagan peoples recognising the true faith, Tolnay suggests that Michelangelo goes beyond this theme to a subject that is 'purely human . . . The slaves are transformed from trophies to symbols of the bitter and despairing struggles of the human soul against the chains of the flesh.' The sculptures on the second level, *Moses* and *Saint Paul*, express the victory of the soul over the body.

The two statues of slaves were the first to be carried out for the second project in 1513. There is an evocation of the Laocoön group in the pose of the *Dying Slave* (or is he simply waking?), a pose accentuated by the bands that encircle his chest and shoulders. The *Rebellious Slave*, more freely conceived, remains unfinished. Michelangelo, who, in 1542, had doubtless anticipated positioning the statues in the alcoves on either side of *Moses*, finally replaced them with *Rachel* and *Leah*. In 1544 he gave the two slaves to the Florentine Roberto Strozzi, in gratitude for having had him to stay in his house in Rome when he was ill. Exiled to Lyons, Roberto Strozzi took the two statues with him. In about 1546 or 1550, he presented them to François I as a gift. The French king gave them in turn to Anne de Montmorency who placed them in alcoves on the façade of the Château d'Ecouen. In 1632 the two statues were offered to Richelieu. Sequestrated during the Revolution, they were to be put up for sale, but were saved by Alexandre Lenoir, and now form part of the collections in the Louvre.

1 *Dying Slave*, 1513
Marble, H: 215 cm
Musée du Louvre, Paris (RMN)

2 *Rebellious Slave*, 1513
Marble, H: 215 cm
Musée du Louvre, Paris (RMN)

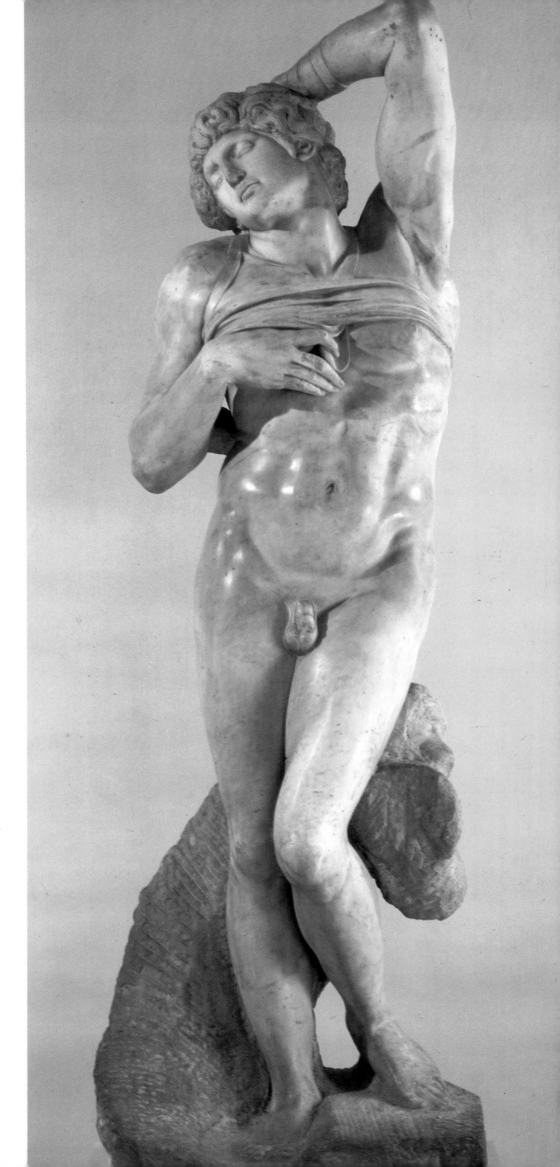

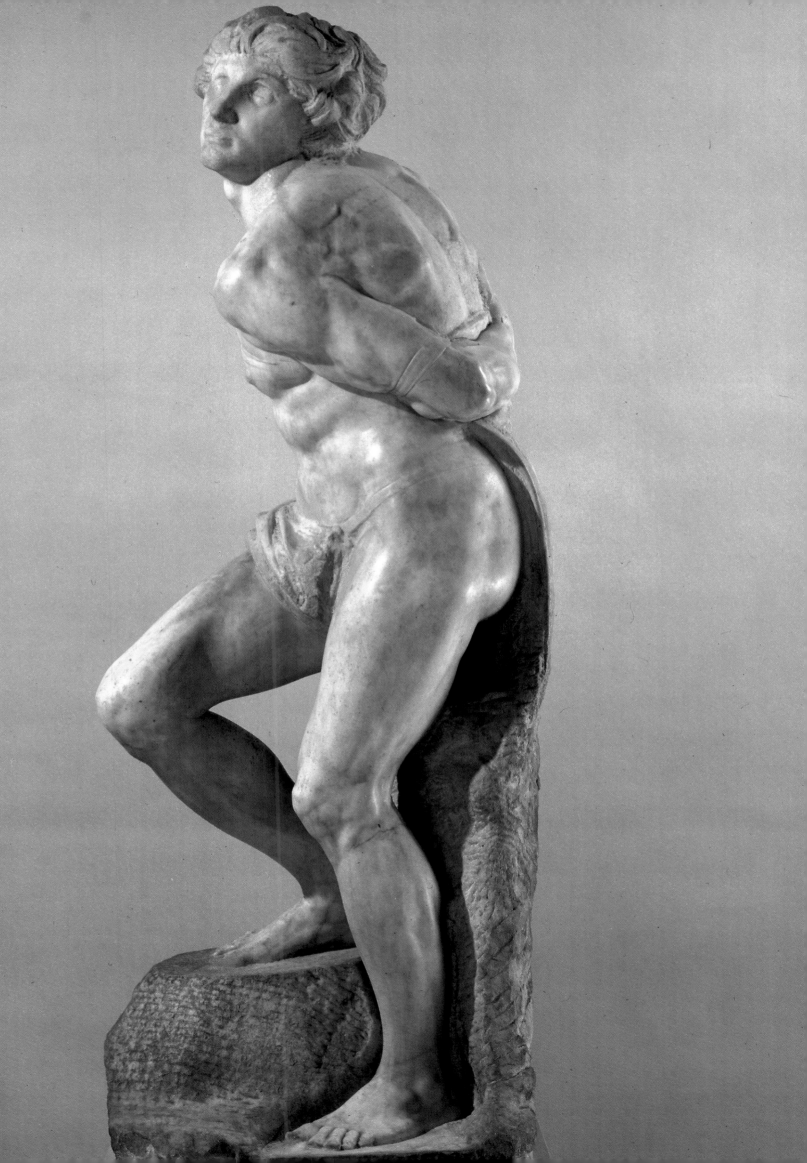

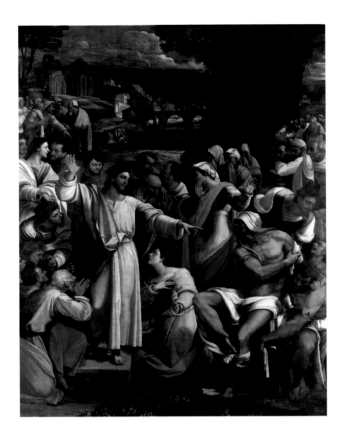

Art and friendship

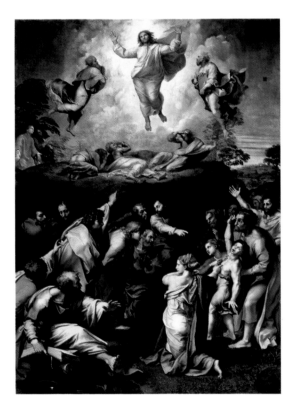

1
The Raising of Lazarus is a composition of figures elaborated by Michelangelo and set in a nocturnal ambience derived from Sebastiano's Venetian apprenticeship.

hile Michelangelo was occupied with the tomb of Julius II in Rome and, shortly after, in 1516, by a commission from Pope Leo X to work on the façade of San Lorenzo in Florence, he gave up painting. However to help his friend the Venetian artist Sebastiano del Piombo with his most ambitious compositions, he executed a number of drawings. He gave him a composition sketch and, according to Vasari, the cartoon for the *Pietà* in the Viterbo Museum, finished in 1515. Sebastiano del Piombo had come to Rome shortly after the first stage of work on the Sistine was completed. Cardinal Giulio de' Medici, the future Clement VII, ordered *The Transfiguration* from Raphael in 1516 and *The Raising of Lazarus* from Sebastiano. With Sebastiano as intermediary, a rivalry took root between Raphael and Michelangelo. The latter provided various studies for *The Raising*, all concentrating on the figure of Lazarus. According to Vasari, Michelangelo was also involved in other parts of the painting. He helped his friend again with the altarpiece for the Borgherini Chapel in San Pietro in Montario which represented *The Flagellation of Christ*. The collaboration between Michelangelo and Sebastiano tells us much about the former's personality: at the height of his fame following the Sistine frescos, he did not hesitate to compete with Raphael via Sebastiano, all the while placing his artistic skills at the service of his friend.

2
The Transfiguration is Raphael's last work. He was still engaged on it when he died. The composition, on two levels, portrays the transfiguration above, and below it the meeting of the Apostles and the child possessed by the devil whom Christ cured on his return from Mount Tabor.

3
This fragment of the drawing (cut away on the left) shows Lazarus supported by two figures. It was used by Sebastiano in his composition.

1 *The Raising of Lazarus*, 1517-19
Sebastiano del Piombo
Panel, 381 × 289.6 cm approx
National Gallery, London

2 *The Transfiguration*, 1510-20. Raphael
Wood, 410 × 279 cm
Pinacoteca, Vatican

3 *Study of Lazarus supported by two figures*
Red chalk, 25.1 × 14.5 cm
British Museum, London

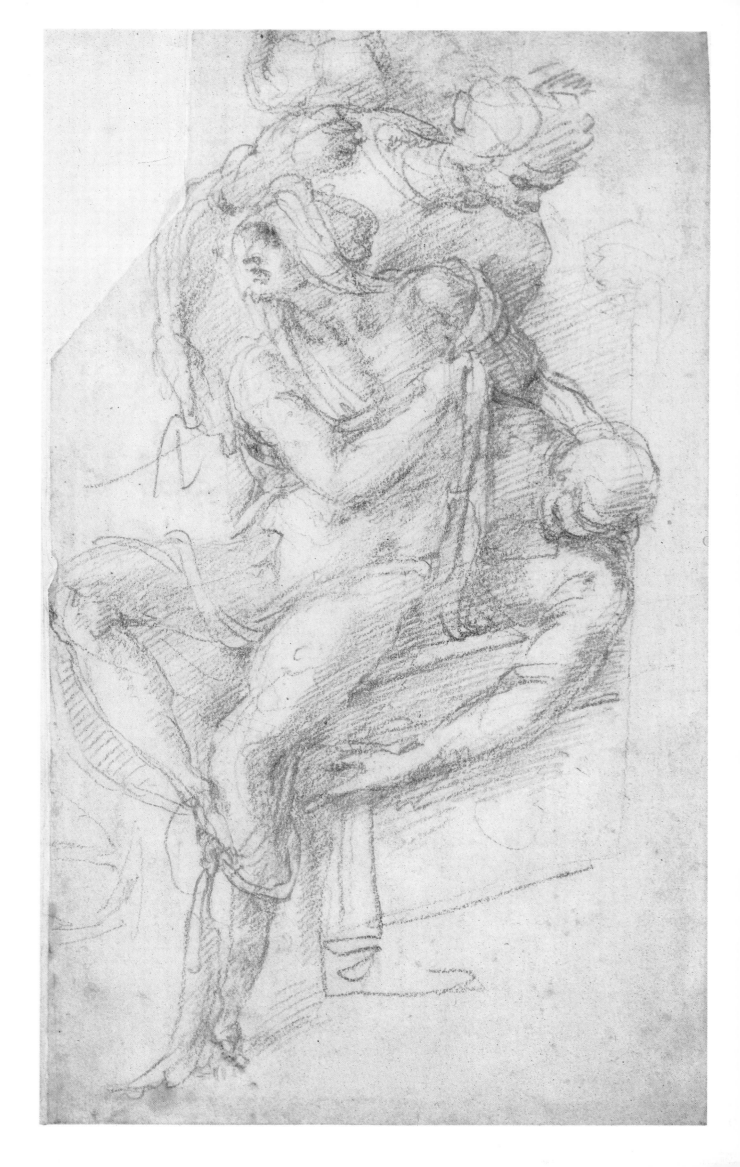

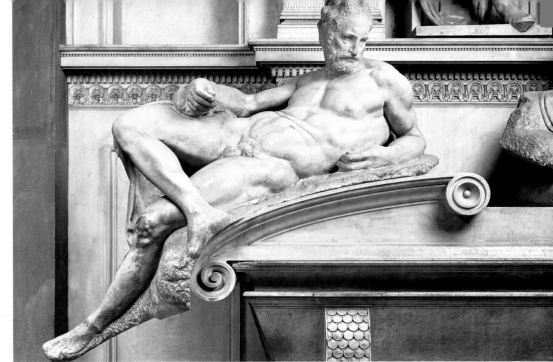

1 2

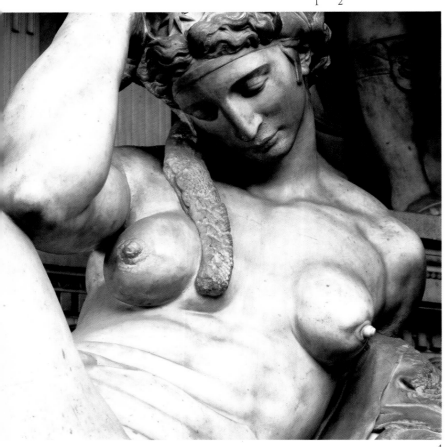

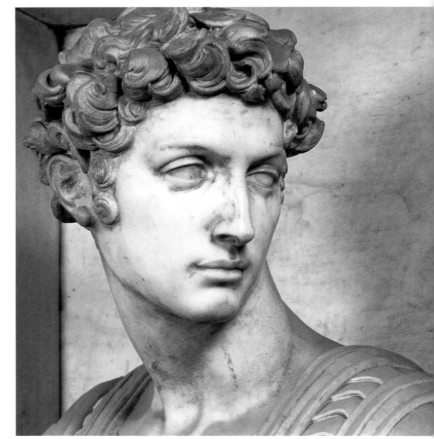

6

4 5

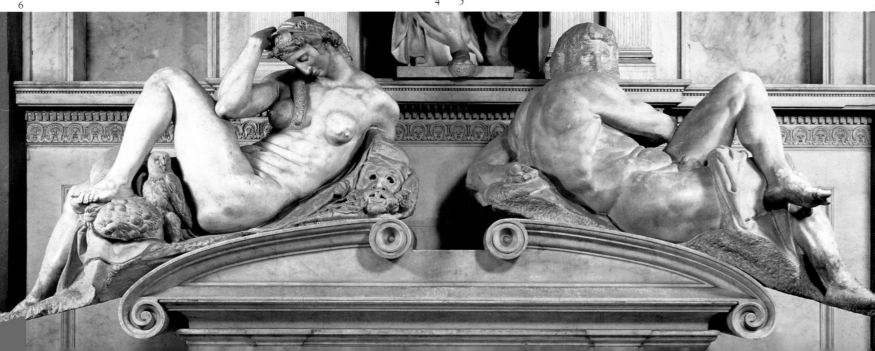

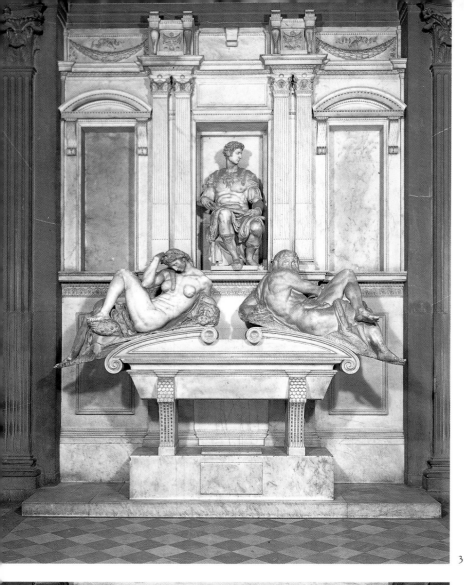

3

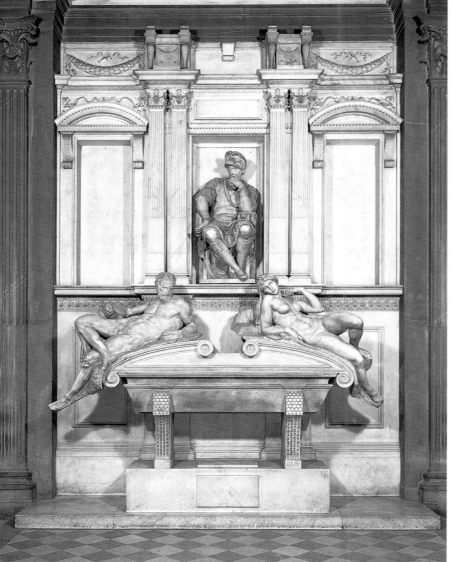

7

A commission
from the Medicis

Leo X, a Medici, and his cousin Cardinal Giulio de' Medici, decided that the chapel then under construction at San Lorenzo should be made into a funerary chapel for the Medicis, forming a pair with Brunelleschi's sacristy. Between November 1516 and January 1521, Michelangelo developed his plans for this project. The construction of the tombs was not intended to start until spring 1524. In the meantime Michelangelo chose and ordered marble from Carrara. What he initially envisaged for the Medicis was a free-standing four-sided monument. The possibility of building tombs in the wall was also studied, however, and this idea was retained in the final production. Michelangelo was between fifty and fifty-five when he embarked on the statues for the tomb and the thoughts of death that then occupied him are apparent in his iconographic scheme. Melancholy is to be read on all the faces: *Day* and *Dawn* seem reluctant to relinquish sleep while *Dusk* and *Night* bow their heads, already overwhelmed by slumber. Lorenzo is sunk deep in thought.

Michelangelo explains his work thus: '*Day* and *Night* speak to each other and say: our rapid race has driven the duke Giuliano to death.' Giuliano, Duke of Nemours and brother of Leo X, died in 1516, and Lorenzo, Duke of Urbino and nephew of Leo X, in 1519.

Left to right:
1 *Owl*, detail of Tomb of Giuliano de' Medici
1526-33. Marble
Medici Chapel, San Lorenzo, Florence

2 *Dusk*, detail of Tomb of Lorenzo de' Medici
1524-31
Marble, L: 195 cm
Medici Chapel, San Lorenzo, Florence

3 Tomb of Giuliano de' Medici, 1526-31
Marble. Medici Chapel, San Lorenzo, Florence

4 *Night*, detail of Tomb of Giuliano de' Medici
1526-33. Marble, L:194 cm
Medici Chapel, San Lorenzo, Florence

5 Head, detail of Tomb of Giuliano de' Medici
1526-33. Marble, H: 173 cm
Medici Chapel, San Lorenzo, Florence

6 *Night* and *Day*, detail of Tomb of Giuliano de' Medici
1526-33. Marble
Medici Chapel, San Lorenzo, Florence

7 Tomb of Lorenzo de' Medici
1524-31. Marble
Medici Chapel, San Lorenzo, Florence

Following pages:
1/2 *Dawn*, detail of Tomb of Lorenzo de' Medici
1524-31. Marble, L: 203 cm

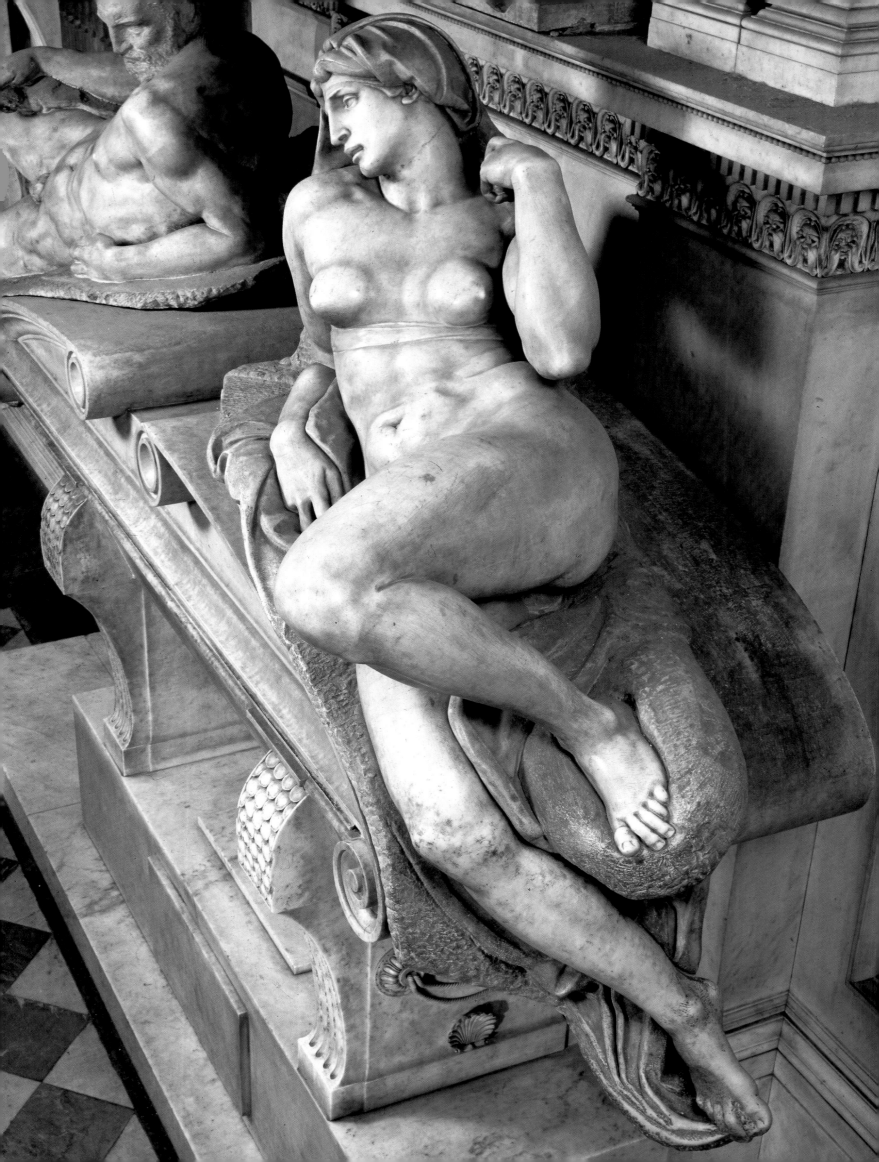

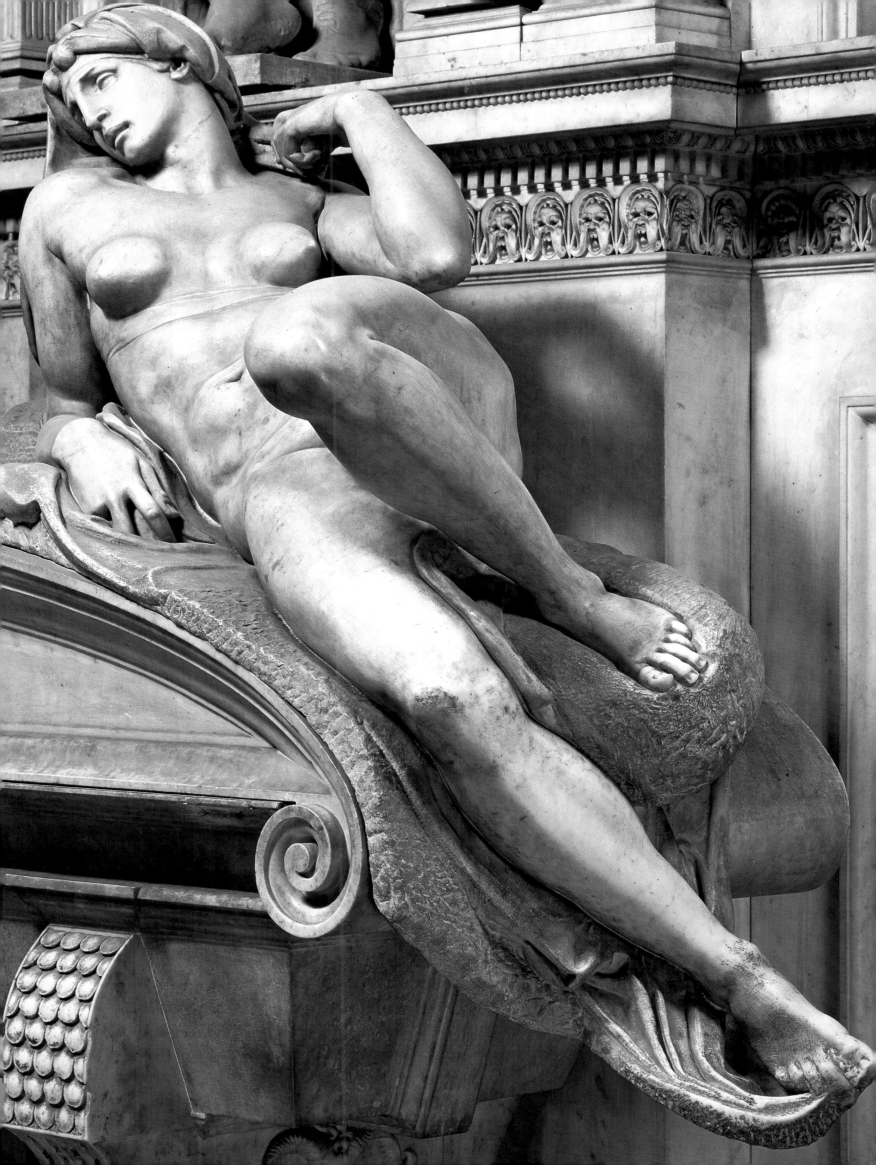

Dawn, *Dusk*, *Day* and *Night* are also allegories of time to which the human body is subject. They are positioned above the sarcophagi in pairs, on the lower level. The Herculean musculation of the figures is virtually *de rigueur* in allegorical representations and *Day* is a particular example of this: the torsion of the upper part of the body seems to tense all the muscles in the arms, chest and back. On the upper level, we find no recumbent figures, but sculptures of Lorenzo and Giuliano seated like *Moses*, their presence a reminder of the immortality of the souls of the departed. They are contemplating a *Madonna and Child* situated in front of a third wall. The walls are embellished with pilasters and architraves in *pietra serena* of a grey-black colour. Michelangelo had dreamed of a series of frescos on the lunettes and the stucco of the dome which, started by Giovanni da Udine, did not please the Pope and was never finished.

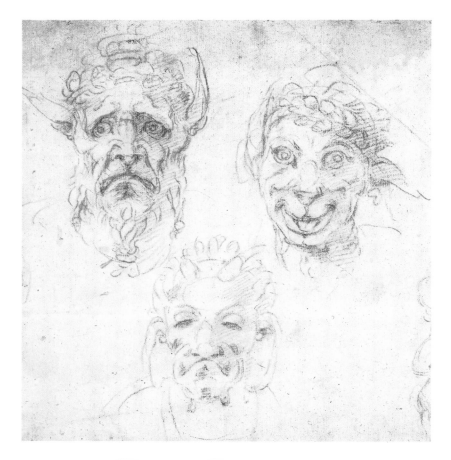

1 *Portrait of Leo X with Cardinals Giulio de' Medici and Luigi de Rossi*, 1517-18. Raphael
Oil on panel, 155.2 × 118.9 cm
Uffizi, Florence

2 *Wall decoration*
Medici Chapel, San Lorenzo, Florence

3 *Studies of grotesque heads*, 1530
Red chalk, 25.5 × 35 cm
British Museum, London

4 *Mask of Night*
detail of Tomb of Giuliano de' Medici, 1526-33
Marble
Medici Chapel, San Lorenzo, Florence

5 *Studies for the back and left arm of Day*,
c. 1524
Black chalk, 19.6 × 25.7 cm
Teylers Museum, Haarlem

6 *Day* (from the back)
detail of Tomb of Giuliano de' Medici, 1526-33
Marble, L: 285 cm
Medici Chapel, San Lorenzo, Florence

Following pages:
1 *Wall decoration* (detail)
Medici Chapel, San Lorenzo, Florence

2 Detail of Giuliano de' Medici's breast-plate
Marble, H: 173 cm

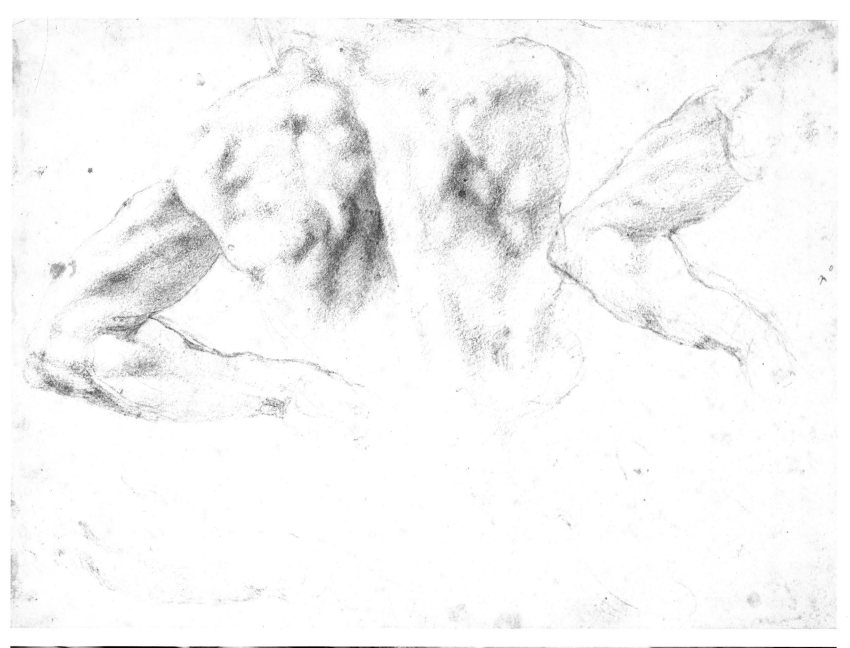

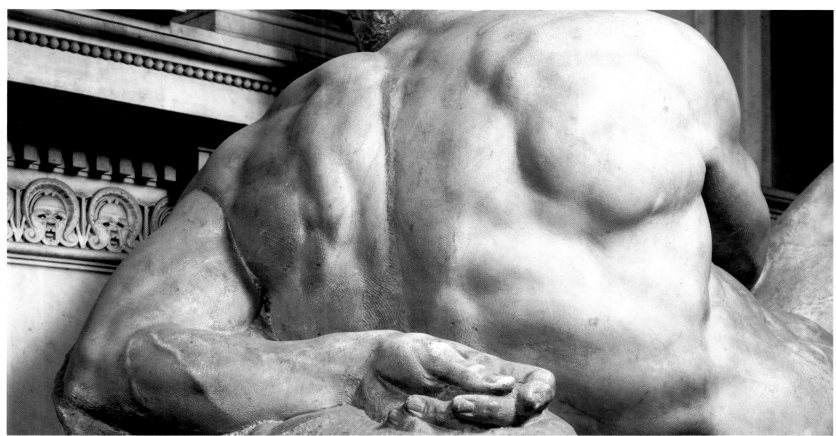

After the Sack of Rome in 1527 the Medicis left Florence and the republic was restored. Michelangelo offered his services to the new government as an ordinary citizen. He volunteered to study the military defences of the city and in autumn 1528 started work as an expert in fortifications. He produced a multitude of plans for the different entrances to Florence but his projects were not accepted by the Gonfalonier Niccolò Capponi, nor by his successor Francesco Carducci. Anticipating the catastrophic 1529 siege by the armies of the Pope and the Emperor Charles V, Michelangelo took flight a few weeks beforehand and sought refuge in Ferrara and Venice. Three days before the siege began the artist made known to the Signoria that he wished to return to Florence provided that he was pardoned. Part of the city was already under siege when he actually went back, at the end of November. It is known that Michelangelo took an active part in defending the city until it capitulated on 12 August 1530.

1/2
The twenty-three drawings for the fortification of the entrances to Florence (all preserved in the Casa Buonarroti) were innovations in the art of military defence. Michelangelo adopted zoomorphic forms, predominantly curves, whose function was to keep the enemy cannon at as great a distance as possible from the entrances and in consequence from the city itself. They were intended to be built not in stone but in beaten earth. The plans exercised a marked influence on fortifications in future centuries. Vauban in the seventeenth century was greatly inspired by them.

1 *Drawing for the fortification of Florence*
Casa Buonarroti, Florence

2 *Drawing for the bastion for the Porta al Prato of Ognissanti*
Ink, red chalk & wash, 41 × 56.8 cm
Casa Buonarroti, Florence

3 *Siege of Florence*, G. Vasari
Palazzo Vecchio, Florence

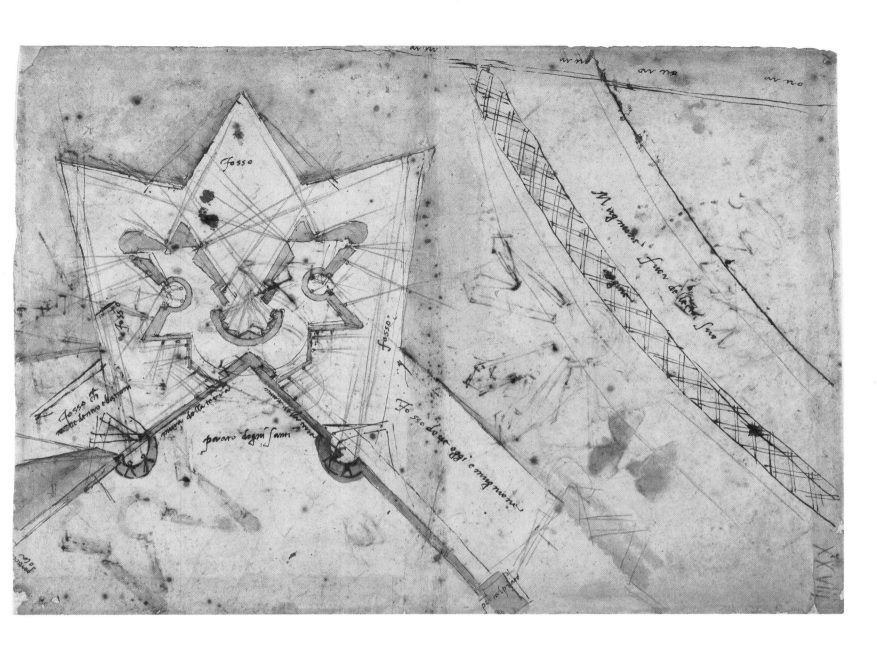

'In 1529 there occurred the siege of Florence . . . his fellow citizens had put him in charge of additional fortifications in the area of the hill of San Miniato. He named a price to the republic of a thousand écus and, appointed to the nove della milizia in the war office, dedicated himself with the utmost concentration to perfecting the fortifications.' (Vasari)

Biblioteca Laurenziana

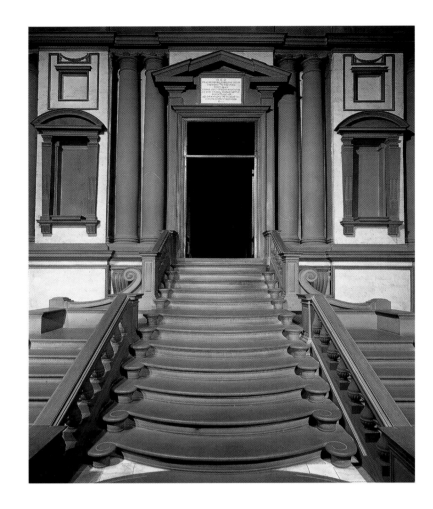

It was in the autumn 1523 that Michelangelo first began to negotiate with Cardinal Giulio de' Medici, that year elected Pope under the name Clement VII. The Medicis were intending to build a new library in the convent of San Lorenzo to house all their valued books and manuscripts. In 1516-18 Michelangelo had embarked on his first great architectural project for the Medici, namely the façade of San Lorenzo, the family church and place of burial. The contract signed in 1518 was cancelled in 1520. The façade was never to be completed, but the Medici's choice again fell on Michelangelo when they were looking for an architect for the Biblioteca Laurenziana. This commission was staggered over a number of years. After several projects in 1524, it was brought to a halt by political troubles which culminated in the Sack of Rome in 1527. Work was then resumed in 1530 following the abdication of the Florentine republic and the return of the Medici helped by the armies of Charles V.

The Biblioteca Laurenziana was conceived in two distinct architectural stages: the vestibule, a passage from the street to the library, admitted the visitor and prepared his approach to the great reading room, the austere architecture of which was to be conducive to concentration and study. On the walls of the vestibule the artist emphasised architectural mass, making use of *pietra serena* of grey colour. Columns, pilasters, niches for statues, tympanums, enlivened the empty space. The focal point of this *ricetto* was the monumental staircase set in a confined area.

2
The son of Michelangelo's nephew, Michelangelo Buonarroti the Younger, a prominent intellectual and man of letters, had the Buonarroti house decorated by seventeenth-century Florentine artists (from 1612 to 1643). Their paintings had a bearing on the arts in general and on the artist Michelangelo in particular. The painter Jacopo Chimenti, known as l'Empoli, is here portraying architectural projects associated with Florence.

1 Front view of staircase
Michelangelo and Bartolommeo Amannati
Biblioteca Laurenziana, Florence

2 *Michelangelo presenting to Leo X his project for the façade of San Lorenzo and other works in the Laurenziana*, 1619. Jacopo Chimenti (l'Empoli)
Oil on canvas
Casa Buonarroti, Florence

3 View down staircase
Biblioteca Laurenziana, Florence

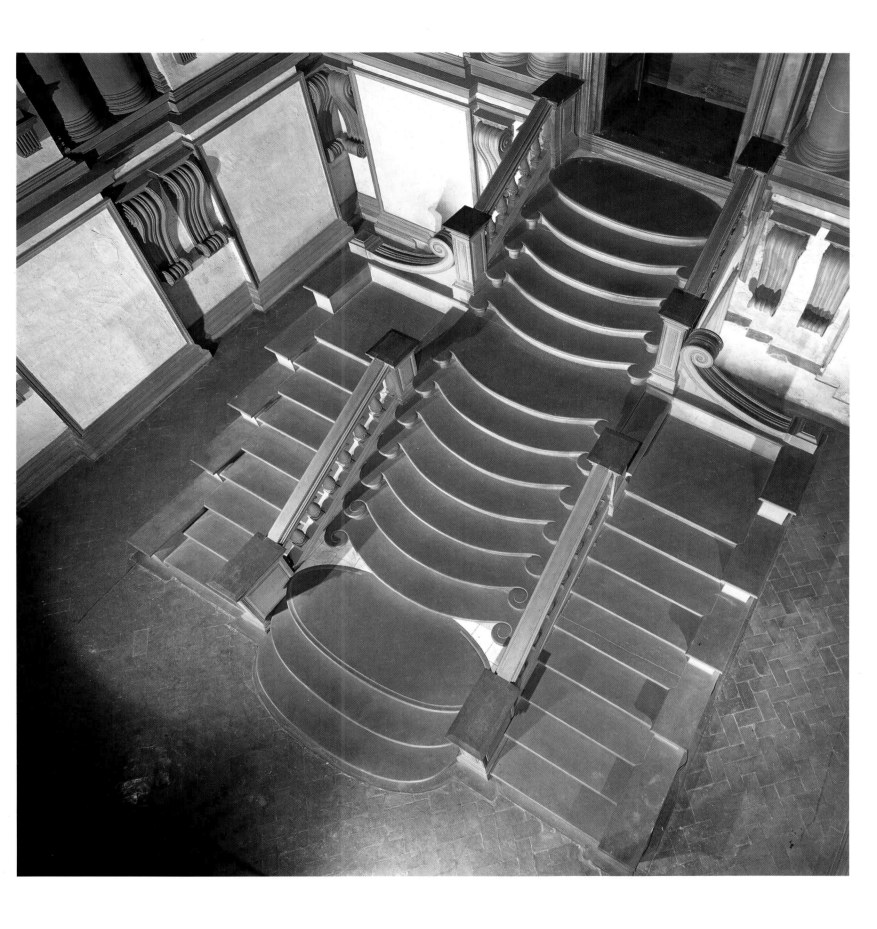

A Christchrist without wounds

In 1514, two years after work on the Sistine was completed, Michelangelo carried out a *Risen Christ* ordered by his friend Metello Vari. The first version, now lost, was abandoned on account of a fault that appeared in the marble. A great black vein crossed the face. A second version was produced between 1519 and 1520 and was also subject to difficulties. The sculptor Pietro Urbano made modifications to the statue when it arrived in Rome. The image of Christ, as elaborated by Michelangelo, is in accordance with the contract which stipulated the execution of 'a marble figure of Christ, life-sized, naked, standing, a cross between his arms, in the pose Michelangelo judges appropriate'. The pose was certainly not conventional: Christ is shown carrying the cross, but without wounds. The *contrapposto* suggests a figure of Apollo rather than a suffering Saviour.

For the Medici *Madonna*, Michelangelo adopts the slender forms later to be seen in *Victory*. The child, seated on its mother's knee, turns with a sharp movement to the maternal breast. Though he had already handled the subject of *Madonna and Child* on several occasions, this is the first time that Michelangelo portrays maternity. The Virgin's clothes mould her body in the antique manner, resembling wet drapery. The two seated dukes turn their gaze towards the Virgin. Michelangelo thus links the figures to each other. The dukes are contemplating the 'Virgin Mother', an image of life, while they themselves, after death, are finally delivered from the prison of the body.

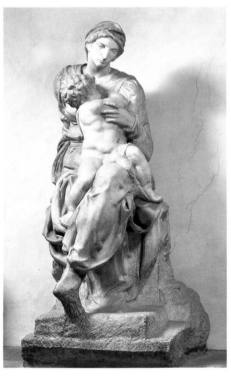

1
In the *Risen Christ*, Michelangelo offers a new approach to his subject, portraying Christ in a state of calmness, with no expression of suffering.

2
The Medici *Madonna* is positioned on the wall opposite the altar in the Medici Chapel. The image the artist creates here is that of a nursing mother.

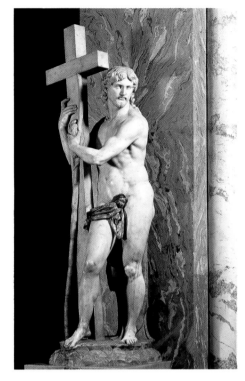

3
This cartoon, executed on two large sheets of paper stuck together, bears no relation to any known composition of Michelangelo's, but it returns to the theme of maternity seen in the Medici *Madonna*. The figures have been drawn in red chalk with a 'finish' which shows a close affinity to the art of painting.

1 *Risen Christ*, 1520
Marble, H: 205 cm
Santa Maria sopra Minerva, Rome

2 *Madonna and Child*, started in 1521
Marble, H: 226 cm including base
Medici Chapel, San Lorenzo, Florence

3 *Madonna and Child*, c. 1520
Black chalk, red chalk, white lead, ink
54.1 × 39.6 cm
Casa Buonarroti, Florence

T he new style created by Michelangelo and put into practice on a monumental scale in the Sistine, both on the vault and in *The Last Judgement*, was to have a strong influence on Florentine artists of the next generation. This new vocabulary of form, described by Vasari as *maniera*, regenerated artistic creation in the sixteenth century in the fields of both painting and sculpture. Pontormo was the artist who best understood what Michelangelo was offering – notably in *The Last Judgement* – and he transposed it to the choir of San Lorenzo in Florence (his decoration has been destroyed). It seems likely that the two artists had friendly, and intellectual, dealings with each other, though there is no documentation to prove this. It was to Pontormo that Michelangelo entrusted the painting, from his cartoon, of the mythological scene *Venus and*

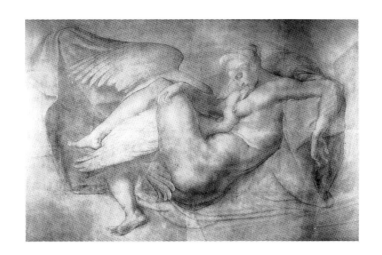

A few of Michelangelo's lost works

Cupid, probably carried out in about 1532-3. Michelangelo's cartoon for '*Noli me tangere*' gave birth to two pictorial representations, one by Pontormo (now in a private collection in Milan), and the other by his pupil, Bronzino. The latter was in charge of Pontormo's workshop since childhood, and until the master's death. Everything suggests that it was from Bronzino that the master ordered replicas. The painting of *Leda and the Swan* was commissioned by Alfonso d'Este, Duke of Ferrara. The latter, host to Michelangelo when he fled Florence in 1529, had long wished for a work by the great Florentine artist. Michelangelo found himself in rivalry with Titian, three of whose mythological paintings decked the walls of the Duke of Ferrara's house. Offended by the arrogance of the duke's messenger, however, Michelangelo did not give him the work and offered it to his pupil, Antonio Mini, who took it to France where it was copied by Rosso Fiorentino.

1 *Leda and the Swan*, after Michelangelo, *c.* 1538
Rosso Fiorentino
Cartoon, black chalk, 170.7 × 248.8 cm
Royal Academy of Arts, London

2 *Venus and Cupid*, 1532-4, Pontormo
Oil on panel, 128 × 197 cm
Accademia, Florence

3 '*Noli me tangere*', after Michelangelo's lost cartoon, after 1531, Bronzino
Oil on panel, 175 × 134 cm
Casa Buonarroti, Florence

4 *Study for Leda's head*, *c.* 1530
Red chalk, 35.5 × 26.9 cm
Uffizi, Florence

4
This handsome study of a head, executed in red chalk, is the only trace of the artist's work on *Leda* to survive. It seems that Michelangelo drew the head of a *garzone* (boy apprentice) in the workshop and one can just imagine a doublet at the nape of the neck. The singular reworking in close-up of the eye is another example of Michelangelo's talents as a draughtsman.

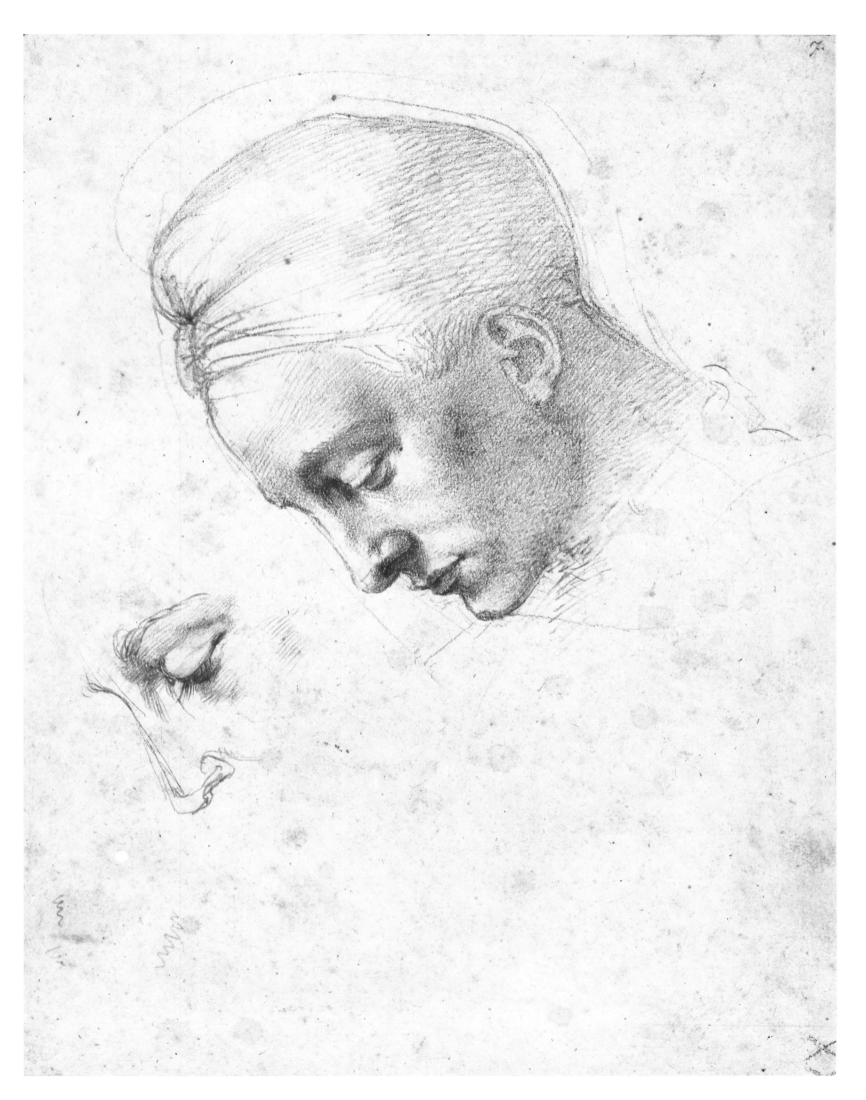

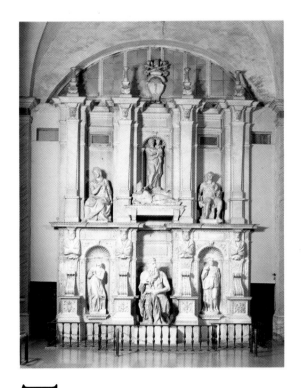

Tomb of Julius II: another stage

'If what is divine [in the artist] has truly conceived the face and gestures of someone, then, with this double force [of spirit and of hand] upon a small and base model, he can breathe life into stones.'

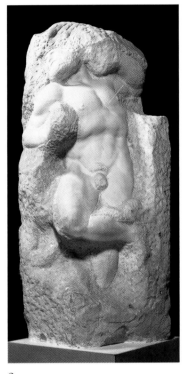

2
The feeling of captivity in this sculpture of a prisoner still trapped by the material is accentuated by its rough-hewn state. The statue became a symbol of human existence.

The fifth plan for the tomb of Julius II, in 1532, represented a crucial stage in the evolution of this monument. Michelangelo obtained fresh authorisation to organise it as he wished. While generally obliged to make use of the sculptures already completed he did nonetheless replace some of them with new ones. In the first place there was *Victory*, a statue of graceful proportions and serpentine line which accords in style with the stock of sculpture on the Medici tombs. The four rough-hewn slaves were intended probably for the lower level of the tomb. Their dating has been subject to much discussion. Michelangelo is generally thought to have sculpted the four figures between 1519 and 1534, with the major part of the work concentrated in 1532-4.

Victory portrays a slender young man with elegant hands and feet. He is resting his knee on his defeated foe who is more crudely sculpted, lacking the fine finish of the dominant figure. According to Panofsky, the group may be interpreted as an autobiographical allusion by Michelangelo who was portraying his relationship with Cavalieri. When Michelangelo embarked on *The Last Judgement*, the tomb was far from complete. Indeed it was not finished until 1542.

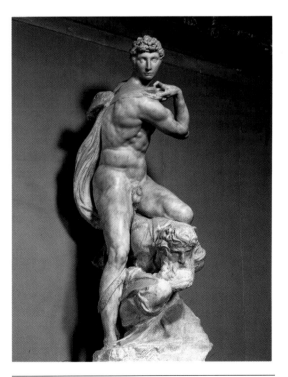

3/4
In its physique the figure symbolising *Victory* resembles the sculptures of Michelangelo's youth, such as *David*.

1 Tomb of Julius II,
Marble. San Pietro in Vincoli, Rome

2 *Slave waking*, between 1530 and 1534
Marble, H: 267 cm including base
Accademia, Florence

3/4 (detail, three-quarters)
Victory, 1532?
Marble, H: 261 cm
Palazzo Vecchio, Florence

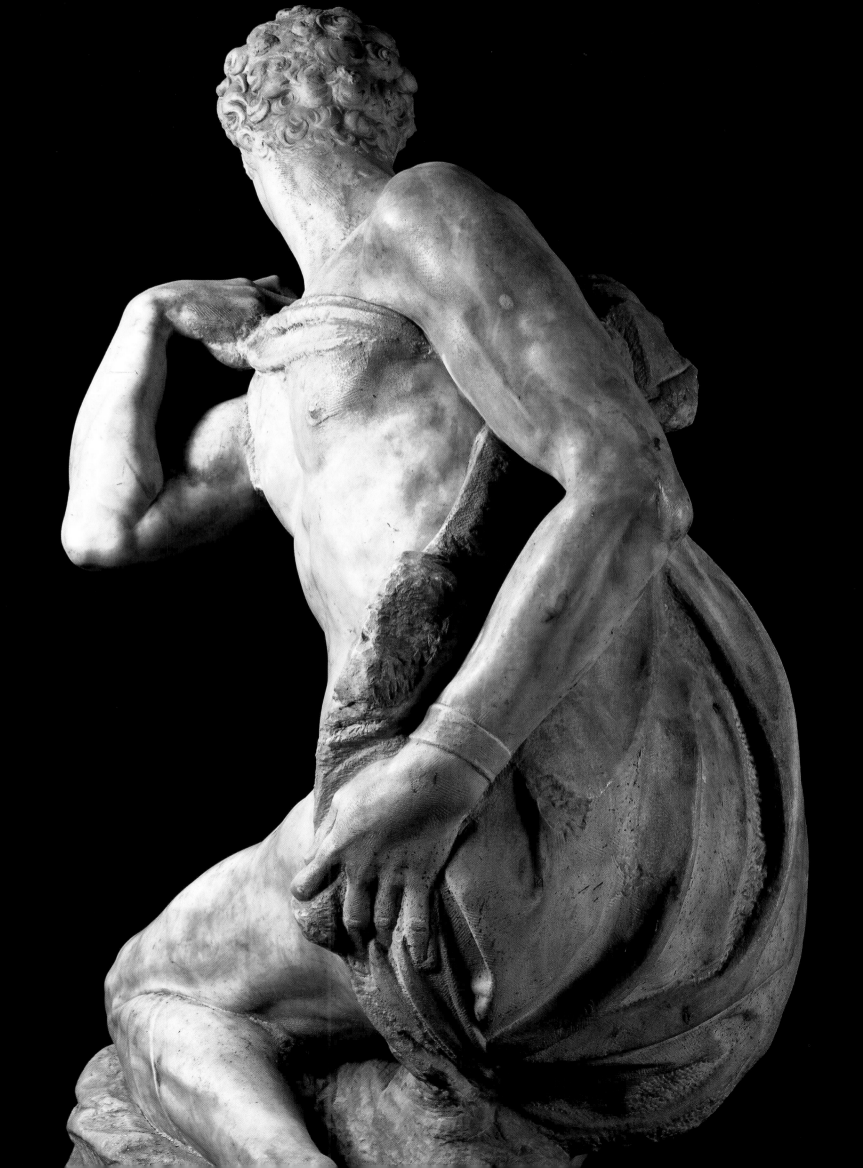

Vasari left us a list of the 'presentation drawings' produced by Michelangelo for Tommaso de' Cavalieri, a Roman of good family whom he met in 1532. This very handsome young man, drawn by Michelangelo (though the work is now lost), inspired in the artist a tremendous love imbued with Platonism, as numerous sonnets and letters testify.

1
Children's Bacchanal is iconographically mysterious. The scene appears to be set in a cavern. In the foreground are two adults in a state of wretchedness, while in the middle *putti* are bearing the carcass of a stag closer to the fire. The *putti* have no wings. If the drawing is a moral allegory, its meaning remains unclear.

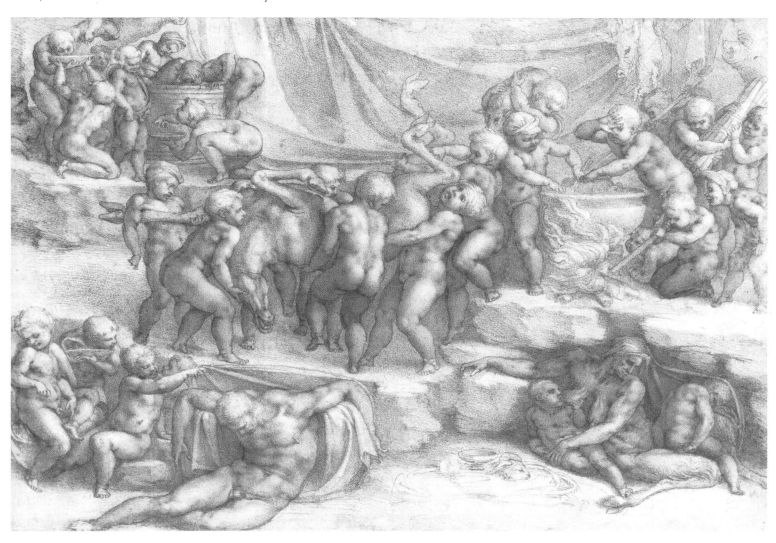

Towards the end of 1532, Michelangelo gave Cavalieri drawings of *Tityus*, tortured in Hades by a vulture who devoured his liver, and of *Ganymede* carried off to heaven. Both works are symbolic representations of the torments of amorous passion. Ganymede, the sole favourite of Zeus admitted to Olympus, was for Plato a justification of love between men, while Tityus suffered an attack to his liver – the seat of the passions – parallel to the torments of love, symbolised by the bird of prey. *The Fall of Phaethon*, drawn from Ovid's *Metamorphoses*, shows Phaethon losing control of the chariot of the sun, struck by Zeus with a thunderbolt and hurled into space. Below, his sisters are transformed into poplars and their cousin into a swan.

3
This composition also derives from the sculpture of antiquity. It brings to mind a sarcophagus relief that featured the same subject and was on view in Rome, close to Cavalieri's house.

1 *Children's Bacchanal*, c. 1533
Dark red chalk, 27.4 × 38.8 cm
Royal Library, Windsor

2 *Punishment of Tityus*, c. 1533
Black chalk, 19 × 33 cm
Royal Library, Windsor

3 *The Fall of Phaethon*, c. 1533
Black chalk, 41.3 × 23.4 cm
Royal Library, Windsor

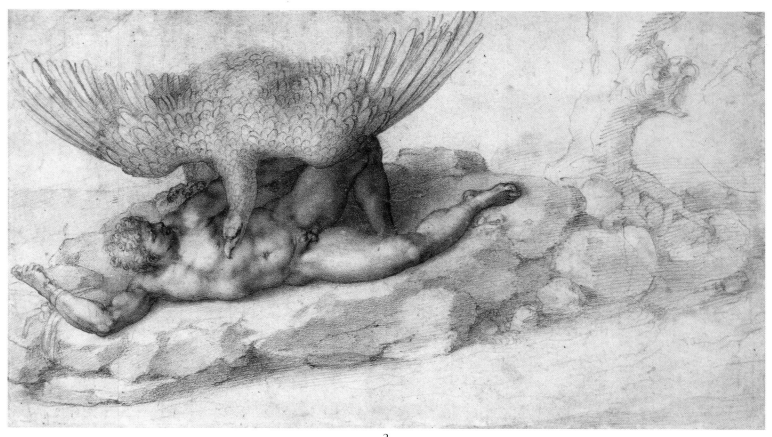

2
Tityus attests to the *riccordi* of antique sculpture, notably the *Fallen Giant* now in the Farnese collection. A sketch of the Risen Christ is on the back of the drawing.

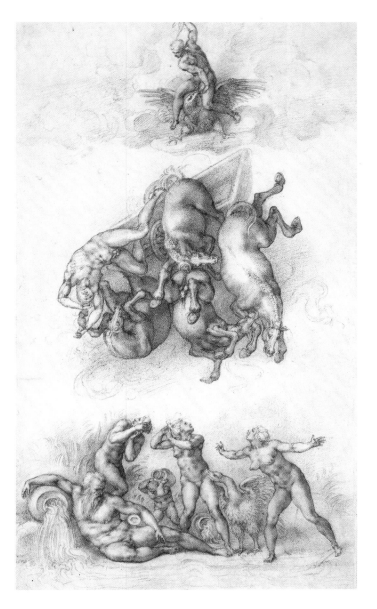

'Michelangelo was above all attached to Tommaso de' Cavalieri, a young Roman gentleman to whom he was drawn by his superior gifts; to teach him drawing he produced striking cartoons of wonderful heads in red and black chalk: he drew for him a Ganymede carried to heaven by Zeus' eagle, a Tityus whose liver is gnawed by a vulture, the Fall of Phaethon with the chariot of the sun falling into the Po, and a bacchanal of putti.' (*Vasari*)

'My soul smitten by its own salvation'

1
Jacopino del Conte (1510-98), a Florentine artist and pupil of Andrea del Sarto, settled in Rome around 1535. There he worked for the Roman aristocracy and painted numerous portraits. His portrait of Michelangelo is singularly powerful, albeit unfinished, and gives us an image of the artist at the age at which he produced *The Last Judgement*.

T he last thirty years of Michelangelo's life, from 1534, the date of his return to Rome, until 1564, the date of his death, were predominantly taken up with architectural work and poetry. He was the foremost artist in Italy, considered without rival. In 1535 he was appointed 'supreme architect, sculptor and painter to the apostolic palace'; in 1537, he was granted citizenship of Rome.

Michelangelo arrived in Rome a few days before the death of Pope Clement VII who had been responsible for commissioning *The Last Judgement*. The new Pope, Paul III Farnese, took over his predecessor's project, although work on it did not start until 8 November 1535, eight years after the Sack of Rome, and was then to continue for six years. Clement VII had had to bow down to Charles V and crown him Emperor in 1530. On his death, Paul III attempted to restore the authority of Rome and the Church. He commissioned Michelangelo on several projects. Michelangelo's first scheme for the altar-wall of the Sistine respected the existing decoration: Perugino's altarpiece, two lunettes also by his hand, two frescos, and the representations of the Popes. He subsequently sacrificed these, however, to leave himself free to occupy the entire altar-wall, on which he assembled a dense crowd of naked figures. These were arranged in relation to the central image of Christ who is charged with dynamic power, expressed in the forceful gesture of his arms. At his side the Virgin, in an expression of compassion, turns her face towards the resurrected who are awaiting judgement. The left side of the fresco is

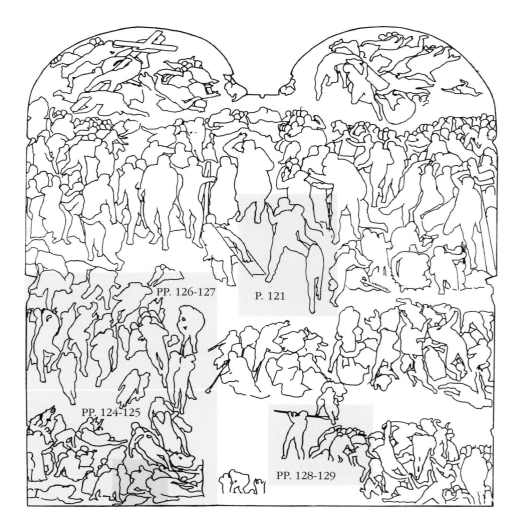

1 *Michelangelo Buonarroti*, Jacopino del Conte
Oil on wood, 88.3 × 64.1 cm
Metropolitan Museum (gift of Clarence Dillon), New York

2 Plan of *The Last Judgement* showing details reproduced (following pages)

3 *Saint Bartholomew*, detail of *The Last Judgement*
Sistine Chapel, Vatican

3
Saint Bartholomew is one of the group of martyrs brandishing the instruments of torture they were forced to endure on earth. Saint Bartholomew was burned alive. This is why he is holding out his skin, which is thought to bear a self-portrait of Michelangelo.

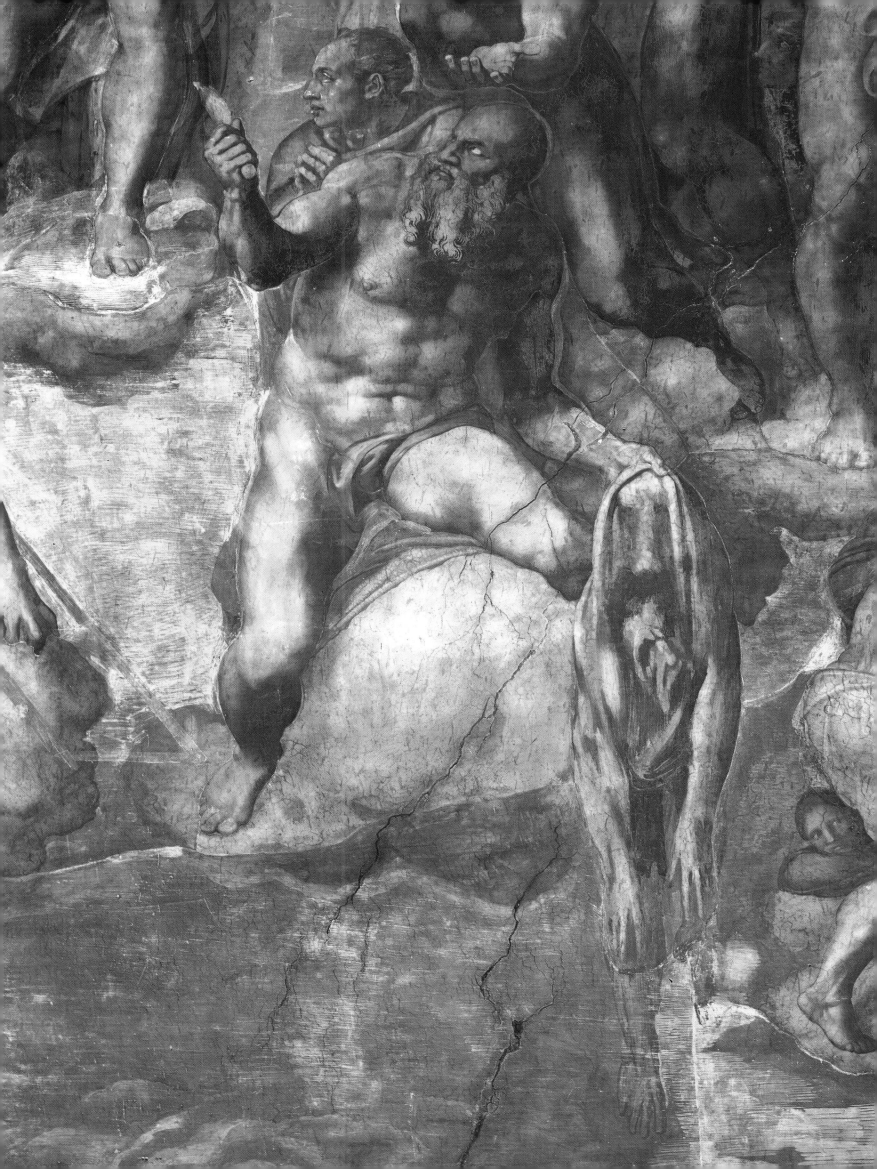

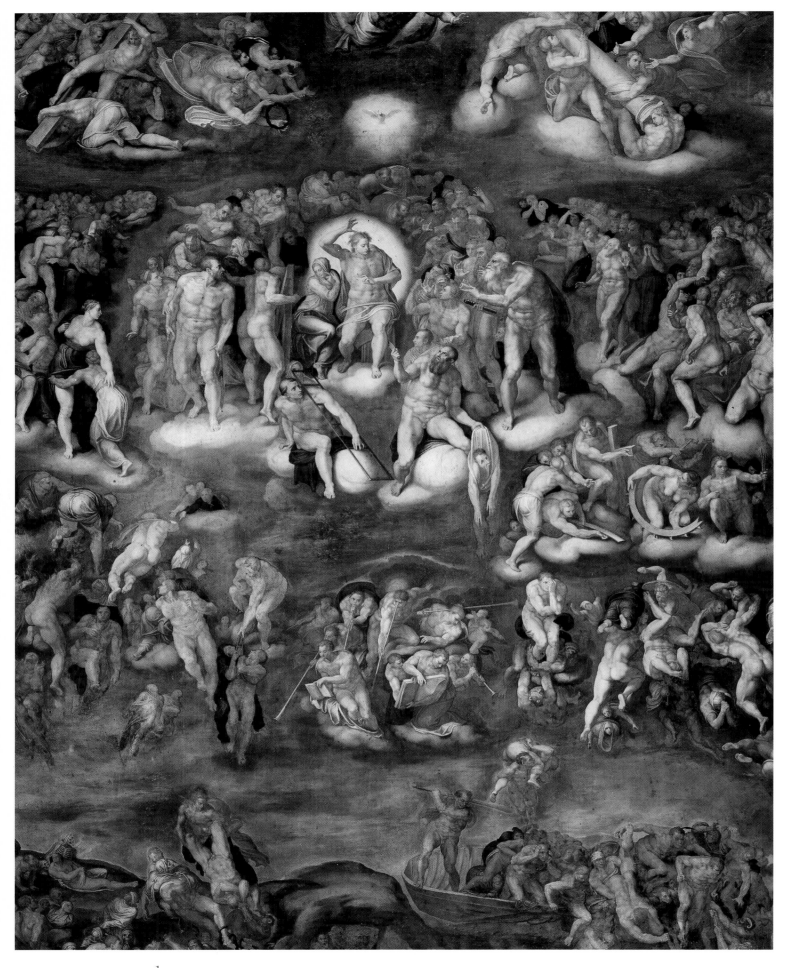

1

This copy, painted for Cardinal Alessandro Farnese, shows the fresco of *The Last Judgement* in its original state, before the prudish repainting imposed by the Counter-Reformation. Like the Sistine ceiling, *The Last Judgement* was frequently copied.

1 *The Last Judgement*, 1549. Venusti
Oil on wood, 187.5 × 144.5 cm
Capodimonte, Naples

2 *The Last Judgement*, 1536-41
Fresco, 17 × 13.3 m including base
Sistine Chapel, Rome

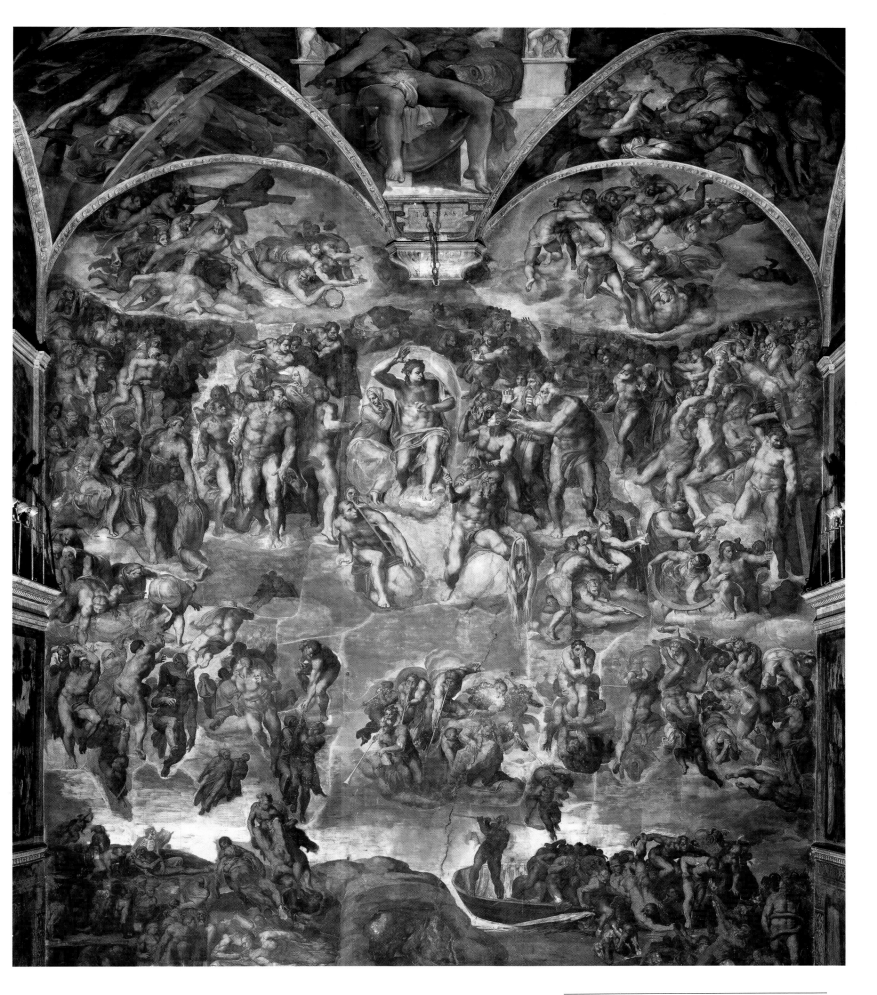

The coverings of modesty

following pages:
1 *The Resurrection*, detail of *The Last Judgement*, 1536-41
Fresco. Sistine Chapel, Vatican

2 *Group of the Resurrected*, detail of *The Last Judgement*
1536-41. Fresco
Sistine Chapel, Vatican

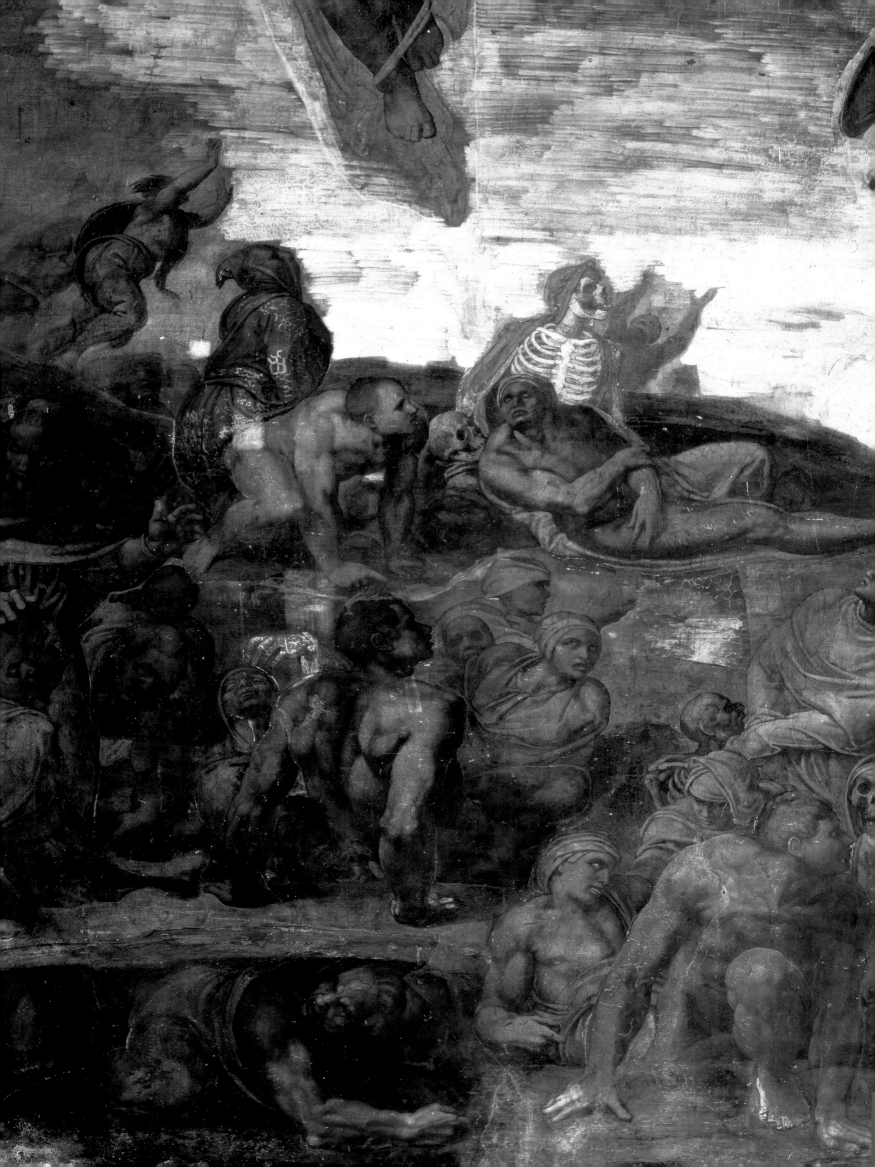

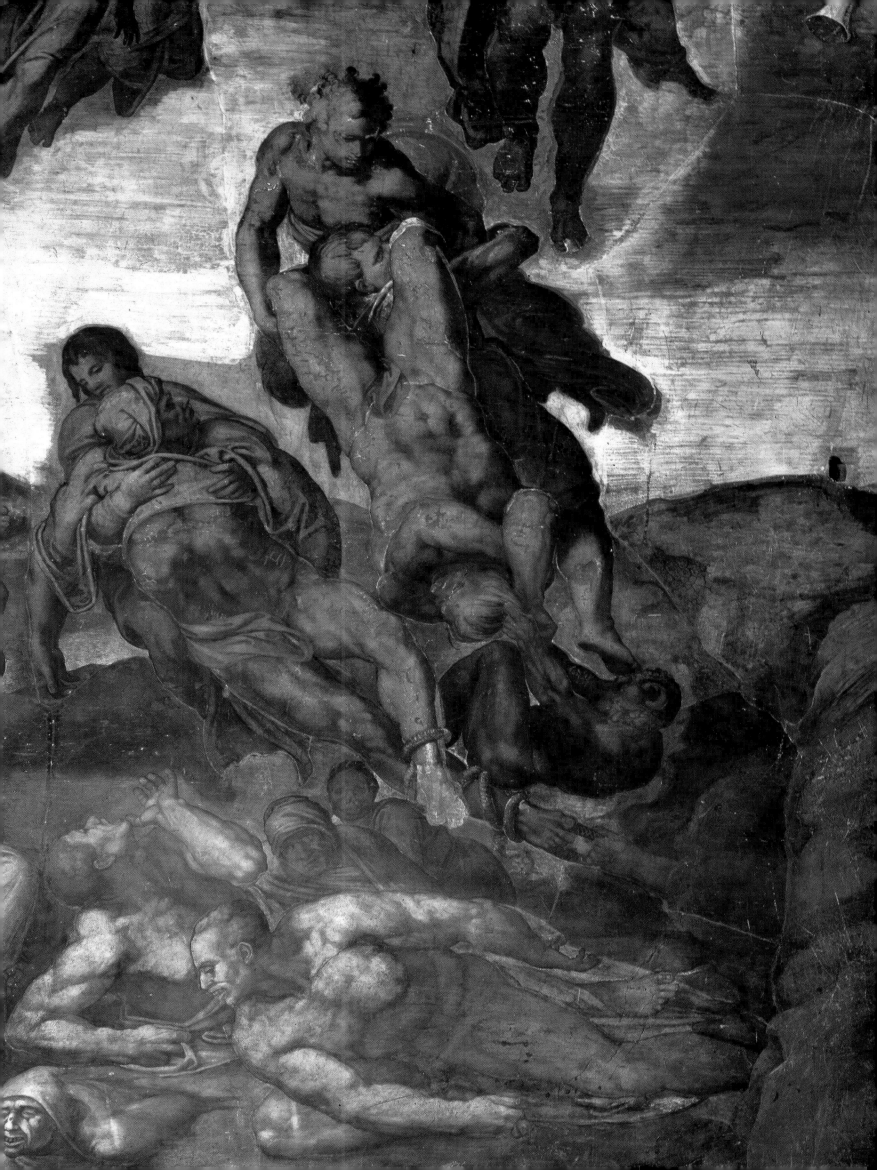

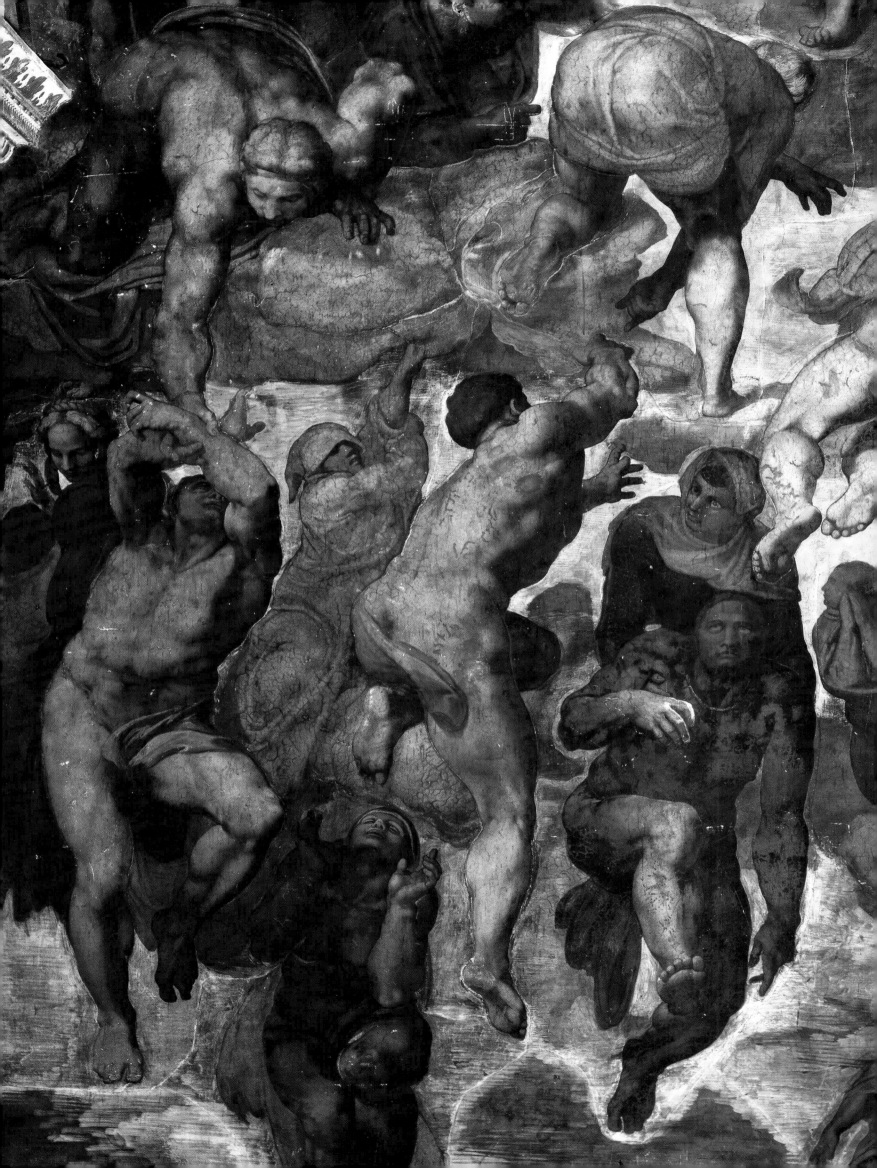

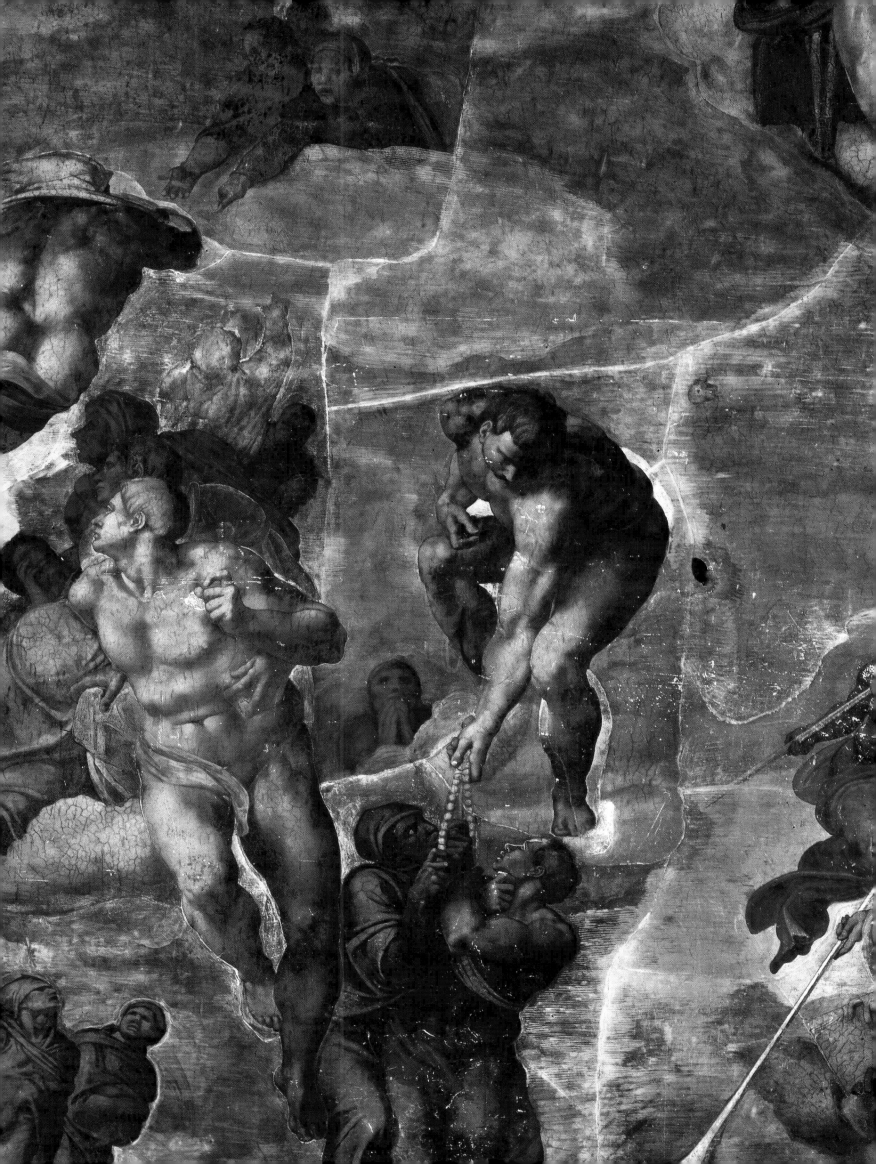

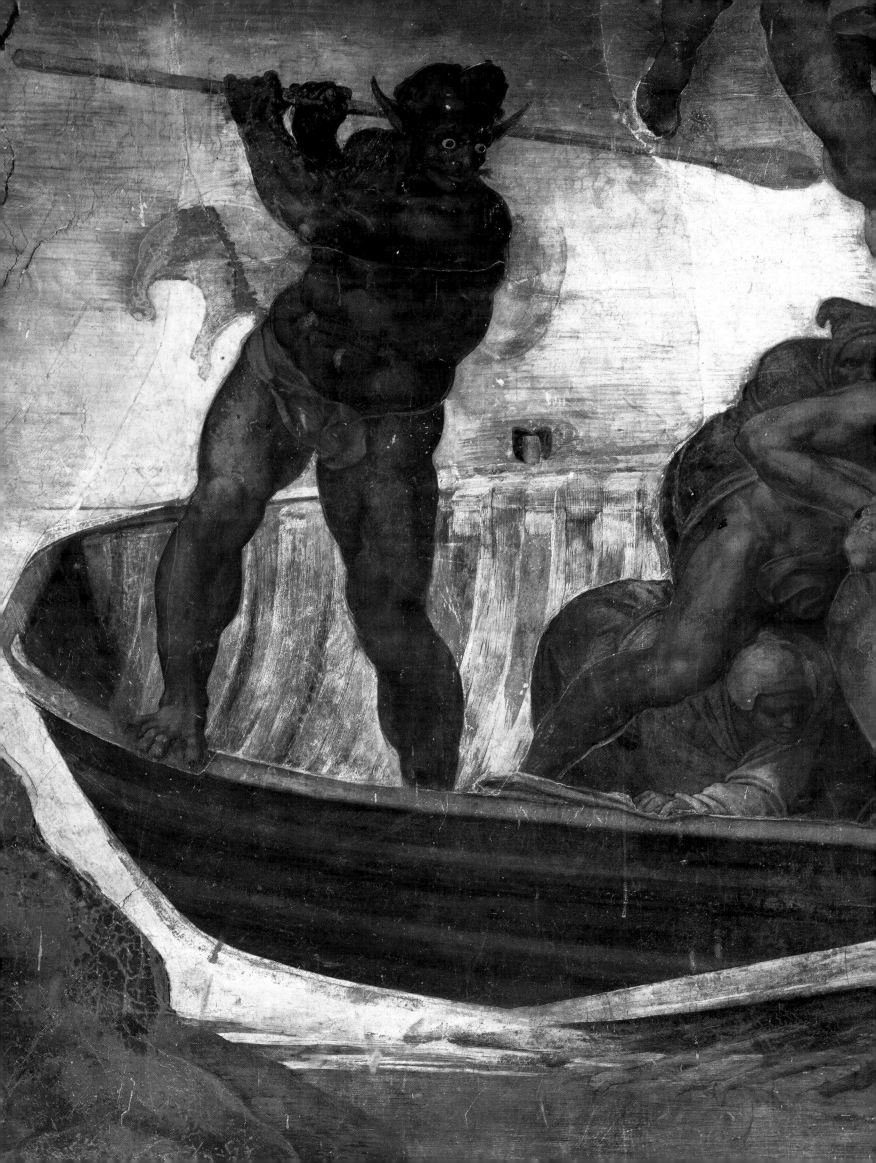

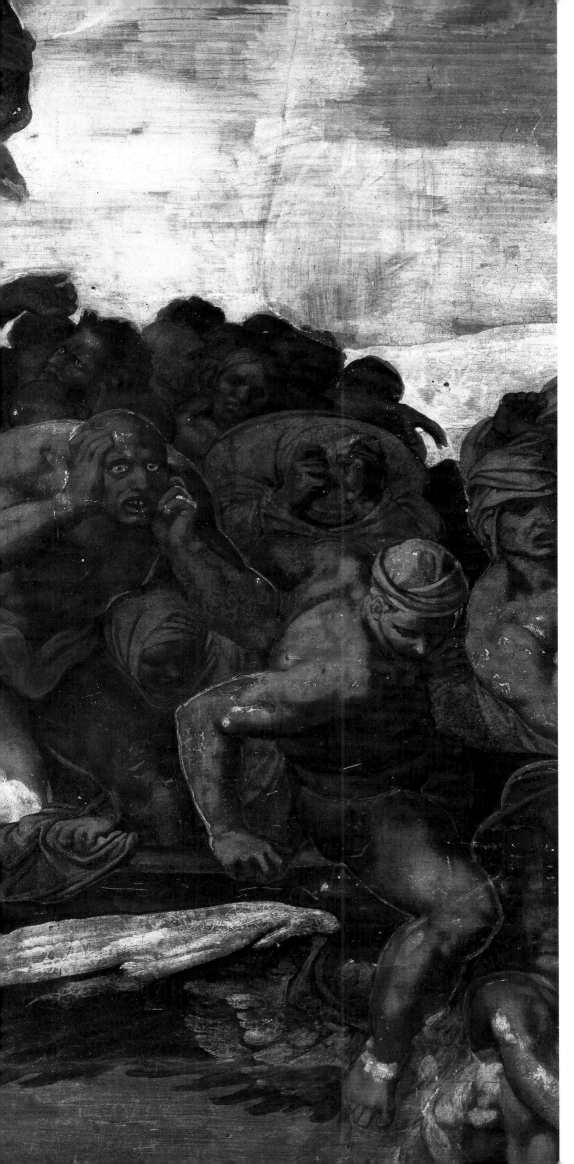

characterised by the ascensional movement of the bodies undergoing the Resurrection, while the right side, below the saints, depicts the fall of the damned with a descending movement. The latter cross the Acheron in an overloaded boat steered by Charon, who is portrayed with demented eyes, threatening his passengers with his oar. In place of the original lunettes, Michelangelo features genii bearing the instruments of the Passion with a wonderful rotational movement. When the whole fresco was uncovered in 1541 critical opinion exploded in all directions. One contingent of the Church and faithful considered that 'the naked figures exposing their private parts were unsuitable in such a place'. To Michelangelo these were supremely harmonious in their somewhat heavy beauty and athletic perfection. The harshness of conception nonetheless apparent in *The Last Judgement* corresponds to the artist's state of mind. He was increasingly prey to anguish and worry about the state of his soul. *The Last Judgement* is an expression of the catholicism Michelangelo had begun to practise with a few moderate humanist reformers, including Vittoria Colonna. This group envisaged a reform which would achieve compromise between the Roman Church and the Protestants. The final outcome of all these ideas was, as far as Michelangelo was concerned, a fervent catholicism which he expressed in many of his sonnets:

Now hath my life across a stormy sea/ like a frail bark reached that wide port where all/ are bidden, ere the final reckoning fall/ of good and evil for eternity./ Now know I well how that fond phantasy/ which made my soul the worshipper and thrall/ of earthly art, is vain; how criminal/ is that which all men seek unwillingly./ Those amorous thoughts which were so lightly dressed,/ what are they when the double death is nigh?/ The one I know for sure, the other dread./ Painting nor sculpture now can lull to rest/ my soul that turns to His great love on high,/ whose arms to clasp us on the cross were spread.

1 *Charon's Ferryboat*, detail of *The Last Judgement*
1536-41. Fresco
Sistine Chapel, Vatican

Following pages:
Two heads, detail of *The Last Judgement*
c. 1536-41. Fresco
Sistine Chapel, Vatican

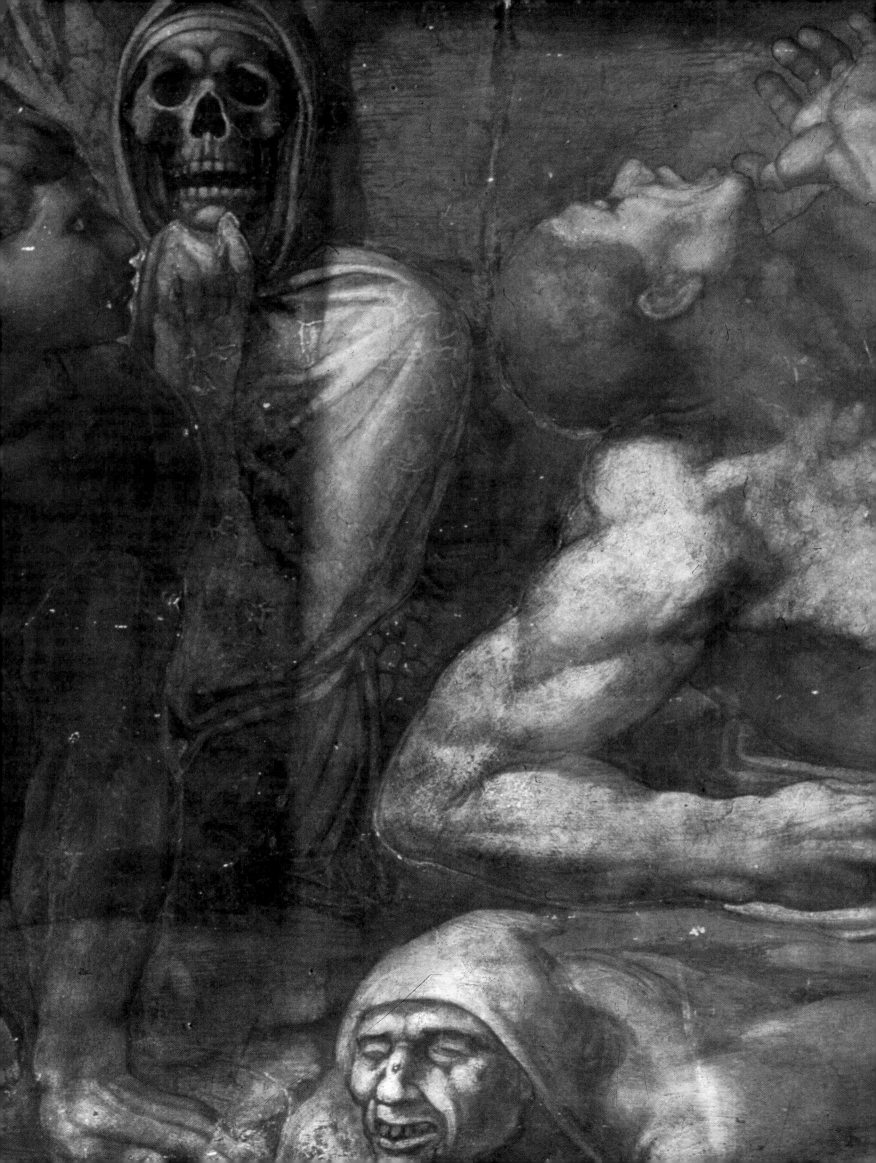

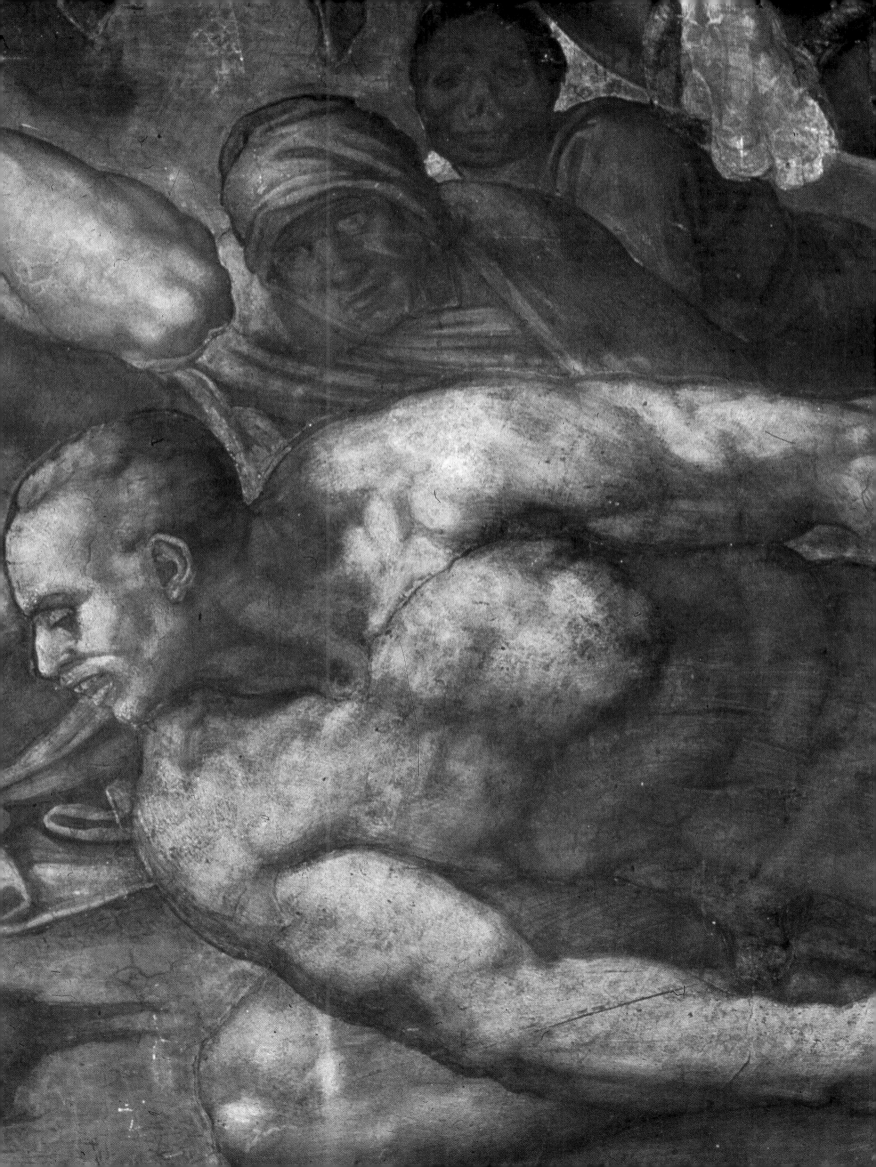

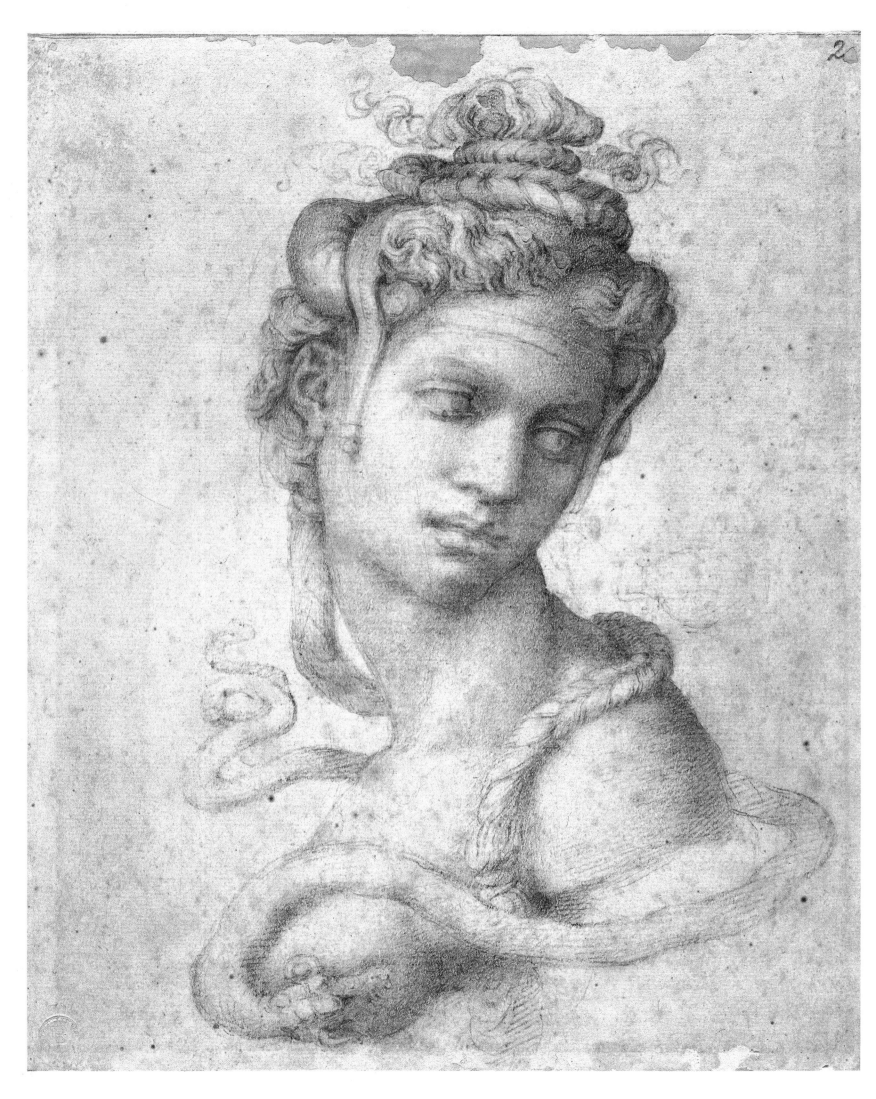

Divine Heads

The group of drawings described by Vasari as 'Teste Divine' – Divine Heads – is striking in its strangeness and novelty of subject. These studies of male and female heads appear to be imaginary portraits in deliberately antique style. The head of *Cleopatra*, perhaps inspired by Piero di Cosimo's portrait of Simonetta Vespucci, is a perfect example. The naked bust of the young woman is treated *al antica*, without arms. Moreover the artist fully respects ancient history: Cleopatra, Queen of Egypt, killed herself with the bite of an asp. Michelangelo leaves no ground for ambiguity of subject such as one finds in Piero di Cosimo's painting where the snake seems purely decorative. He resembles Piero di Cosimo, however, in his commendably careful rendering of the complicated hairstyle.

The drawing generally entitled *The Damned Soul* is inscribed with the name of the person for whom it was intended: Gherardo Perini. There are letters in existence confirming that Michelangelo gave him three drawings, of which this would have been one. This howling head – very beautifully rendered – can be taken as a metaphor of a damned soul.

The head of a young girl in a turban (now in the Uffizi, Florence) is currently considered a fine old copy of that in the Ashmolean Museum, Oxford. The Uffizi version provides further confirmation that Michelangelo's drawings were widely known and admired and copied like his work in the Sistine. This idealised head is generally thought to date from the Sistine period as it seems to represent a biblical character.

2
This *Portrait of Simonetta Vespucci* by Piero di Cosimo possibly inspired Michelangelo's *Cleopatra*. According to Vasari in the sixteenth century it belonged to Francesco da Sangallo, son of Giuliano da Sangallo.

1
This drawing, done for Tommaso de' Cavalieri, was given by the latter to Duke Cosimo de' Medici. A letter by Cavalieri dated 20 January 1562 declares that he made the gift reluctantly, feeling he was 'losing one of his children'.

1 *Cleopatra*, c. 1533-4
Black chalk
Uffizi, Florence

2 *Portrait of Simonetta Vespucci*, c. 1480
Piero di Cosimo
Oil on wood, 57 × 42 cm
Musée Condé, Chantilly

Following pages:
1 *The Damned Soul*, c. 1525
Black ink, 35.7 × 25.1 cm
Uffizi, Florence

2 *Head of Woman*, copy from Michelangelo
Uffizi, Florence

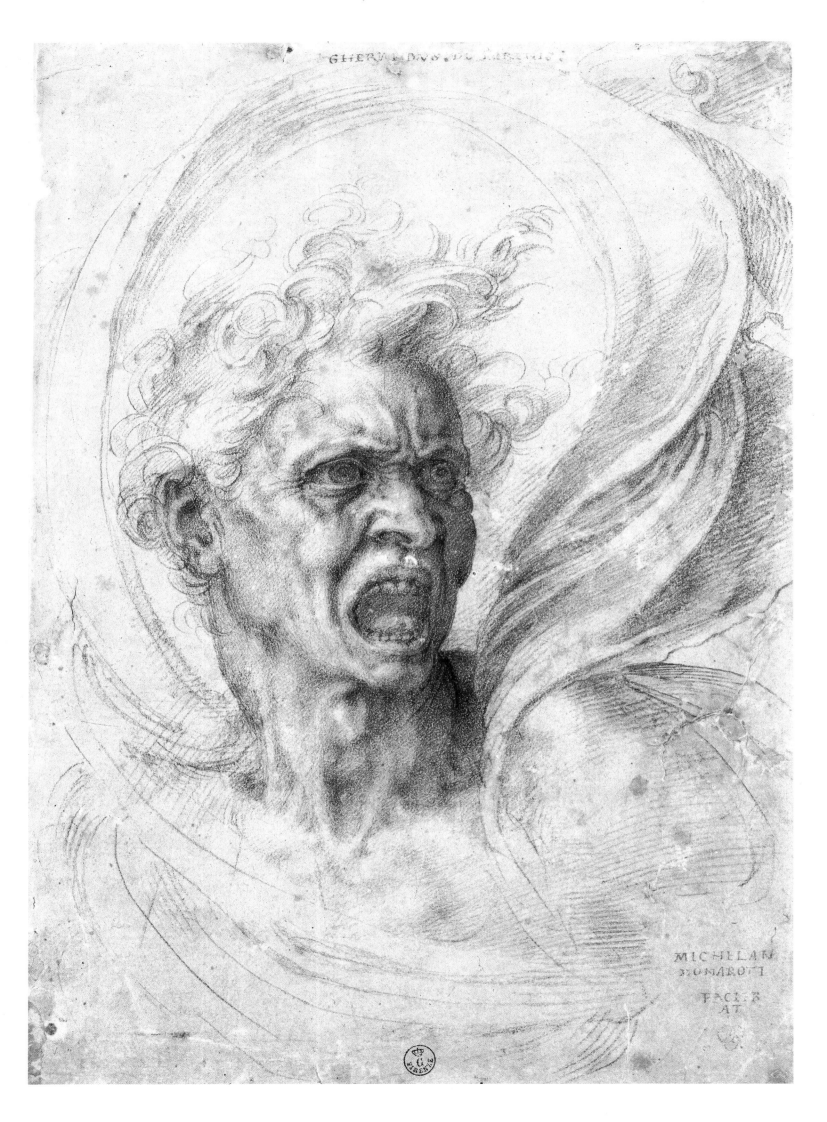

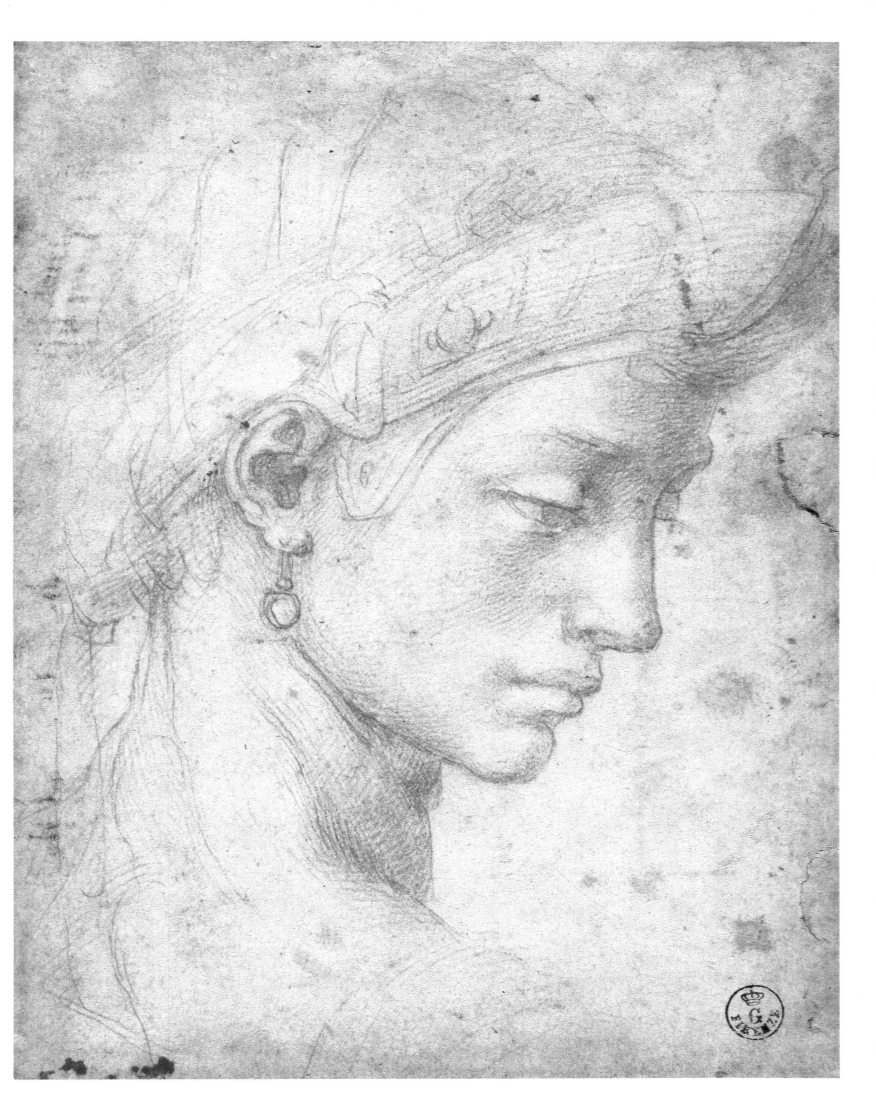

135

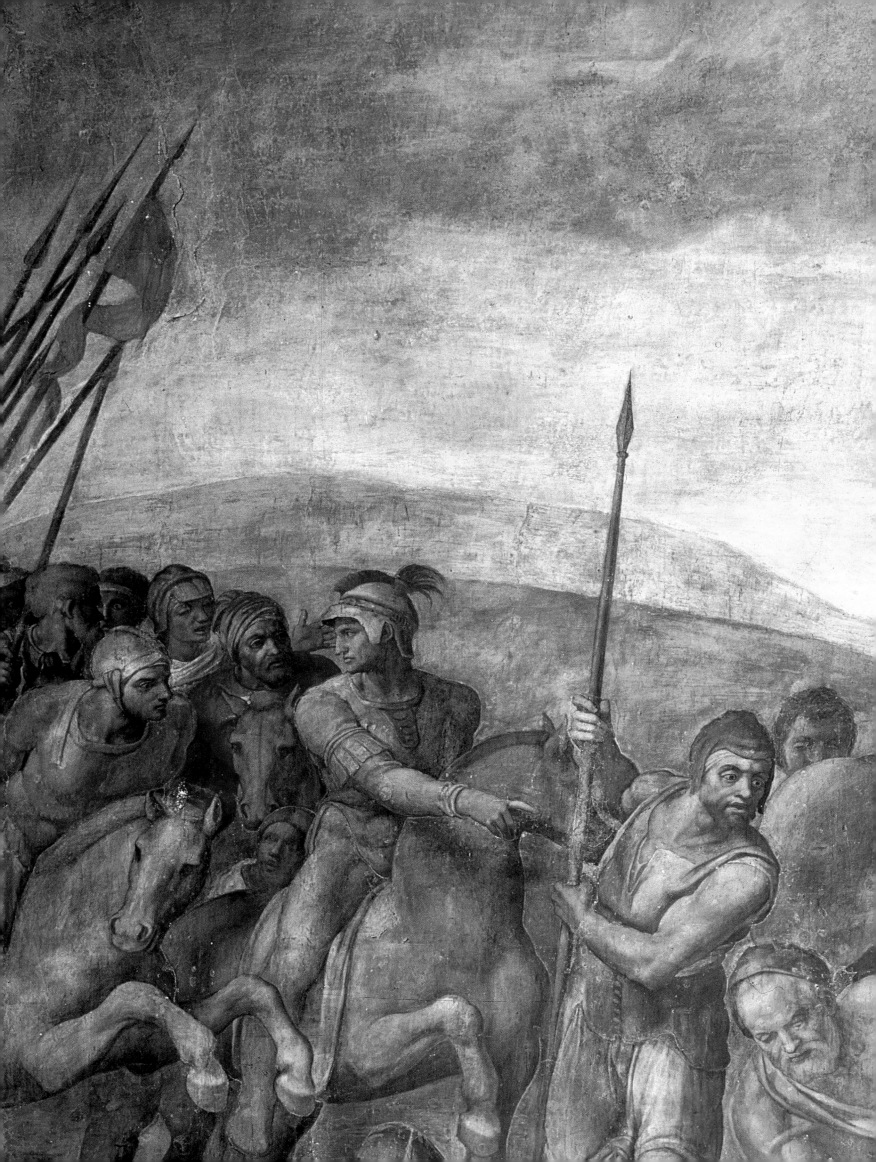

Saint Peter and Saint Paul: founders of the Church of Rome

'These were his last paintings, produced at the age of seventy-five. He spoke to me one day of fatigue: one discovers at a certain age that painting, particularly fresco, is not an art for old age.' (Vasari)

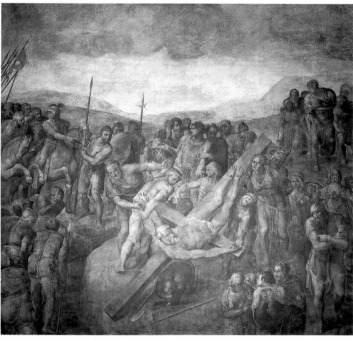

1/2/3
'Michelangelo . . . dreamed only of perfection; he eliminated landscapes, trees, buildings, and all the various embellishments of art. refusing to stoop to them, to let his genius stoop to such things' (Vasari). These compositions are indeed reduced to a few great lines, the horizon embodied as a great deserted region.

1 (detail)/2
Crucifixion of Saint Peter, 1545-50
Fresco, 625 × 661 cm
Cappella Paolina, Vatican

3/4 (detail)
Conversion of Saint Paul, 1542-5
Fresco, 625 × 661 cm
Cappella Paolina, Vatican

After *The Last Judgement*, Paul III commissioned Michelangelo to paint two frescos in his private chapel, the Cappella Paolina, newly built by Antonio da Sangallo the Younger. The first fresco was probably the *Conversion of Saint Paul*, started in July 1542 and finished in 1545. The following year the artist embarked on a second fresco, work on which took him up to the early 1550s. These two compositions, focused on the altar, and devoted to the two Apostles who founded the Church of Rome, depicted an important moment in the lives of each of these two saints: conversion and martyrdom. The conversion of Saint Paul is represented traditionally in terms of his fall from his horse, struck by divine grace. Christ is shown in the midst of a whirlwind, at the top of the fresco, his act of grace visualised as a beam of yellow light falling towards the saint, who is surrounded by soldiers. Michelangelo diverges from tradition, however, in portraying Saint Paul as an old man, struck down by God, seeming that very instant to realise all the errors of his past life. The curve of Saint Paul's body brings to mind images of the river gods of antiquity.

The *Crucifixion of Saint Peter*, in accordance with history, represents the martyrdom of the saint crucified upside down. Saint Peter was punished thus at his own request, as he had not considered himself worthy to suffer the same martyrdom as Christ. Michelangelo nonetheless found a way of portraying him with his head lifted, his gaze turned to the viewer, so that he becomes the central focus of the composition.

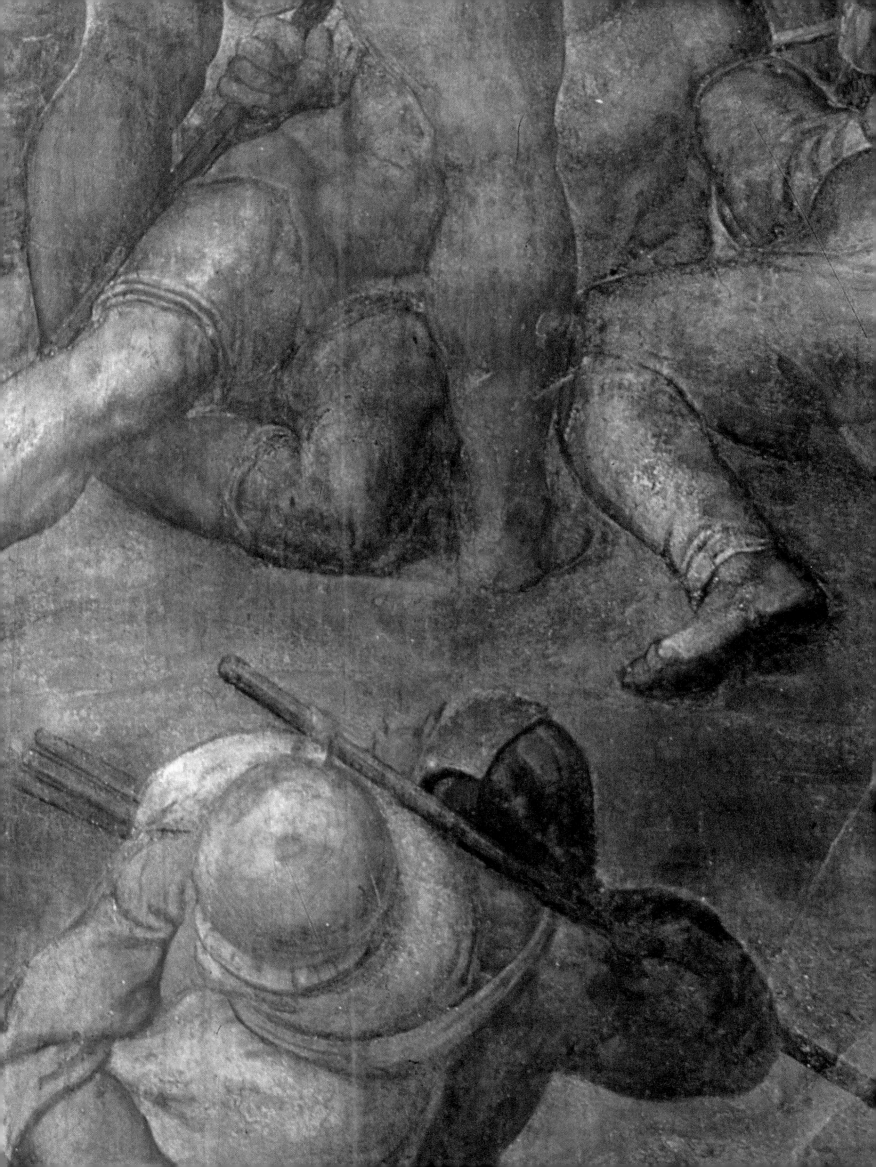

In 1549, Paul III appointed Michelangelo architect in charge of Saint Peter's. He was seventy-one years old when he undertook this commission. The history of the architecture of Saint Peter's begins with Bramante, under the pontificate of Julius II. On the death of this architect, first Raphael took charge of the project, then, in 1520, until his death in 1546, Antonio da Sangallo the Younger.

The last architectural works

Michelangelo next became responsible for the works and took particular interest in the construction of the dome. His source of inspiration here was Brunelleschi's dome in Santa Maria del Fiori in Florence. The idea of raising the dome on a high drum gave it a more elongated form in which the lantern played an essential role. On Michelangelo's death the dome had been constructed as far as the drum, the southern arm of the transept completed, the northern arm taken as far as the vaults, and the apse on the western side just begun. Michelangelo's architectural activities did not stop here. He drew plans for the church of San Giovanni dei Fiorentini, and for the conversion of Diocletian's Baths to a church. A plan for the rearrangement of the Capitoline Hill was brought to a halt before 1548; only a small part of it was to be effected in the artist's lifetime. In parallel with his work on Saint Peter's, he was also architect for the Palazzo Farnese, and a few years before his death he produced plans for the Porta Pia.

2
Titian, who, in Michelangelo's eyes, would have been the greatest of all painters had he more perfectly mastered drawing, was heaped with honour as an artist. He was a great portrait painter and this picture done in Rome of the Pope with his great-nephews shows an acute psychological perception.

1 Piazza del Campidoglio, Rome

2 *Paul III Farnese with his great-nephews
Alessandro and Ottavio*, 1546. Titian
Oil on canvas, 200 × 173 cm
Capodimonte, Naples

3 Dome of Saint Peter's, Vatican

140

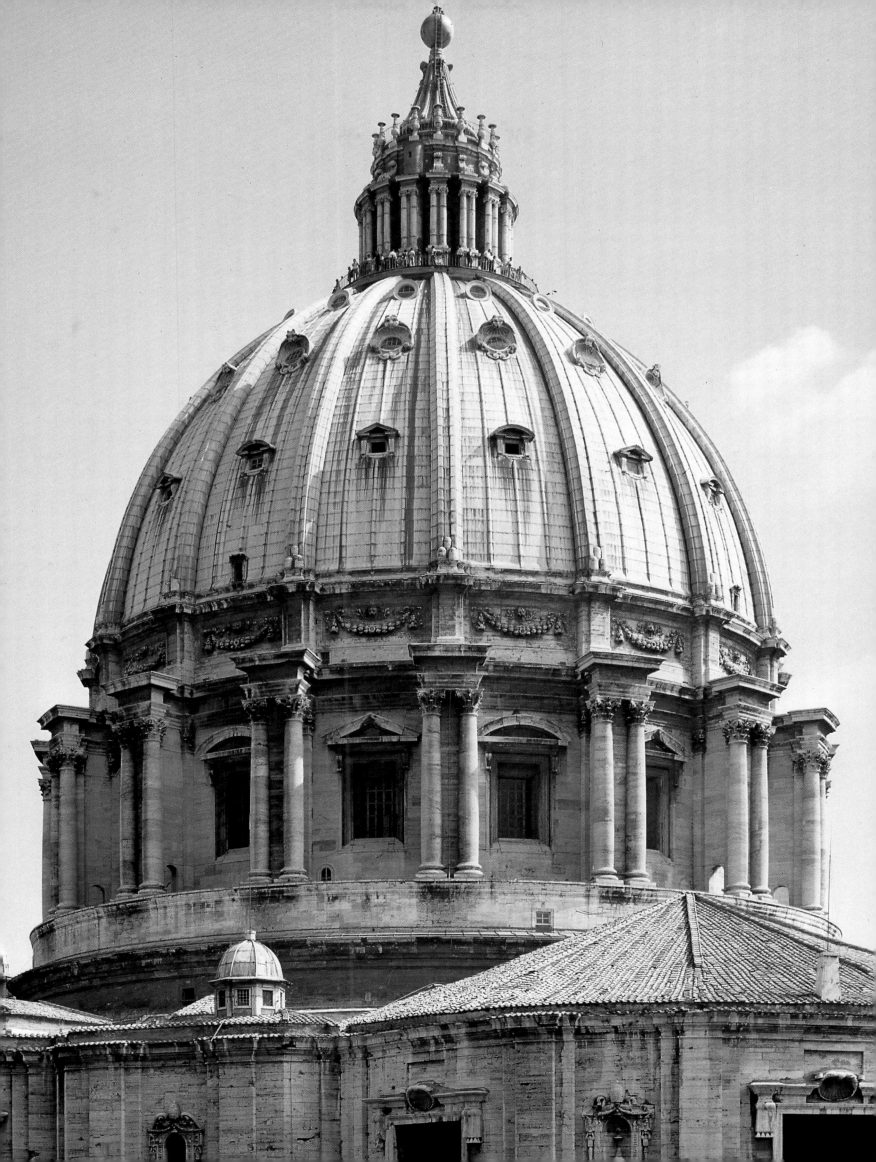

'The Pope having asked Michelangelo for a plan for the Porta Pia,
he produced three, all exceptional and of great beauty;
the Pope decided to carry out the least onerous,
which is what one sees today and is much admired.' (Vasari)

1
The erection of a monumental gateway at the end of the existing Via Settembre in Rome was part of the Pope's renovation project for the area. Michelangelo completed his project at the age of eighty-six, three years before his death. Numerous drawings testify to his great interest in this commission.

2
This drawing is mentioned several times in Michelangelo's correspondence with Vittoria: 'I placed my greatest faith in God that He might give you supernatural grace in painting the Christ. I have since seen this admirable work which surpasses all I might have hoped of you in every way . . . I tell you that I am greatly delighted that the angel on the right is by far the most beautiful, because it is Michael, and he will place Michelangelo at the Lord's right hand on the last day.'

1 *Study for the Porta Pia,*
superimposed on drawings of figures, c. 1561
Black chalk, pen & brown ink, brush
& brown wash, white gouache, 44.2 × 28.1 cm
Casa Buonarroti, Florence

2 *Crucifixion for Vittoria Colonna,* 1538-41
Black chalk, 37 × 27 cm
British Museum, London

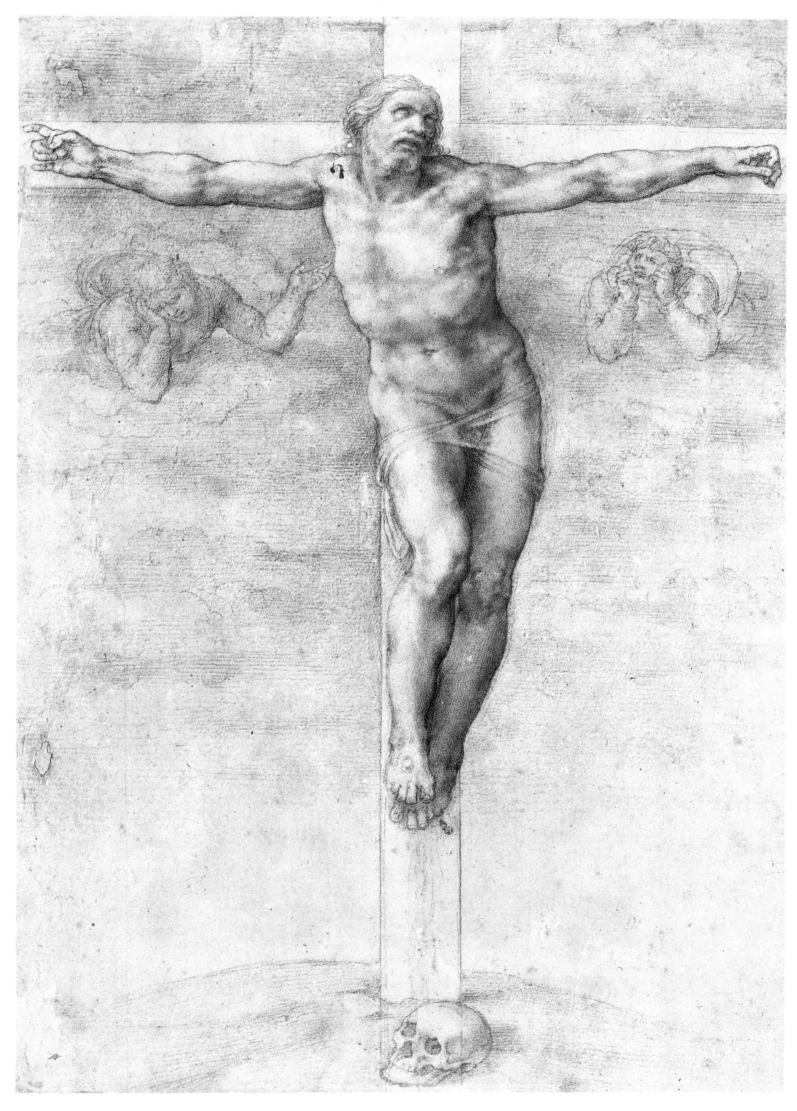

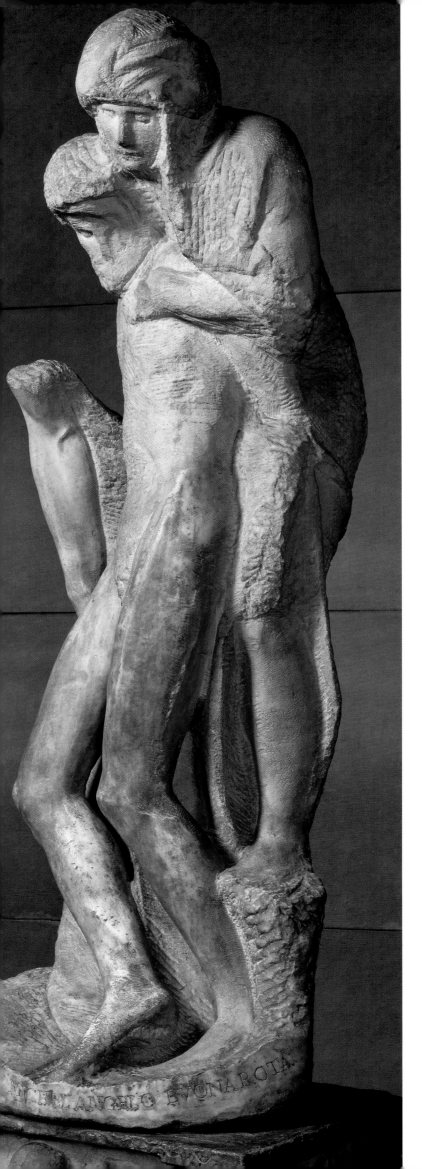

Michelangelo's friendship with the widow of the Marquis of Pescara, Vittoria Colonna, whom he met around 1536, played an important part in his spiritual development. On the death of her husband, Vittoria Colonna had retreated to a convent where she devoted herself to writing and to the religious problems that had been threatening Rome and Christianity for some years. In the convent of Saint Catherine at Viterbo, a number of humanists gathered round Cardinal Reginald Pole, among them Michelangelo. Preoccupied by the doctrine of salvation, they debated the subject of free will and the justification of religion by faith, trying to find an equilibrium between these beliefs and the works they considered equally essential to a Christian life. In 1538 Michelangelo and Vittoria met to discuss religion and art, every Sunday at Saint Sylvester's, a Dominican convent in Monte Cavallo. *Dialogues with Michelangelo*, written by Francisco da Hollanda, gives us an insight into this part of his life. This group of moderate reformers found a basis for its beliefs in the Epistles of Saint Paul. Michelangelo, lost in admiration and love for Vittoria, gave her several drawings of the *Crucifixion* and the *Pietà*, as well as one of the *Samaritan*, of which only an engraving is left to us. The subjects on which he worked up to his death betray a strong religious feeling. The concept of sacrifice is given prominence: Christ on the cross, still alive, turns his face to God and asks him not to forsake him; the inscription on the cross, behind the Pietà, recalls the blood Christ has shed for humanity. The *Pietà Rondanini* is a last message from the artist who portrays there a real union of Mother and Son, suffering together for the salvation of mankind. This Pietà is characterised by its elongated proportions and the imbrication of the two bodies in a long vertical spiral. Michelangelo was working on it in the last days of his life.

1/2 (detail) *Pietà Rondanini*, final version 1564
Marble, unfinished, H: 195 cm
Castello Sforzesco, Milan

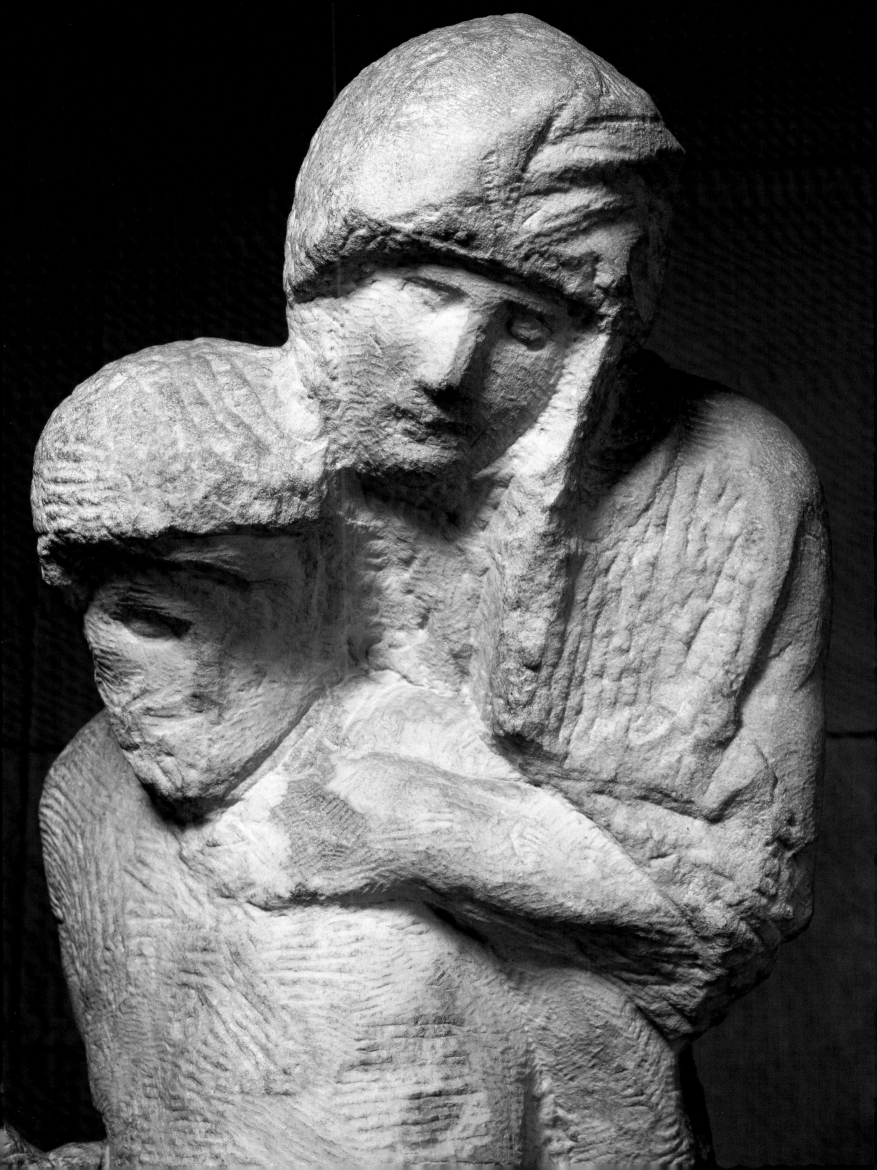

In the service of a new Church

2

Vittoria Colonna also had a copy of this *Pietà*. The Christ, in contrast to the first *Pietà* for Saint Peter's, is the central focus of the composition, arranged in vertical position between his Mother's knees, his arms supported by two angels. The inscription on the cross NON VI SI PENSA QUANTO SANGUE COSTA is a line from Dante's *Il Paradiso*.

*The fables of the world have filched away
the time I had for thinking upon God;
the grace lies buried 'neath oblivion's sod,
whence springs an evil crop of sins alway.*

*What makes another wise, leads me astray,
slow to discern the bad path I have trod:
hope fades; but still desire ascends that God
may free me from self-love, my sure decay.*

*Shorten half-way my road to heaven from
 earth!
Dear Lord, I cannot even half-way rise,
unless Thou help me on this pilgrimage.*

*Teach me to hate the world so little worth,
and all the lovely things I clasp and prize;
that endless life, ere death, may be my wage.*

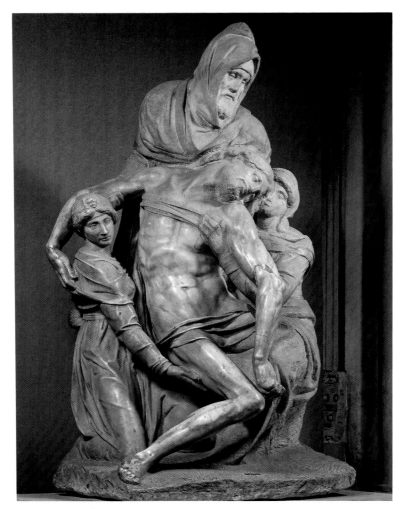

1
This group was executed by Michelangelo for the altar of a church where he envisaged being buried. Michelangelo is traditionally identified with Nicodemus. The very year of the artist's death, Vasari wrote to Leonardo Buonarroti about this *Pietà*: ' . . . and there is an old man there in whom he has represented himself'. According to legend, Nicodemus was a sculptor and considered to be responsible for the Volto Santo of Lucca Cathedral.

1 *Pietà, c.* 1550
Marble, H: 226 cm
Museo dell'Opera del Duomo, Florence

2 *Pietà c.* 1540-4
Black chalk, 29 × 19 cm
Isabella Stewart Gardner Museum, Boston

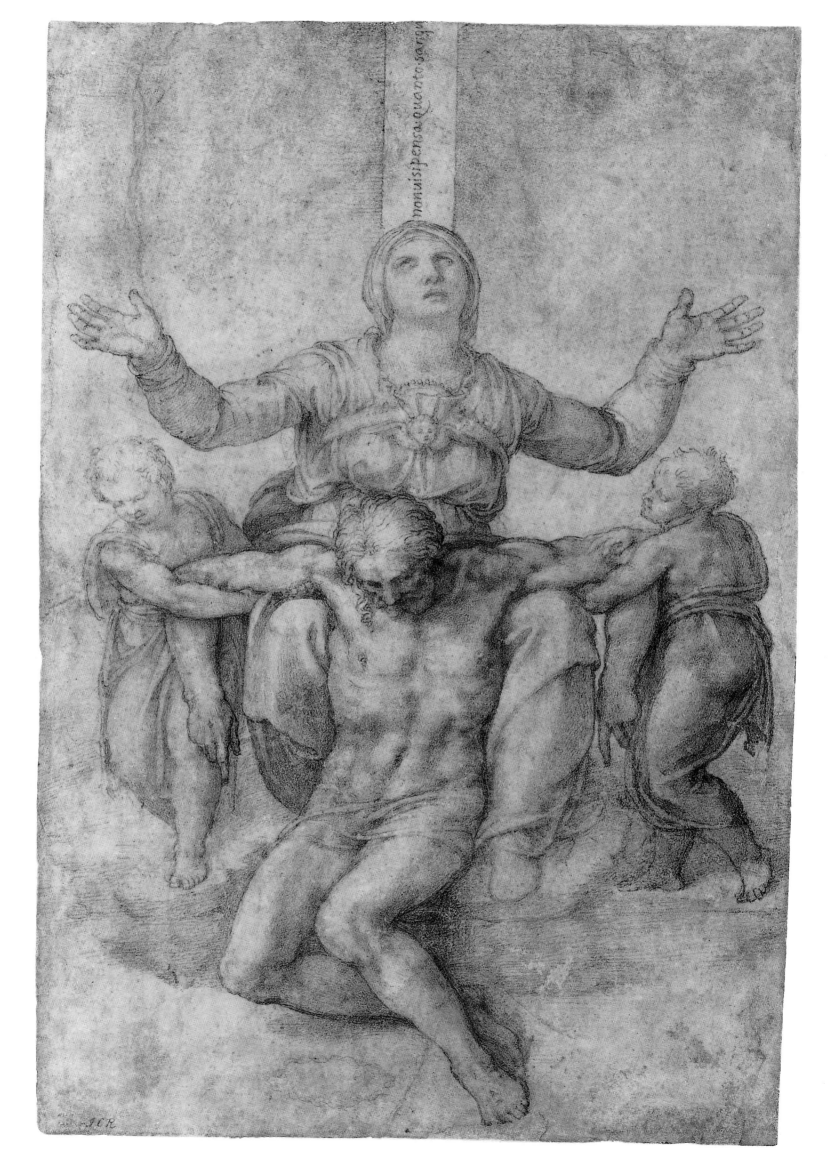

Looking towards an eternal life

Vittoria Colonna's death in 1547 'left him dazed by grief and almost mad', wrote Condivi, going on to add that 'he had known no greater sorrow in this world than to have let her depart this life without having kissed her forehead, or her face, but only her hand'. Many poems testify to the lasting affection that Michelangelo bore for Vittoria.

The last years of his life found him no less occupied by drawing: though his eyesight was failing, he spent hours seated at his work. The abstemious life he had led, concentrated solely on his art, continued until his death. The famous words the artist spoke to his pupil Ascanio Condivi are an apt summing up: 'Ascanio, rich as I have been, I have always lived like a poor man!' Michelangelo's last drawings of note are his series of *Crucifixions*, or more precisely his six variations on this subject which, once again, reflect his strong religious preoccupations. These drawings trace the artist's development as he aged and faced death. The *Virgin and Saint John*, each time grouped differently around the cross, vary also in their expressions. The *Crucifixion* in the Royal Library, Windsor, is notable for its conveyal of the Virgin's grief as she clutches her own face. Saint John is always less clearly defined, the real dialogue being that between Mother and Son. Michelangelo died on 18 February 1564, at the age of eighty-nine. His body was secretly transported to Florence as he had made clear to his nephew that he wished to be buried close to his father. The solemn funeral ceremonies took place at San Lorenzo; all the artists of Florence had helped in the organisation of the great catafalque. Afterwards Michelangelo's body was taken to Santa Croce where a monument was erected under the personal supervision of Duke Cosimo de' Medici.

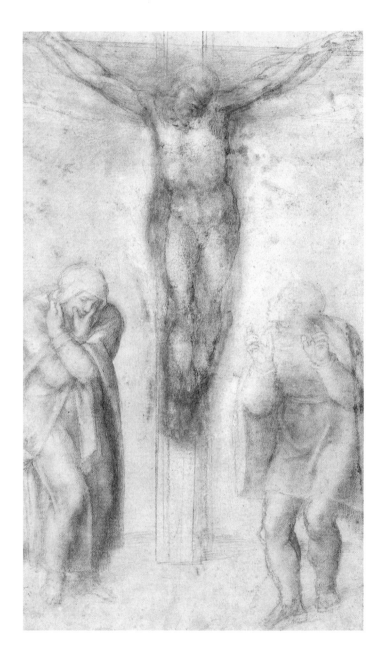

1 *Crucifixion with the Virgin and Saint John*
c. 1552-4
Black chalk & white lead, 38.2 × 21 cm
Royal Library, Windsor

2 *Crucifixion with the Virgin and Nicodemus*
c. 1552-4
Black chalk, touches of brown wash,
white lead, 43.3 × 29 cm
Musée du Louvre, cabinet des dessins, Paris (RMN)

Following pages:
1 *Crucifixion with the Virgin and Saint John*
Black ink & white lead, 41.2 × 27.9 cm
British Museum, London

2 *Crucifixion with the Virgin and Saint John*
Black ink & white lead, 41.3 × 28.6 cm
British Museum, London

The series of *Crucifixions*, variations on a theme, are characterised by the extreme care Michelangelo brought to his works. The crosses are traced with a ruler. White lead and gouache technique were used to cover details that displeased him.

148

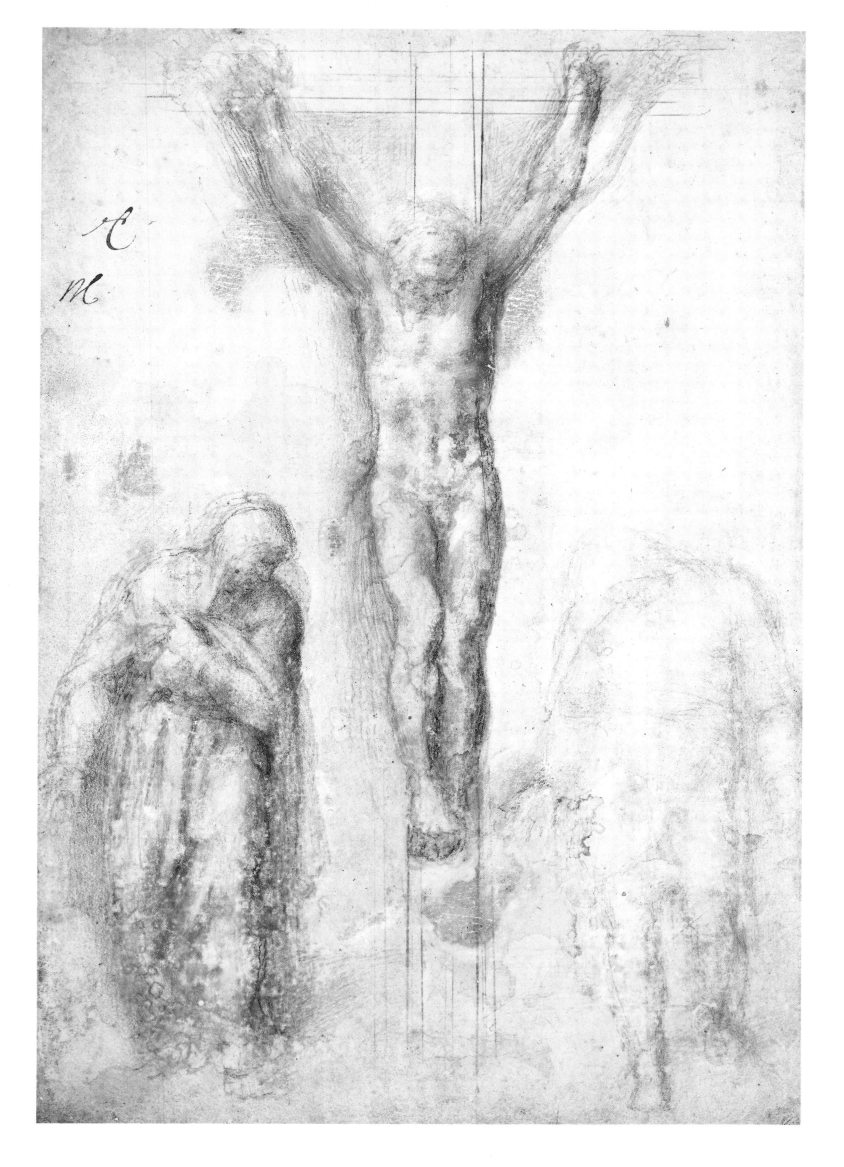

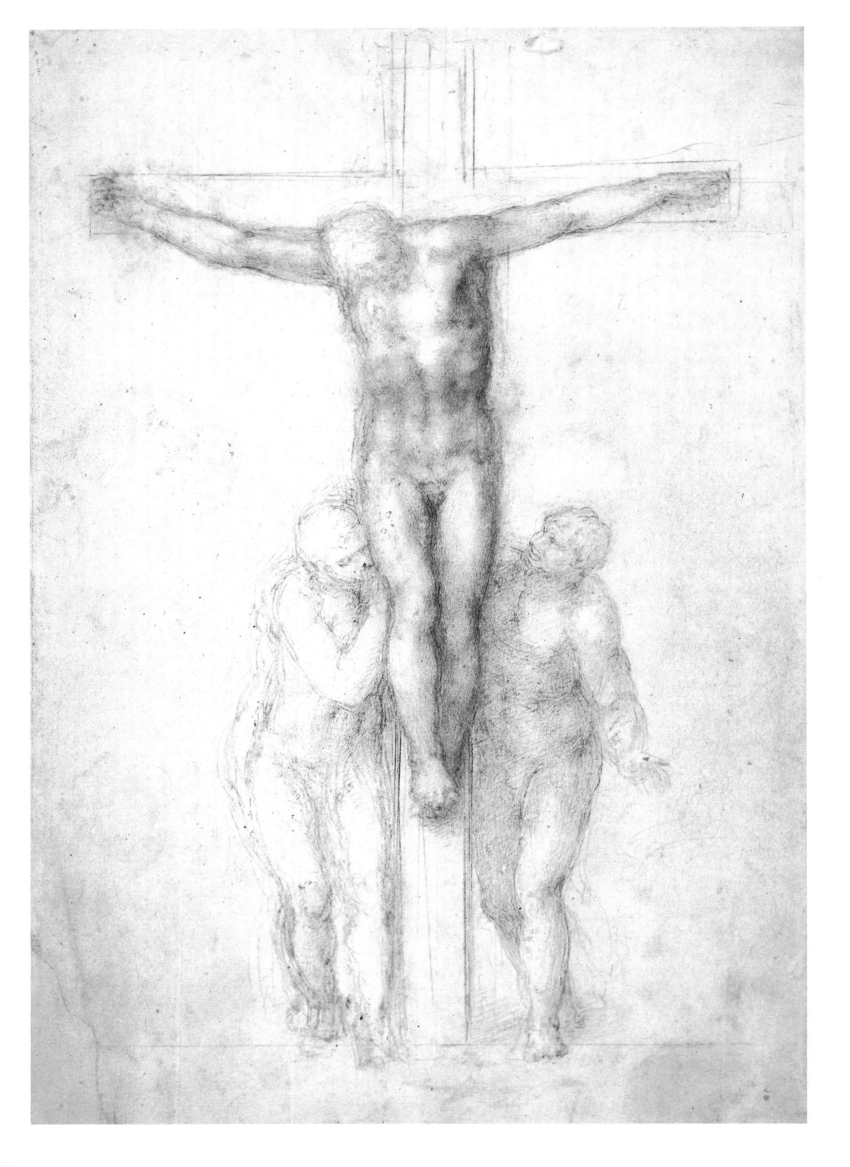

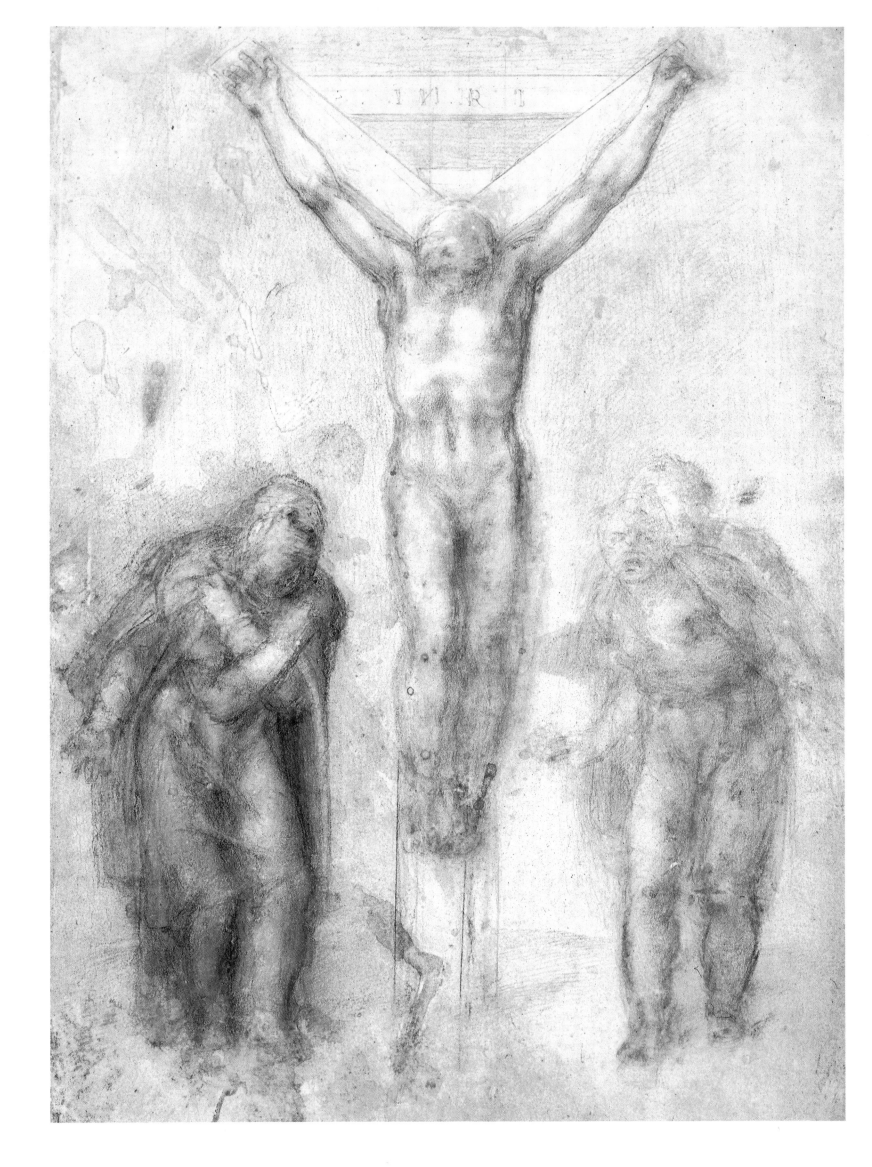

Catalogue of other main works

1

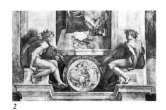

2

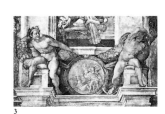

3

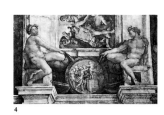

4

5

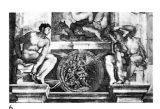

6

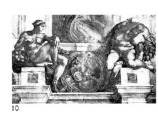

7

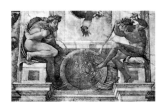

8

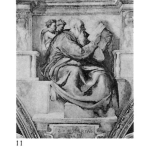

9

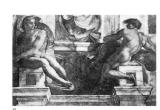

10

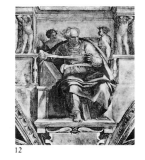

11

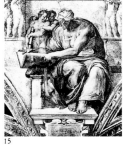

12

13

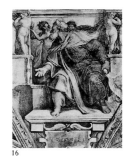

14

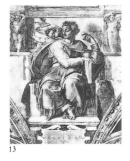

15

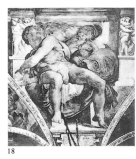

16

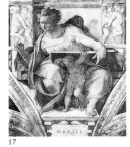

17

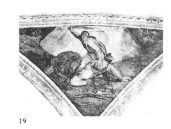

18

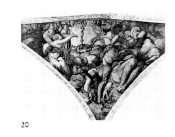

19

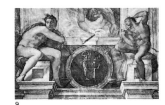

20

1 *Pair of Ignudi above Delphic Sibyl*, 1509
Fresco, 190 x 385 cm
Sistine Chapel (ceiling), Rome

2 *Pair of Ignudi above Joel*, 1509
Fresco, 190 x 385 cm
Sistine Chapel (ceiling), Rome

3 *Pair of Ignudi above Isaiah*, 1509
Fresco, 190 x 395 cm
Sistine Chapel (ceiling), Rome

4 *Pair of Ignudi above Erythraean Sibyl*, 1509
Fresco, 190 x 390 cm
Sistine Chapel (ceiling), Rome

5 *Pair of Ignudi above Cumaean Sibyl*, 1509-10
Fresco, 195 x 385 cm
Sistine Chapel (ceiling), Rome

6 *Pair of Ignudi above Ezekiel*, 1509-10
Fresco, 195 x 385 cm
Sistine Chapel (ceiling), Rome

7 *Pair of Ignudi above Daniel*, 1511
Fresco, 195 x 385 cm
Sistine Chapel (ceiling), Rome

8 *Pair of Ignudi above Persian Sibyl*, 1511
Fresco, 200 x 395 cm
Sistine Chapel (ceiling), Rome

9 *Pair of Ignudi above Libyan Sibyl*, 1511
Fresco, 195 x 385 cm
Sistine Chapel (ceiling), Rome

10 *Pair of Ignudi above Jeremiah*, 1511
Fresco, 200 x 395 cm
Sistine Chapel (ceiling), Rome

11 *Zechariah*, 1509
Fresco, 360 x 390 cm
Sistine Chapel (ceiling), Rome

12 *Joel*, 1509
Fresco, 355 x 380 cm
Sistine Chapel (ceiling), Rome

13 *Isaiah*, 1509
Fresco, 365 x 380 cm
Sistine Chapel (ceiling), Rome

14 *Erythraean Sibyl*, 1509
Fresco, 360 x 380 cm
Sistine Chapel (ceiling), Rome

15 *Cumaean Sibyl*, 1510
Fresco, 375 x 380 cm
Sistine Chapel (ceiling), Rome

16 *Ezekiel*, 1510
Fresco, 355 x 380 cm
Sistine Chapel (ceiling), Rome

17 *Daniel*, 1511
Fresco, 395 x 380 cm
Sistine Chapel (ceiling), Rome

18 *Jonah*, 1511
Fresco, 400 x 380 cm
Sistine Chapel (ceiling), Rome

19 *David and Goliath*, 1509
Fresco, 570 x 970 cm
Sistine Chapel (ceiling) Rome

20 *The Brazen Serpent*, 1511
Fresco, 585 x 985 cm
Sistine Chapel (ceiling), Rome

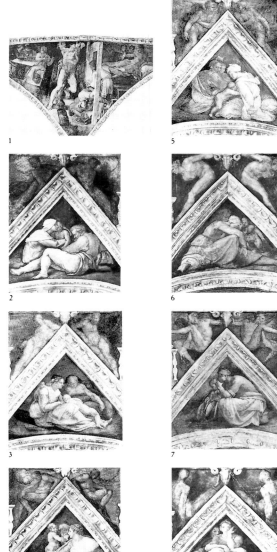

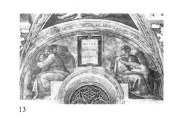
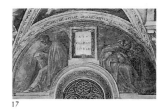
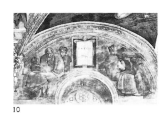
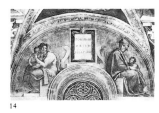

1 *Haman Crucified*, 1511
Fresco, 585 x 985 cm
Sistine Chapel (ceiling), Rome

2 *Josias and his Parents*, 1509
Fresco, 245 x 340 cm
Sistine Chapel (ceiling), Rome

3 *Zorobabel and his
Parents*, 1509
Fresco, 245 x 340 cm
Sistine Chapel (ceiling), Rome

4 *Hezekiah and his father Ahaz*,
1510
Fresco, 245 x 340 cm
Sistine Chapel (ceiling), Rome

5 *The Future King Ozias*, 1510
Fresco, 245 x 340 cm
Sistine Chapel (ceiling), Rome

6 *The King Asa*, 1511
Fresco, 240 x 340 cm
Sistine Chapel (ceiling), Rome

7 *Roboam and his Mother*, 1511
Fresco, 240 x 340 cm
Sistine Chapel (ceiling), Rome

8 *The Future King Jesse
and his Parents*, 1511
Fresco, 245 x 340 cm
Sistine Chapel (ceiling), Rome

9 *Solomon and his Mother*, 1511
Fresco, 245 x 340 cm
Sistine Chapel (ceiling), Rome

10 *Jacob and Joseph*, 1511-12
Fresco, 215 x 430 cm
Sistine Chapel (ceiling), Rome

11 *Azor and Sadoch*, 1511-12
Fresco, 215 x 430 cm
Sistine Chapel (ceiling), Rome

12 *Achim and Elioud*, 1511-12
Fresco, 215 x 430 cm
Sistine Chapel (ceiling), Rome

13 *Josias, Jechonias and
Salachiel*, 1511-12
Fresco, 215 x 430 cm
Sistine Chapel (ceiling), Rome

14 *Zorobabel, Abioud and
Eliachim*, 1511-12
Fresco, 215 x 430 cm
Sistine Chapel (ceiling), Rome

15 *Ezechias, Manasses,
Amon*, 1511-12
Fresco, 215 x 430 cm
Sistine Chapel (ceiling), Rome

16 *Ozias, Ioatham, Achaz*,
1511-12
Fresco, 215 x 430 cm
Sistine Chapel (ceiling), Rome

17 *Asa, Josaphat and Joram*,
1511-12
Fresco, 215 x 430 cm
Sistine Chapel (ceiling), Rome

18 *Roboam, Abias*, 1511-12
Fresco, 215 x 430 cm
Sistine Chapel (ceiling), Rome

19 *Jesse, David, Solomon*,
1511-12
Fresco, 215 x 430 cm
Sistine Chapel (ceiling), Rome

20 *Solomon, Booz, Obeth*,
1511-12
Fresco, 215 x 430 cm
Sistine Chapel (ceiling), Rome

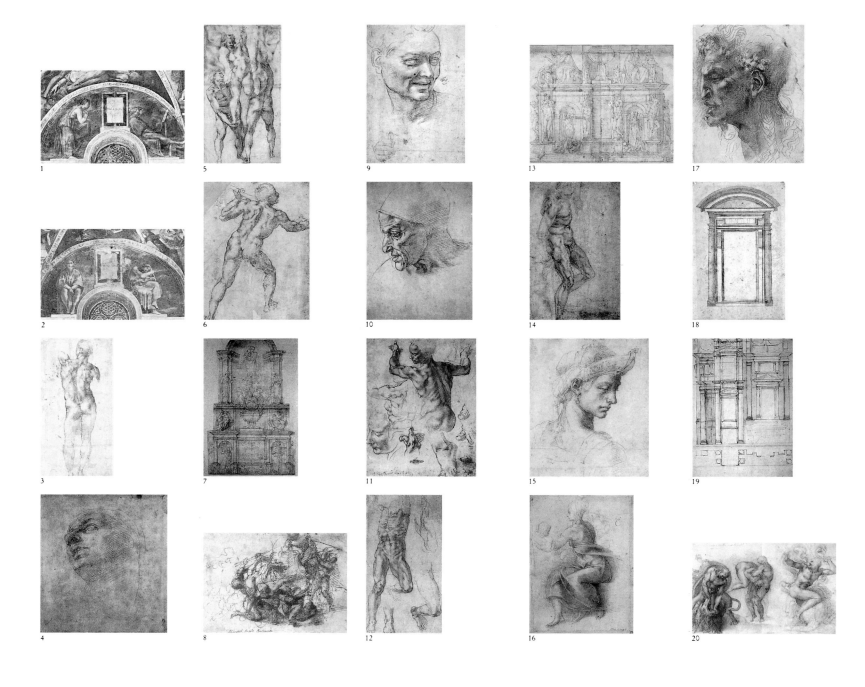

1 *Naasson*, 1511-12
Fresco, 215 x 430 cm
Sistine Chapel (ceiling), Rome

2 *Aminadab*, 1511-12
Fresco, 215 x 430 cm
Sistine Chapel (ceiling), Rome

3 *Male nude, standing, c.* 1501
Pen & ink, 37.9 x 18.7 cm
Albertina, Vienna

4 *Study of a head
turned upwards, c.* 1504
Red chalk, 19.9 x 17.2 cm
Casa Buonarroti, Florence

5 *Group of three male nudes,
c.* 1504
Black chalk, stylus, 33.2 x 17.4 cm
Louvre, Paris

6 *Male nude from behind, c.* 1504
Black chalk, 28.2 x 20.3 cm
Louvre, Paris

7 *Study for a tomb. c.* 1505?
Black chalk, pen,
ink, wash, 51 x 31.9 cm
Metropolitan Museum of Art
(Rogers fund), New York

8 *Combat of horsemen
and foot soldiers c.* 1506
Pen & ink, 17.9 x 25.1 cm
Ashmolean Museum, Oxford

9 *Study of head of young
man and a right hand* (Sistine)
Black chalk & white lead,
30.5 x 21 cm
Louvre, Paris

10 *Study for the head of
Cumaean Sibyl* (Sistine)
Black chalk & white lead,
32 x 22.8 cm
Biblioteca Reale, Turin

11 *Study for Libyan Sibyl* (Sistine)
Red chalk, 28.9 x 21.4 cm
Metropolitan Museum of Art,
New York

12 *Four studies for Haman*
(Sistine)
Red chalk, 40.6 x 20.7 cm
British Museum, London

13 *Study for wall tomb, c.* 1513
Black chalk, pen & brown ink,
brown wash, 29 x 36.1 cm
Uffizi, Florence

14 *Study of a male nude,
standing, c.* 1513 or 1516
Red chalk on stylus outline,
32.7 x 20 cm
Ecole des Beaux-Arts, Paris

15 *Head in profile*, 1518-20
Red chalk, 20.5 x 16.5 cm
Ashmolean Museum, Oxford

16 *Virgin and Child
with Saint John, c.* 1520
Red chalk, 29 x 20.4 cm
Louvre, Paris

17 *Head of a satyr*, after 1522
Pen & brown ink, red chalk
27.6 x 21.1 cm
Louvre, Paris

18. *Study for a door, c,* 1526
Black chalk, pen & ink,
brush & bistre wash
40.5 x 25.3 cm
Casa Buonarroti, Florence

19 *Elevation and plan for a
tomb, c.* 1526
Black chalk, pen, brown ink, brush
& wash, 39.7 x 27.4 cm
Casa Buonarroti, Florence

20 *Three labours of Hercules,
c.* 1530
Red chalk, 27.2 x 42.2. cm
Royal Library, Windsor

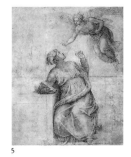

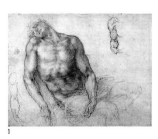

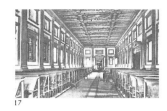

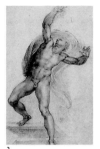

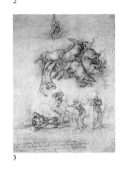

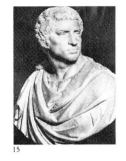

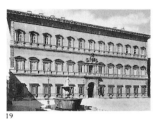

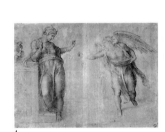

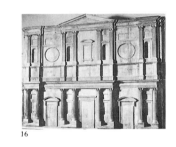

1 *Study for a Pietà: two studies of a right arm*, 1532?
Black chalk, 25.4 x 31.8 cm
Louvre, Paris

2 *Risen Christ*, *c.* 1532
Black chalk, 37.3 x 22.1 cm
Royal Library, Windsor

3 *Fall of Phaethon*, 1533
Black chalk, 31.3 x 21.7 cm
British Museum, London

4 *The Annunciation*, 1530-40
Black chalk, 40.5 x 54.5 cm
Uffizi, Florence

5 *The Annunciation*, *c.* 1540
Black chalk, 38.3 x 29.6 cm
Pierpont Morgan Library, NY

6 *Group of soldiers, cartoon fragment*, *c.* 1542
Black chalk, 263 x 156 cm
Capodimonte, Naples

7 *Study of man leaning forward*, *c.* 1550
Black chalk, 23.3 x 10 cm
National Gallery of Art (Hammer Collection), Washington

8 *Virgin at foot of cross*, *c.* 1552-4
Black chalk, 23 x 10.2 cm
Louvre, Paris

9 *Saint John at foot of Cross*
c. 1552-4
Black chalk, 25 x 8.2 cm
Louvre, Paris

10 *Plan of San Giovanni de Fiorentini*, 1559. Stylus, black chalk, pen & ink, wash, white lead, 42.8 x 38.6 cm
Casa Buonarroti, Florence

11 *Saint Matthew*, 1506
Marble, unfinished, H: 261 cm
Accademia, Florence

12 *Bearded Slave*, 1530-4
Marble, 263 x 248 cm
Accademia, Florence

13 *Young Slave*, 1530-4
Marble, 257 x 235 cm
Accademia, Florence

14 *Slave called 'Atlante'*,1530-4
Marble
Accademia, Florence

15 *Bust of Brutus*, *c.* 1539
Marble, unfinished, 74 x 95 cm
Bargello, Florence

16 *Façade of San Lorenzo in Florence*, 1517
Wood model
Casa Buonarroti, Florence

17 *Biblioteca Laurenziana*, reading room,
1523-71
Florence

18 *Façade of Palazzo Farnese*, 1546-9
3rd storey and cornice, Rome

19 *Piazza del Campidoglio*, *c.* 1538
Based on Michelangelo's plans, Rome

20 *Porta Pia*, 1561-5?
Rome

	Life of Michelangelo	Principal Works
1475	Born 6 March in Caprese, son of Lodovico de Buonarroti, Mayor of Caprese, and Francesca di Neri di Miniato del Sera	
1481	Death of his mother. Attends grammar lessons of humanist Francesco Galatea da Urbino	
1485	Starts to draw, encouraged by painter Francesco Granacci	
1488	On 1 April joins workshop of Ghirlandaio brothers, Domenico and David	
1490	Leaves Ghirlandaio workshop. Stays with Lorenzo *il Magnifico*. Frequents Medici garden, studies antiques there	*Madonna of the Steps*; *Battle of the Centaurs*
1492	On death of Lorenzo, returns to father's house	Wooden crucifix for Santo Spirito; *Hercules* (lost)
1494	Flees political troubles. Goes to Venice, then Bologna where he stays about a year	Statues for Shrine of Saint Dominic: *Angel bearing a candlestick*, *Saint Petronius* and *Saint Proculus*
1495	Returns to Florence. Sympathises with ideas of Dominican Savonarola	*Saint John the Baptist* (lost); *Cupid* (lost)
1496	Goes to Rome for the first time, guest of Cardinal Riario	
1497	Given commission for *Pietà* for Saint Peter's. Goes to Carrara to choose marble	*Bacchus*
1498	Completes *Pietà* in Rome	*Pietà*
1501	In Florence signs contract for 15 statues for Cardinal Piccolomini's tomb in Sienna. Given commission for *David*	*David* (1501-4). *Bruges Madonna*
1502	Florentine government commissions from him a bronze *David* for maréchal Pierre de Rohan, sent to France and now lost	*David* (in bronze), unfinished in 1508, completed by Benedetto da Rovezzano
1503	12 statues of Apostles commissioned for Santa Maria del Fiore, of which only an unfinished *Saint Matthew* was produced	*Saint Matthew*
1504	*Battle of Cascina* commissioned in August. On 8 September marble *David* positioned in front of Palazzo della Signoria	*Pitti tondo*; *Taddei tondo*; *Doni tondo*; *Battle of Cascina*
1505	Pope Julius II summons him to Rome and commissions his tomb. Goes to Carrara to choose marble	First project for Tomb of Julius II
1506	Returns to Florence in fury: the Pope abandoned the tomb and commissioned the Sistine ceiling. Reconciliation in Bologna	
1507	In Bologna. At end of year plans to go to Rome	Statue of *Julius II* in bronze, destroyed in 1511 (façade of San Petronie Bologna)
1508	Soderini orders a statue of *Hercules and Cacus*. Paid an advance for the Sistine. Surface preparation for the frescos	Completes 1st project for Tomb of Julius II; *Hercules and Cacus* (bak terracotta)
1509	February-March: 'I am dissatisfied . . . alone and penniless.' By the end of the year, about a third of ceiling finished	Execution of frescos on Sistine ceiling begins
1511	Seems to have started cartoons for the lunettes. 14-15 August: the Sistine ceiling uncovered	Sistine ceiling finished
1512	31 October: official inauguration of Sistine ceiling	
1513	February: Leo X succeeds Julius II. New contract for tomb, 28 statues instead of 40. Trips to Carrara	*Dying Slave*; *Rebellious Slave*; embarks on *Moses*
1514	15 June: commission of a *Risen Christ* for Santa Maria sopra Minerva in Rome	
1516	Leo X, a Medici, commissions him for façade of San Lorenzo, burial place of his family. Friendship with Sebastiano del Piombo	
1517	Many visits to Carrara	Begins projects for façade for San Lorenzo
1518	Signs contract for San Lorenzo (cancelled 1520). Chooses marble at Pietrasanta and Carrara. Has three workshops in Florence	

Artistic Life	History
Pollaiulo: *Martyrdom of Saint Sebastian*; Ghirlandaio: *Frescos in San Gimignano*; Marsilio Ficin: *Platonic Theology*; death of Uccello	Sixtus IV opens the Vatican library to the public; Edward IV invades France; signs Treaty of Picquigny
First decoration of Sistine by Melozzo da Forli; Leonardo da Vinci: *Adoration of the Magi*	Turkish raid at Otranto; Inquisition in Spain: Torquemada; Louis XI brings Franche-Comte into subjection; death of Muhammad II
Ghirlandaio: starts frescos of Trinity at Santa Maria Novella; birth of Sebastiano del Piombo	Revolt against Ferrante of Naples; 110 printing presses in Europe (50 in Italy, 30 in Germany, 9 in France); death of Richard III
Filippino Lippi: *Frescos of Santa Maria sopra Minerva*; death of Verrocchio	Bartolommeo Diaz reaches South Africa
Leonardo da Vinci: *Lady with an ermine*; Lefevre d'Etaples: *Introduction à la métaphysique d'Aristote*; birth of Titian	
Pinturicchio: *Decoration of apartments of Alexander VI*; death of Piero della Francesca; birth of Aretino	Death of Lorenzo *il Magnifico* and Innocent VIII; Christopher Columbus reaches America; edict against Jews in Spain
Brant: *La Nef des Fous*; Paccioli: *Book of arithmetic*; deaths of Ghirlandaio, Memling; births of Correggio, Pontormo, Rabelais	Death of Ferrante of Naples; Charles VIII enters Rome; fall of the Medicis in Florence
Botticelli: *Calumny of the 'Apelles'*; Mantegna: *Madonna of Victory*; death of Cosimo Tura	Charles VIII takes Naples
Raphael is Perugino's pupil in Perugia; Filippino Lippi: *Adoration of the Magi*; death of Ercole de Roberti; birth of Clement Marot	
Leonardo da Vinci: *The Last Supper*; Signorelli: *Decoration of Monastery of Monte Oliveto Maggiore*; death of Benozzo Gozzoli	Excommunication of Savonarola; Vasco da Gama's expedition; Jean Cabot reaches Newfoundland; birth of Melanchthon
Fra Bartolommeo: *Frescos of Santa Maria*; Château de Blois; deaths of Fra Diamante and Pollaiulo; birth of Moretto	Death of Charles VIII, succession of Louis XII; Savonarola burnt in Florence; Vasco da Gama discovers route to India
Pinturicchio: *Frescos of Santa Maria Maggiore, Spello*; Mantegna: *Minerva Triumphing over the Vices, Parnassus*	
Carpaccio: *Saint George and the Dragon*; Josquin des Prés: *first collection of masses*	Edict of expulsion of unconverted Moors in Spain; Julius II succeeds Alexander VI; 2nd voyage of Vasco da Gama
Bellini: *Portrait of Doge Leonardo Loredano*; Leonardo da Vinci: *Mona Lisa*; Raphael: *The Dream of a Knight*	Foundation of Benedictine order; Albuquerque in India; Portuguese in Japan; invention of Venetian mirror
Pinturicchio: *Frescos in Cathedral of Sienna*; Erasmus: *Enchiridion*; death of Filippino Lippi; birth of Bronzino	French lose Naples; Treaty of Blois
Bellini: *Sacra Conversazione*; Il Sodoma: *Life of Saint Bernard*; anatomical research by da Vinci	Luther goes into monastery
Raphael: *The Three Graces*; Bramante starts Saint Peter's in Rome, Reuchlin: *Rudimenta Linguae Hebraicae*; death of Mantegna	Portuguese in Socotra
Leonardo: *Trattato della Pittura*; Lotto: *Marriage of Saint Catherine*; Raphael: *La Belle Jardinière, Entombment*; death of Bellini	Genoa revolts against French; death of Cesare Borgia; Luther ordained priest; Albuquerque at Ormuz
Lotto: *The Annunciation*; Raphael: *Madonna del Baldacchino, Cowper Madonna*; Titian: *Le Concert Champêtre*	
Bramante and Raphael work in the Vatican; Andrea del Sarto: *Life of S. Filippo Benizzi*; Erasmus: *Encomium Morae*	Julius II excommunicates Venice, reoccupies the Romagna; accession of Henry VIII; Portuguese in Malacca; births of Calvin and M. Servet
Titian: *Portrait of a Man*; Raphael: *painting of Stanza d'Eliodoro*	Julius II forms a league against France; invention of pocket watch by Peter Henlein
Raphael: *Madonna di Foligno*; Sebastiano del Piombo: *La Fornarina*; Lefèvre d'Etaples: *Epistle according to Saint Paul*; birth of Vasari	Return of Medicis to Florence; French lose Italy; Council of Milan dissolved; Luther prior of Wittenburg
Titian: *Sacred and Profane Love*; Sarto: *Mystical Marriage of Saint Catherine*; Machiavelli: *The Prince*; death of Pinturicchio	Inquisition condemns Reuchlin; Louis XII treats for peace with Leo X and recaptures Milan; Battle of Novara; Balboa reaches the Pacific
Fra Bartolommeo: *Saint Sebastian*; Correggio: *Madonna of Saint Francis*; Raphael architect of Saint Peter's; death of Bramante	Louis XII restores peace; revolt of Hungarian peasants; Portuguese in China
Titian: *Madonna of the Cherries*; Leonardo da Vinci is in France; Thomas More: *Utopia*; Ariosto: *Orlando Furioso*; death of Hieronymus Bosch	Luther's sermons; agreement of Pope with François I; death of F.d'Aragon; Charles V inherits Spain and south Italy
Raphael: *Saint Cecilia*; Andrea del Sarto: *Madonna of the Harpies*; Sebastian del Piombo: *Pietà*; death of Fra Bartolommeo	Publication of Luther's 95 theses against indulgences; Spanish in Yucatan; Portuguese in Canton; Turks in Egypt
Andrea del Sarto: *Charity*; Il Sodoma; *Presentation at the temple*; births of Tintoretto and Palladio	Luther summoned to Rome and appeals to Council

	Life of Michelangelo	Principal Works
1519	Works on Julius tomb; Pope commissions him to make Sacristy of San Lorenzo into a funerary chapel	2nd version of the *Risen Christ* at Santa Maria sopra Minerva
1520	November: agrees to execute plans and statuary for Medici chapel: 2 tombs instead of the previous 6	
1521	Death of Pope Leo X in December; August: *Christ of the Minerva* is taken to Rome	Start of work on the Medici tombs
1524	Work begins on Biblioteca Laurenziana in Florence (1524-6, 1530-4)	*Dusk*; *Dawn*; starts *Lorenzo de' Medici*
1526	Conflict with new Pope Clement VII about Julius tomb	*Night*; *Day*; starts *Giuliano de' Medici*
1527	Fall of the Medicis; work stops on San Lorenzo; carries out fortifications of city against papal and imperial armies	Fortification projects
1528	Distraught by the death of his favourite brother, Buonarroto	
1529	Appointed to the *Nove della Milizia* and Governor-General of fortifications. July-Aug: studies fortifications of Ferrara	
1530	12 August: capitulation of Florentine republic; Clement VII pardons artist who resumes work on the Medici Chapel	Cartoon for *Leda*; *Apollo-David*
1531	Draws plans for relics loggia in San Lorenzo (Oct. 1531-July 1533)	Cartoon for '*Noli me tangere*' and *Venus and Cupid*; *Dusk*; *Day*
1532	New contract with heirs of Julius II for his mausoleum; meets the young Tommaso de' Cavalieri and settles near him in Rome	*Victory*; *The Four Slaves*
1534	Death of his father Lodovico (aged 91) and of Clement VII; papacy of Paul III an era of great productivity	Finishes the Medici tomb in Florence
1535	Paul III confirms commission for *The Last Judgement*	Cartoon for *The Last Judgement*
1536	Starts work on *The Last Judgement* (1536-41); meets Vittoria Colonna around 1536-7	Start of *The Last Judgement* (Sistine Chapel)
1538	Numerous religious subjects for Vittoria Colonna; their relationship is recounted in F. da Hollanda's *Dialogues*	Starts (?) *Brutus*
1542	20 August: final contract for Julius tomb; finishes *Moses* and executes *Leah* and *Rachel*	Starts frescos in Capella Paolina; *Conversion of Saint Paul*
1544	Drawing of tomb of Francesco Bracci, nephew of Luigi del Riccio; contacts with Vasari and the future Academician Varchi	Start of work on Capitoline Hill following his plans
1546	Illness; helped by Luigi del Riccio; appointed architect for Saint Peter's	Works on *Crucifixion of Saint Peter* (1545-50), Cappella Paolina
1547	Death of Vittoria Colonna which causes him much grief	
1550	Projects for San Giovanni dei Fiorentini; Vasari publishes his *Lives* (1st edn) including a biography of Michelangelo	Finishes frescos in Cappella Paolina
1553	Works on *Pietà* (Florence Cathedral); Condivi, his pupil, publishes *Life of Michelangelo Buonarroti*	*Pietà* (Florence Cathedral)
1555	Paul IV commissions him for dome of Saint Peter's; following accusations of heresy, nudity of *The Last Judgement* is disguised	1st version of *Pietà Rondanini*
1559	Sends model of staircase for Biblioteca Laurenziana to Florence; accession of Pope Pius IV (1559-65)	Drawings for church of San Giovanni dei Fiorentini and the Sforza Chapel in Santa Maria Maggiore
1560	Drawing for Catherine de' Medici of a monument dedicated to Henry II	
1561	Execution of *Porta Pia* and *Santa Maria degli Angeli*	Produces great wooden model of dome of Saint Peter's
1563	Takes charge with Duke Cosimo I de' Medici of foundation of Academy of drawing, established that same year in Florence	
1564	18 Feb. dies aged 89. In accordance with his wishes, his nephew Leonardo has his body taken to Florence for solemn burial	

istic Life	History
reggio: *Mystic Marriage of Saint Catherine*; Titian starts *Pesaro donna*; death of Leonardo da Vinci	Charles V Emperor; Luther condemned in Cologne; Melanchthon and Luther at Leipzig; Cortés in Mexico; Magellan rounds Cape Horn
reggio: *Transfiguration*; death of Raphael	Luther: *Christian Nobles of Germany*, *On the Babylonish Captivity of the Church*; Field of the Cloth of Gold; discovery of the Straits of Magellan
rea del Sarto: *Caesar receiving tribute from Egypt*; Machiavelli: *Art of* ·; death of Piero di Cosimo	Sforza recaptures Milan; Luther excommunicated, put under ban of the Empire by the Diet of Worms; death of Leo X; Turks occupy Belgrade
migianino: *Self-portrait in a convex mirror*; death of Perugino; births onsard and Palestrina	La Tremoille recaptures Milan; Luther: *Letters to the Princes of Saxony*; Munzer elected pastor of Anabaptists
odoma: *Descent into Limbo*; Andrea del Sarto: *The Last Supper*; Titian: *aro Madonna*; death of Carpaccio	League of Cognac between Italian states; Menezes discovers New Guinea; Capuchin order founded; formation of Lutheran church
bein: *Portrait of Fischer*	Rome sacked by Imperial army; French defeated in Italy; Lutheranism becomes state religion in Denmark
reggio: *Madonna with Saint Jerome*; Parmigianino: *Madonna della* ·; deaths of Palma Vecchio and Durer; birth of Veronese	Ignatius of Loyola in Paris; Reformation in Berne; Council of Sens; Thomas More Chancellor of England
ni: *Frescos of Santa Maria degli Angeli* in Lugano (The Passion); migianino: *Madonna*; Altdorfer: *Battle of Issus*	Independence of Genoa; triumph of Reformation in Basle, St Gall, Schaffhausen, Mulhouse; Turks at the gates of Vienna
reggio: *The Night*; Titian: *Madonna del Coniglio*; Rosso invited to ainebleu; death of Andrea del Sarto	François I founds Collège de France; Siege of Florence; Confession of Augsburg; Coronation of Charles V
naticcio in France; Cranach: *Venus*	Henry VIII head of the Anglican church
elais: *Pantagruel*	Alexander is Duke of Tuscany; Pizarro sets sail for Peru
un: *Presentation of the Virgin*; Parmigianino: *Madonna with the long* ·; Rabelais: *Gargantua*	Lorenzaccio assassinates Alexander; Thomas More executed; Cartier reaches Canada; Loyola founds Society of Jesus
ino: *Ragionamenti*	François I allied to Turks, new war against House of Austria; Cromwell is appointed Lord Protector; Inca revolt in Peru
celsus: *Treatise on Medicine*; Calvin: *Christianae Religionis Institutio*; h of Erasmus	François I occupies Savoy and captures Turin; Calvin settles in Geneva; Cosimo defeats French at Monte Murlo; Anne Boleyn executed
un: *Venus of Urbino*	Treaty of Nice between François I and Charles V; Holy League between the Pope, the Emperor and Venice; De Soto explores Mississippi
rgio Vasari; *Ceiling of a room in the Palazzo Corner-Spinelli* nice); Palladio designs Villa Godi, Lonedo, Vicenza	Tuscany: Grand Duchy; Charles V and Henry VIII form alliance against François I; Carafa runs Inquisition in Rome
un: *Danaë*; Antonio Francesco Doni: *Il Dialogo della Musica*	Founding of first Jesuit college in Cologne; Imperial armies invade Champagne; English siege of Boulogne
oretto: *Frescos of Santa Maria dell'Orto* in Venice; Rabelais: *The Third* k; death of Gaudenzio Ferrari; birth of Tycho Brahe	Death of Luther; Etienne Dolet, a printer, is burnt as a heretic in Paris; Jesuits in Brazil
oretto: *The Last Supper*; 1st translation of Koran in Venice; deaths of astiano del Piombo and Pietro Bembo; birth of Cervantes	Death of François I, succession of Henry II; death of Henry VIII, succession of Edward VI; quarrel between Charles V and Paul III
nzino: *Cosimo I de' Medici*; Tintoretto: *Adam and Eve*; Palladio: first ension bridge; Ronsard: *Odes*	Anglo-French peace treaty; election of Julius III; founding of Jesuit college in Rome
rin: *Defence of the orthodox faith*	Mary Tudor succeeds Edward VI; execution of M. Servetus in Geneva; end of 1st Council of Lima; Universities of Lima and Mexico
onese starts frescos of Saint Sebastian in Venice; Louise Labbe: nets; birth of Malherbe	Sienna surrenders; Jules III dies, succeeded by Marcellus II, then Carafa (Paul IV); invention of amalgam to process silver
egel: *Proverbs*, *Fight between Carnival and Lent*; Tintoretto: *Suzanne* ing; Amyot: French translation of Plutarch's *Lives*	First Vatican index; François II succeeds Henri II; 1st *auto-de-fe* in Seville and Valladolid; Treaty of Cateaux-Cambraisis
onese: Frescos of Villa Barbaro at Maser; Theodore de Beza: *Traité de torité du magistrat*	François II dies, regency of Catherine de' Medici; Christian community of Jesuit Villela in Japan; Nicot sends tobacco to Paris
egel in Brussels: *Dulle Gliet*; Veronese: *Marriage Feast at Cana*; oretto: *The Finding and the Removal of the Body of Saint Mark*	Bankruptcy of Fugger; assassination of François de Guise; closure of Council of Trent
egel: *Hunters in the Snow*; invention of graphite pencils encased in od; births of Shakespeare and Galileo	Death of Ferdinand I, succession of Maximilian II; death of Calvin; bull ratifying acts of Council of Trent

List of Michelangelo's Works

Select Bibliography

L'Oeuvre littéraire de Michel-Ange avec une vie du maître par son élève Ascanio Condivi, first translation by Boyer d'Agen, Paris, 1911

The Drawings of the Florentine Painters, Bernard Berenson (3 vols), Chicago & London, 1938

The Architecture of Michelangelo, James S. Ackerman (2 vols), London, 1961; rev. edn., Harmondsworth, 1970

Michelangelo architetto, P. Portoghesi & B. Zevi, Turin, 1964

Le Grand atelier d'Italie 1460-1500, André Chastel, Paris, 1965

Il Carteggio di Michelangelo, Paola Barocchi & R. Ristori, Florence, 1965, 1983

Michelangelo, Charles de Tolnay (5 vols), Princeton University Press, 1970; Flammarion, Paris, 1970

The Drawings of Michelangelo, F. Hartt, London, 1971

Les Temps des génies: Renaissance Italienne 1500-1540, L.H. Heydenreich & Günter Passavant, Paris, 1974

Michelangelo, Howard Hibbard, London, 1975

Michel-Ange au Louvre: les dessins, R. Bacou & F. Viatte, Paris, 1975

Michel-Angel: l'artiste, sa pensée, l'écrivain, (2 vols), introduced by Mario Salmi, collected essays, Editions Atlas, Paris, 1976

A project of Michelangelo's for the Tomb of Julius II, pp. 375-82, Master Drawings XIV, 1976

'Les Ignudi de Michel-Ange' in *Fables, Formes, Figures* (vol. I, pp. 273-92), André Chastel, Paris, 1978

'Michel-Ange en France' in *Fables, Formes, Figures* (vol. II, pp. 189-206), André Chastel, Paris, 1978

Drawings by Michelangelo from the British Museum, exhibition catalogue, Pierpont Morgan Library, New York, 1979

Drawings by Michelangelo from the British Museum, J.A. Gere & N. Turner, New York, 1979

Corpus dei Disegni di Michelangelo, Charles de Tolnay (4 vols), Novare, 1976, 1980

Michelangelo, Linda Murray, London, 1980

L'Art italien, André Chastel, Paris, 1982

Art et humanisme à Florence au temps de Laurent le Magnifique, André Chastel, PUF, Paris, 1959, 1982

Disegni italiani del Teylers Museum Haarlem provenienti dalle collezioni di Christina di Svezia e dei principi odescalchi, B.W. Meijer & C. Van Tuyll, Florence, 1983

'La Vie de Michel-Ange' in *La Vie des meilleurs peintres, sculpteurs et architectes*, Giorgio Vasari (1550, 2nd extended edn, 1568), annotated edn by André Chastel (t.9, pp. 169-340), Paris, 1985

Michelangelo e i maestri del Quattrocento, exhibition catalogue, Carlo Sisi, Florence, Casa Buonarroti, 20 June-20 Nov. 1985

Tout l'oeuvre peint de Michel-Ange, introduction by Charles de Tolnay, documentation Ettore Camesasca, Paris, 1966 (in Italian), 1967, 1968 (in French)

Renaissance artists and Antique sculpture, P.P. Bober & R.O. Rubinstein (a Handbook of sources), London and Oxford, 1968

Michel-Ange et la chapelle Sixtine, collection of essays by André Chastel, John Shearman, John O'Malley, Pierluigi de Vecchi, Michael Hirst, Fabrizio Mancinelli, Gianluigi Colalucci, Paris, 1986

Michelangelo at work: the painting of the Ceiling, F. Mancinelli, London 1986, pp. 218-59

La Théorie des arts en Italie, Anthony Blunt (1st English edn, 1940), Paris 1986

Michel-Ange et la peinture à fresque, Alessandro Conti, trans. from Italian by Odile Ménégaux, Paris, 1987

Michel-Ange dessinateur, exhibition catalogue, Michael Hirst. Musée du Louvre, Paris, (RMN), 9 May-31 July 1989

Michelangelo e la Sistina: la tecnica, il restauro, il mito, exhibition catalogue, Musei Vaticani e biblioteca apostolica vaticana, Rome, 1990